THE ARTISTS IN PERSPECTIVE SERIES
H. W. Janson, general editor

The ARTISTS IN PERSPECTIVE SERIES *presents individual illustrated volumes of interpretive essays on the most significant painters, sculptors, architects, and genres of world art.*

Each volume provides an understanding of art and artists through both esthetic and cultural evaluations.

JUDITH WECHSLER is Associate Professor of Art History at Massachusetts Institute of Technology. She has published articles and reviews of contemporary art and a study of the Song of Songs in twelfth- and thirteenth-century Latin Bibles. Currently she is at work on Daumier's use of gesture and the physiognomy of the spectator, and on aesthetic perspectives in science and technology associated with her work at M.I.T.

CÉZANNE

in Perspective

Edited by

JUDITH WECHSLER

A SPECTRUM BOOK

Prentice-Hall, Inc., Englewood Cliffs, New Jersey

Library of Congress Cataloging in Publication Data

WECHSLER, JUDITH comp.
 Cézanne in perspective.

 (The Artists in perspective series) (A Spectrum Book)
 Bibliography: p.
 1. Cézanne, Paul, 1839–1906. I. Title.
ND553.C33W42 759.4 74–13479
ISBN 0–13–123356–4
ISBN 0–13–123349–1 (pbk.)

*To my parents
Nahum and Anne Glatzer
with love*

© 1975 BY PRENTICE-HALL, INC.
ENGLEWOOD CLIFFS, NEW JERSEY

A SPECTRUM BOOK

1 2 3 4 5 6 7 8 9 10

Printed in the United States of America

PRENTICE-HALL INTERNATIONAL, INC. (LONDON)
PRENTICE-HALL OF AUSTRALIA, PTY. LTD. (SYDNEY)
PRENTICE-HALL OF CANADA, LTD. (TORONTO)
PRENTICE-HALL OF INDIA PRIVATE LIMITED (NEW DELHI)
PRENTICE-HALL OF JAPAN, INC. (TOKYO)

CONTENTS

Reflections of Some Major Painters: 1908–1943

PREFACE

Cézanne was a revolutionary painter. The complexity of his art has led to a considerable literature in the past one hundred years. The history of these critical stands reflects most of the core intellectual and artistic concerns of the late nineteenth and twentieth century. This book is intended to give perspective to these varied interpretations of Cézanne's painting.

The following reviews, articles and essays were chosen to capture both the development and diversity of interpretations of Cézanne's work. I have given preference, where a choice obtained, to lesser known or inaccessible sources, a number of which are translated into English here for the first time. The sequence of the selections is primarily chronological, in order to give historical perspective. Exception is made when two pieces by the same author are placed consecutively, or when the views of various contemporary painters and critics are grouped together. The date of the original publication is placed in parentheses after the author's name as the date sometimes differs from that of the edition quoted. My deletions are indicated by the sign ". . . ."

I am particularly grateful to Professor Linda Nochlin for her advice and support throughout the preparation of this material, first on my doctoral dissertation and then on this book. I think Professor Frederick Wight for his encouragement while I was writing my thesis. I have discussed various issues which arose in the introduction with Rosalind Krauss, Flora Natapoff, and Leo Steinberg. To Professor Meyer Schapiro I give special homage; it is because of him that I came to study art history.

I am indebted to all those who permitted me to reprint material. The new French translations were done for the most part by Miss Kathleen Pond, with a few shorter passages translated by Caroline Malcolm, and myself. Dr. Raymond Ockenden translated the Novotny selections from the German. S. B. Sutton read the introduction and was most helpful in her suggestions regarding style. Finally, my fondest appreciation goes to my constant companion, Dr. Benson Snyder, who was unfailing in his moral support and astute advice, and to my daughter, Johanna, for her loving patience and understanding.

INTRODUCTION

Judith Wechsler

Paul Cézanne's painting heightens our awareness of pictorial form and structure as it articulates his outlook on the world. He conceived of painting as a way of realizing his sensation before nature and not as a problem in abstract composition. The subjective element of his painting was asserted as *a way of seeing,* rather than an imposition of mood or atmosphere on a landscape or portrait. Cézanne revealed how we come to see reality when the various schemata of vision and painting are rejected. At the same time he created a new unity and cohesiveness of composition by laying bare the elements of color relationships and space definitions. He bound color to structure, surface to depth, form to content, process to realized work. In so doing Paul Cézanne evolved a new syntax for painting.

Many of Cézanne's interpreters believed that he was a "pure painter" concerned with composition for its own sake. They claimed that he paid no regard to the relation between his finished canvas and the world imagined, experienced or observed. At first sight, Cézanne's subject matter in his mature work appears neutral, objective, devoid of expression. The image character of his painting shifted from an implied stage space, a microcosm of subject and structure, to the constructive small units of composition, the pictorial micro-structure. However, the facets of his brushstroke transmitted the fragments we perceive in the process of scanning and selection of a scene.

Generations of Cézanne's critics focused on *how* Cézanne painted and ignored the questions of *what* he painted and *why.* His work was viewed simply as a matter of style and technique. Underlying Cézanne's composition is, however, an outlook which, partly unconscious as it may have been, is nevertheless necessary to decipher. Only when the preoccupation with the question of means had been exhausted could the multidimensionality of Cézanne's vision and pictorial composition be appreciated and his work be understood as the record of his perceptual and conceptual experience.

The richness and complexity of Cézanne's art has evoked a wide range of interpretations which reflect most of the intellectual movements

1

of the past hundred years. There are Naturalist, Symbolist, Neoclassical, perceptual, formalist, didactic, Marxist, psychoanalytic (both Freudian and Jungian), phenomenological and existentialist interpretations of Cézanne. To be sure, many major figures in art and literature have evoked multiple interpretations bound to aesthetic biases. One of the most serious ideological conflicts in twentieth century criticism is apparent in the Cézanne literature—the conflict between formalist and humanist interpretations. The formalist approaches consider primarily the intrinsic problems of Cézanne's composition and formal inventions. The humanistic interpretations regard Cézanne's composition in relation to his subject matter in the light of his personal, social, historical and even spiritual context. Cézanne is almost unique among nineteenth-century painters in catalyzing both the most exacting formal analyses and psychoanalytic, existentialist and phenomenological investigations. While Cézanne's painting invites a formalist approach, it also reveals the insufficiency of it. What is unique to the Cézanne literature is that it marks a shift in mid-twentieth-century criticism from a predominantly formal trend to a humanistic one.

The interpretation of Cézanne's work requires both an accurate observation of his formal structure and an overall understanding of his oeuvre, his life and times. Without a concrete perception of his composition, theories have no substance, and without a sense of reality as he perceived and recorded it, interpretation suffers from a lack of depth and coherence. We must ask whether the bias of a critic in singling out a particular aspect of Cézanne's work throws the whole perspective of his painting out of balance, or whether in elucidating a selected aspect the critic illuminates his work as a whole. By restricting the domain of investigation to a narrow band, the knowledge that is proved does not always correspond to the reality experienced. The critic's need for certainty may preclude speculations which are by nature more far-reaching and profound.

In their response to Cézanne's work successive generations of painters and critics have consciously or unconsciously reflected the aesthetic attitudes and experiences of their own intellectual and artistic milieu. What was visible to observers of Cézanne's art depended, at least in part, on what they could see as a function of their particular period. For example, the Impressionists prepared the critics to see Cézanne's color, but their frame of reference did not prepare the interpreters for a sympathetic understanding of Cézanne's use of line or his deviations from traditional perspective. Emile Zola, a Naturalist, could grasp Cézanne's early violent and impassioned subject matter, and his concern for the realized object of perception, but he could not sympathize with Cézanne's later emphasis on his own process of perception in paintings with apparently dispassionate motifs. The Symbolists were sensitive to Cézanne's formal arrangements, but explained the effect of flatness of his composition as a function of a decorative sensibility rather than a perceptual one. The advocates of tradition in French painting, the Neoclassicists of the 1890's, equated Cézanne's art with that of Poussin, ignoring his relation to Impressionism. The Cubists were the first to understand Cézanne's spatial construction in

relation to his perception. Their essentially abstract and purely pictorial transformation of Cézanne's model after nature laid the foundation for the formal understanding of Cézanne advanced by Roger Fry.

We see Cézanne through a filter of interpretations. To claim that one can bypass the critics in an attempt to see Cézanne "as he really is" ignores the extent to which all of us have a perceptual bias, whether or not we are critics. The interpretations which have accrued to Cézanne's work have become part of the conditions of our seeing. The literature on Cézanne reflects not only the need to explain his paintings, but is also a response to previous interpretations of his work. The interpretations are linked one to another in a historical network.

CÉZANNE'S FIRST CRITICS

"He belongs to a school which has the privilege of provoking criticism," noted Marius Roux in the first printed mention of Cézanne; the context, a review of Emile Zola's novel dedicated to Cézanne, *La Confession de Claude,* published in an Aix-en-Provence newspaper in 1865.[1] No specific work of Cézanne's was discussed. Although Zola requested that Roux mention Cézanne, he did not take the opportunity himself to deal with his friend's painting at this stage. Zola could easily have done so in his *Salon* reviews in which rejected painters were considered as well. Instead, in 1866 he dedicated his collected Salon reviews (*Mon Salon*) to Cézanne in praise of their friendship and shared ambitions.

Cézanne first exhibited his painting at the Salon des Refusés of 1863 —evoking no critical response. When he showed again in 1867—this time at the Salon—he was derisively referred to by a critic, Arnold Mortier, in *Le Figaro* as Mr. Sésame, who went on to say that his work was worthy of exclusion from the Salon.[2] Zola defended Cézanne in *Le Figaro* by pointing out the inaccuracies of Mortier's descriptions, accusing him of never having actually seen Cézanne's work.[3] In 1870 Cézanne was caricatured with his paintings which had been rejected by the Salon.

In 1874 when Cézanne exhibited at the first Impressionist exhibition, he was more widely taken up by the critics. The 1874 reviews were critical of the Impressionists' inept drawing, bizarre color and unconventional composition. Cézanne was considered the least acceptable. Both his subject matter and style were ridiculed, his particular deviations from the then accepted formal standards leading one critic, Marc de Montifaud, to characterize him as "a sort of madman who paints in delirium tremens."

Three years later, at the third Impressionist exhibition, Cézanne was again severely attacked by most of the reviewers. But there was one exception. A young critic, George Rivière, sensed in Cézanne's forms an "epic grandness" which he equated with that of the ancient Greeks.

[1] "La Confession de Claude," *Memorial d'Aix,* Dec. 3, 1865. The information in the first three footnotes is cited in John Rewald, *Paul Cézanne* (New York, 1968).

[2] Arnold Mortier, in *Le Figaro,* April 8, 1867.

[3] Emile Zola, in *Le Figaro,* April 12, 1867.

After the generally disastrous reception Cézanne had received at the two exhibitions, he retreated from the public eye until 1889. There is no reference to new works by Cézanne in critical reviews during these twelve years. However, Cézanne continued to receive disparaging references in the early 1880's.

No account of the way Cézanne was seen at the time would be complete without some further discussion of Emile Zola's attitude toward his childhood friend. While Zola was quite well known as an art critic, particularly through his defense of Manet in the 1860's, he wrote only two explicit paragraphs on Cézanne's work, one in 1877 and one in 1880; the latter was fault-finding.[4]

A more complete reflection of Zola's views of Cézanne and the Impressionists can be gathered from his novel *L'Oeuvre* (*The Masterpiece*), published in 1886. Claude Lantier, the principal character, was portrayed as an important Impressionist painter, the leader of a new school of painting, who committed suicide in his futile attempt to "realize" his work. Zola's notes indicated that Lantier was patterned after Cézanne. What characterized a realized artist for Zola? Perhaps one whose work exhibited sufficient "finish" to be acceptable to the public. (Zola confessed to Gustave Geffroy that he was disappointed with Manet, the Impressionists and Cézanne because of their lack of finish and composition.)[5] After all, finish and acceptability characterized Zola's own later work and success. Lantier's work, comprised largely of sketches, no longer had public acceptance. Thus Zola revealed in his novel his inability to acknowledge open-ended, at times unfinishable works, as works of art. Zola simply could not conceive of presenting as art the problems associated with the act of perception. He thought that this problem would drive the artist mad rather than sustain him. Lantier's (Cézanne's) works were too ambitious; they could never be realized—not in the sense of imposing a closed pictorial solution.

In the 1880's Cézanne was barely known outside of a small circle of painters and critics associated with the Symbolist movement. During the 1880's and 1890's Albert Aurier, Emile Bernard, Maurice Denis, Felix Fénéon, Paul Gauguin, Gustave Geffroy, J. K. Huysmans—previously a follower of Zola's Naturalism—and Paul Sérusier all expressed interest in Cézanne in their letters and articles. The founding of the journals *La Cravache* in 1886 and *Mercure de France* in 1890 gave the Symbolists two places in which to express their aesthetic aims. It was in this milieu that the first attempts were made to understand Cézanne's art theoretically.

The critics, initiated by Impressionism, were prepared to understand Cézanne's color, but not his space. The Symbolists, who flattened volumes in order to create a decorative surface, interpreted Cézanne's

[4] *Le Sémaphore de Marseille*, April 19, 1877; reprinted in *Oeuvres Complètes* (Paris, 1969), Vol. 12, p. 974; "Le Naturalisme au Salon," *Le Voltaire* June 18–22, 1880. Reprinted in Lionello Venturi, *Les Archives de l'Impressionnisme* (Paris, 1939), II; p. 280.

[5] Gustave Geffroy, *Claude Monet, sa vie, son oeuvre* (Paris, 1924), II, p. 80.

equivocation between three-dimensional and two-dimensional space from the perspective of their own movement. They pressed Cézanne's pictures into the service of a theory of decorative abstraction, without considering sufficiently the role of nature in his work.

The Symbolists were the first to advance the idea that Cézanne was a "pure painter." Cézanne's maxim that one must not reproduce nature but interpret it by means of plastic equivalents was interpreted by them as a search for symbolic correspondences. Cézanne probably found the idea that his art was being linked with that of the Symbolists abhorrent. In 1904 he wrote to Émile Bernard, ". . . you will soon turn your back on the Gauguins and the Van Goghs!" [6]

The attention Cézanne received from progressive painters and critics —Bernard's article of 1891, Gustave Geffroy's article of 1893, the Caillebotte bequest of 1893, the 1894 sale of the Duret-Tanguy collection, Cézanne's participation in the 1889 World's Fair, and Pissarro's persuasiveness—all served to prompt Ambroise Vollard, the young art dealer, to organize a one-man show for him in 1895. Many painters responded enthusiastically to the exhibition. Pissarro praised Cézanne's work highly and reported in a letter that Renoir, Degas and Monet had all been deeply impressed,[7] while regretfully commenting that many "outsiders" still did not recognize the quality of Cézanne's art.

In the next eleven years Cézanne exhibited five times in Paris (the Salon des Indépendants of 1899 and 1901, the Salon d'Automne of 1904, 1905, 1906). Artists and critics noted that his influence was to be seen everywhere. By 1907 Louis Vauxcelles, a critic, wrote that one could subtitle the 1904 and 1905 Salons "Homage to Cézanne." [8]

Cézanne interpretation between 1904 and 1907 took two basic forms: criticism in response to his exhibitions, and articles, essays and reports of conversations by progressive painters and critics.

NEOCLASSICAL CRITICS

A number of Cézanne's followers, attracted to his work by a Symbolist aesthetic, developed their interest and interpretation further when they came under the influence of the Neoclassical movement which had emerged around 1900 in music, literature and art.

Cézanne's admiration for Poussin was considered proof of his affinity to Classicism. But the extent to which the Neoclassical interpreters stressed this theory reflected their own aesthetic bias, as Theodore Reff has pointed out.[9] These critics minimized the role of nature and dis-

[6] Letter to Emile Bernard, April 15, 1904, in *Letters,* edited by John Rewald (Oxford, 1941), p. 234.

[7] Letter of November 21, 1895, in *Camille Pissarro, Letters to His Son Lucien,* edited by John Rewald (New York, 1943), p. 275. See also John Rewald, *Paul Cézanne.*

[8] *Gil Blas,* March 30, 1907.

[9] Theodore Reff, "Cézanne and Poussin," *Journal of the Warburg and Courtauld Institutes,* Vol. XXIII, 1960, no. 1–2, January–June, pp. 150–174.

couraged the associating of Cézanne and the Impressionists, in order to encourage a Neoclassical foundation for modern art, led by Cézanne.

Emile Bernard and Maurice Denis are the two outstanding examples of painter-writers who began as Symbolists under the influence of Gauguin and subsequently became advocates of Neoclassicism.

As early as 1891 Bernard cited Cézanne's work as "one of the greatest attempts of modern art in the direction of classical beauty." [10] A lengthier article by Bernard, published in 1904 and based on conversations and correspondence with Cézanne, was authorized by the artist as an accurate representation of his views. Bernard acknowledged the pivotal role of Impressionism in turning Cézanne's eye toward nature as the source for his paintings. Cézanne, Bernard noted, believed in complete submission to the model; but the more he worked, the more his painting took on the quality of a pure conception. In a similar vein, Maurice Denis acknowledged Cézanne's passion for nature but maintained that painting is an abstraction made from the subject represented, and intended to evoke pure aesthetic pleasure. Both Bernard in 1904 and Denis in 1905 thought that Cézanne was a Classical painter in the tradition of Poussin,[11] a viewpoint they increasingly developed in their articles of 1907—Bernard's "Souvenirs sur Paul Cézanne, et lettres inédites" and Denis' "Cézanne." [12]

Bernard described Cézanne as "a mystic precisely by his scorn for any subject, by the absence of material vision"—a notion echoed in Denis' writings as well. The epithet "mystic" reflected both Bernard's and Denis' Catholic, Symbolist leanings. It was also in harmony with Denis' participation in the Nabi movement of 1888–1899, which fostered a mystical approach to art and life.[13] Elements of Bernard's and Denis' theoretical outlook—the emphasis on classical affinities, pure composition and mystical metaphors—reappeared in Roger Fry's essay of 1927.

Bernard's and Denis' notion of an abstract work of art conformed to their neo-Platonic conception of "pure painting," which held that painting should not represent the manifold appearance of reality but rather should correspond to an essential quality evoked in the unity of the pictorial composition. The work of art was understood in a Symbolist manner to be an equivalent of nature. Bernard and Denis were not referring to abstract painting as we have come to know it since the Cubists.

[10] Emile Bernard, "Paul Cézanne," *Les Hommes d'Aujord'hui*, Vol. III, no. 387, 1891, reprinted in Linda Nochlin, *Impressionism and Post-Impressionism 1874–1904: Sources and Documents* (New Jersey, 1966), p. 101.

[11] Emile Bernard, "Paul Cézanne," *L'Occident*, July, 1904. Maurice Denis, "De Gauguin, de Whistler et de l'excès des théories," *L'Ermitage*, November 15, 1905, reprinted in *Théories 1890–1910* (Paris, 1912), pp. 199–210.

[12] Emile Bernard, "Souvenirs sur Paul Cézanne et lettres inédites," *Mercure de France*, October 1 and 15, 1907, reprinted as *Souvenirs sur Paul Cézanne et Lettres*, (Paris, 1921). Maurice Denis, "Cézanne," *L'Occident*, September 1907, reprinted in *Théories*, pp. 247–267.

[13] The Nabi were a small group of French artists including Bonnard, Vuillard, and Maillot who rejected naturalism in favor of Gauguin's advice to paint in flat, pure colors.

Denis made an important distinction between progressive painting with its concern for a new compositional unity, which he identified with Classicism, and the literal and sentimental representation typical of the prevailing academic painting of the time. By focusing on formal coherence, he attempted to shift the criteria of aesthetic judgment from a misplaced hierarchy based on subject matter and other external factors to the composition of the work of art itself.

However, by the 1920's, when abstract painting had become familiar, Bernard and Denis both developed reservations about Cézanne's work. To Bernard, Cézanne's painting led to academicism, while to Denis his pictures appeared philosophically limited.[14] It was almost as if Denis regretted having suggested abstract art predicated on the work of Cézanne's art on "pure conception" in painting. The relationship of abstract art to the visible world was far more tenuous than Bernard or Denis had imagined. However, Denis' statement of 1900 that "a picture— before being a war horse, a nude woman, or an anecdote—is essentially a flat surface covered with colors assembled in a certain order" became the battle cry of abstract art. Denis' and Bernard's advocacy of "pure art" was meant more in a Symbolist than an abstract vein. Despite their intentions, Denis' and Bernard's essays were read in the light of the abstract movement.

Between 1904 and 1906, as previously noted, Cézanne, despite an essentially reclusive life in Aix-en-Provence, was increasingly sought out by a number of young painters, writers and others in the art world. As a result of these meetings, Ambrose Vollard, Joachim Gasquet, Gustave Geffroy, Léo Larguier, Jules Borély, K. E. Osthaus, R. Rivière and J. K. Schnerb, in addition to Bernard and Denis, published their recollections of conversations with Cézanne. These accounts, however, vary in reliability, some of the articles having been published years after the encounter, but the most reliable are Bernard's essay of 1904, Rivière and Schnerb's account of 1907 and Jules Borély's report of 1905, published only in 1926.[15] In contrast to the panegyrical overtones of Bernard's and Denis' essays, Rivière and Schnerb, two young Parisian printmakers, presented a clear exposition of Cézanne's ideas on color and form, quite free of aesthetic biases.

CUBIST VIEWS OF CÉZANNE

In 1907, the year after Cézanne's death, fifty-six works, mainly paintings and a few drawings, were shown at a major retrospective at the Salon d'Automne, followed by seventy-nine watercolors exhibited at

14 Maurice Denis, "L'Influence de Cézanne," *L'Amour de l'Art,* December, 1920; Emile Bernard, "L'Erreur de Cézanne," *Mercure de France,* May 1, 1926.

15 R. Rivière and J. K. Schnerb, "L'Atelier de Cézanne," *La Grande Revue,* December 25, 1907; Jules Borély, "Cézanne a Aix," *L'Art vivant,* II, no. 37, July 1, 1926, pp. 491–493.

the Gallery Bernheim-Jeune. That same fall *Mercure de France* published Cézanne's letters to Emile Bernard.

Cézanne's influence was already considerable among progressive young painters. The statements of Matisse, Kandinsky, Rouault and Dufy testify to Cézanne's effect on a variety of emerging styles.[16] However, his work became especially influential among those who were to engender Cubism. The Cubists viewed Cézanne's concern for purely pictorial problems as a healthy corrective and alternative to the emotionalism and decorative symbolism of other Post-Impressionists.[17] But there was a divergence of opinion among the Cubists concerning Cézanne's most significant contribution, as the statements of Gleizes and Metzinger, Allard, Leger, Gris, Picasso and Apollinaire indicate.[18]

The 1907–1908 paintings of Picasso and Braque, the founders of Cubism, revealed their logical development of Cézanne's precepts in the use of flat planes, shallow depths and shifting perspectives. The way Picasso and Braque integrated three-dimensional vision with a two-dimensional surface stated not only a further development of Cézanne's pictorial structure, but implied that the way we come to know objects in reality is not through a single static position in space, but through shifting and successive perceptions.

A fundamental Cubist view of Cézanne held that his art was based on his concern with the process of perception. Cézanne was the first to paint the consequences of selective focus at the same time that he was concerned with his grasp of the whole, which united those multiple focuses. Cubism was based on the notion that fragmenting objects and space is a means toward reality, rather than a barrier to reality. The Cubist understanding of the question of focus and the evocation of wholeness cleared Cézanne from the accusation that he could not "realize" a painting. In the light of the Cubist vision, we could see that the task Cézanne had set for himself was to try to come closer to perceived reality through radically new means. The crux of the problem for Cézanne, and for the Cubists at the initial stage, was how to translate fragments of three-dimensional space into facets of the two-dimensional picture plane.

Cézanne's comprehension of the nature of visual cognition may have been born in the act of painting. In transposing the visual data into pictorial structure Cézanne may have discovered for himself the nature of his vision, rather than approaching the painting with a preformulated theoretical framework that dictated multiple viewpoints. His painting then became the symbolic representation of a way of seeing that had a profound effect on art in the twentieth century. The way in which Cézanne represented on canvas what he saw and how he thought came to embody more and more his *mode of interaction* with his environment, and not that environment itself. The significance of this mode of inter-

[16] See the text for specific references.

[17] John Golding, *Cubism, A History and an Analysis, 1907–1914* (London, 1959), p. 65.

[18] See the text for specific references.

significance of this mode of interaction, and its relationship to his own life, was not examined until the idea of Cézanne's painting as a symbolization of his vision was first explored and accepted several decades later.

Though Cézanne's art, as we have just seen, was predicated on his concern with the act of seeing, the assumption that he was principally concerned with structure or pure composition evolved under Cubism. This notion of his art, characterized by the primacy of formal procedures and decisions, prevailed in the 1920's.

ROGER FRY AND FORMALIST CRITICISM

Roger Fry was the most observant, articulate, convincing advocate of the purity of Cézanne's composition. He set the standard for the next generations of Cézanne scholars and critics.

Fry first saw the work of Cézanne in a London exhibition of Impressionist art in 1905, but at the time did not consider it worth serious attention. However, by the next year Fry had come to recognize "a power which is entirely distinct and personal and though the artist's appeal is limited, and touches none of the finer issues of the imaginative life, it is nonetheless complete." [19]

Four years later, in 1910, increasingly impressed by the painting and new aesthetic of the "Post-Impressionists" (a term he coined to designate the painters' position in time), Fry, along with Clive Bell and Desmond McCarthy, organized a major exhibition in London. The exhibition displayed twenty-one of Cézanne's paintings, and works by Gauguin, Van Gogh, Seurat, Matisse and Picasso. Fry continued to advance the cause of Cézanne's art in the two subsequent Post-Impressionist exhibitions of 1912 and 1913. In the face of widespread criticism of the paintings among the British public, Fry maintained that Cézanne was a profoundly classic artist.

Fry had translated and published Maurice Denis' essay of 1907 in *The Burlington Magazine* of 1910,[20] and his Neoclassical and purist understanding of Cézanne reflected certain attitudes and ideas of Denis and Emile Bernard.

In his preface to the 1912 exhibition, Fry noted that:

All art depends upon cutting off the practical responses to sensations of ordinary life, thereby setting free a pure and as it were disembodied functioning of the spirit.

The object of these artists (is) [. . .] to attempt to express by pictorial and plastic form certain spiritual experiences [. . .].[21]

[19] Desmond McCarthy, "Roger Fry and the Post-Impressionist Exhibition of 1910," *Memories* (London, 1953), p. 181.

[20] "Cézanne," *The Burlington Magazine*, Vol. XVI, 1910.

[21] Preface to catalogue of Second Post-Impressionist Exhibition, Grafton Galleries, 1912. Reprinted in Roger Fry, "The French Post-Impressionists," *Vision and Design* (New York, 1965), pp. 237, 242.

In 1917, reviewing Vollard's book on Cézanne in *The Burlington Magazine*, Fry further stated his formalist position on Cézanne:

> That Cézanne became a supreme master of formal design everyone would now-a-days admit. . . . In later works . . . there is no longer any suggestion of a romantic *decor;* all is reduced to the purest terms of structural design.[22]

And in 1920 he wrote: ". . . the modern movement was essentially a return to the ideas of formal design." [23]

Fry believed that detached scientific evaluation of aesthetic objects, characteristic of contemporary German art history, was enormously beneficial. "The object is itself everything, its historical reference of no interest," he wrote in 1926.[24] Fry felt that his own task was to do for the understanding of contemporary art that which Wölfflin had done for the understanding of Italian Renaissance art. In some ways his paradigm was Wölfflin's *Classical Art*, published in 1889.[25]

As an English critic, Fry had to contend with the prevailing aesthetic of John Ruskin, who called for morality in content. Fry countered that integrity in art consisted in the artist's fidelity to his own vision and in his devotion to the creation of form rather than the evocation of sentiment. Thus Fry developed new criteria for aesthetic judgement based on principles and priorities in the formal construction of a painting which, he believed, revealed its own order of "profound reality."

Roger Fry's full scale formal analysis of Cézanne in 1927, *Cézanne, a Study of His Development*, was first published the preceding year as notes to the Pellerin collection in the magazine, *L'Amour de l'Art*. Fry asserted in his monograph that Cézanne was perpetually concerned with articulating what the critic characterized as the artist's "passionate consciousness." In the early paintings Fry saw that quality both in the work inspired by an inner vision and by the copying of old masters at the Louvre. As his work developed, "passionate consciousness" emerged from the way of looking at things, rather than from the thing looked at.

Fry saw in Cézanne's works the expression of his own aesthetic beliefs: that the vitality and originality of a work lay not in the subject but in the formal expression of a vision. Through his study of neutral objects, Cézanne was able to concentrate on the composition itself. The still lifes, as prime examples, were presented by Fry as dramas of color, plane, volume and composition whose subject matter was irrelevant.

[22] "Paul Cézanne," *The Burlington Magazine*, Vol. XXXI, August 15, 1917. Reprinted in Roger Fry, "Paul Cézanne," *Vision and Design*, pp. 256–257.

[23] "Retrospect," *Vision and Design*, p. 290.

[24] Roger Fry, "Some Questions in Aesthetics," *Transformations, Critical and Speculative Essays in Art* (New York, 1958), p. 15.

[25] Fry was influential in introducing the work of Wölfflin to England through his praise in a review of Wölfflin's *Das Klassische Kunst*, 1889, published in *The Athenaeum*, no. 3974, December 26, 1903, pp. 862–863, and in the introduction to his own essay, "The Seicento," *Transformations*, pp. 96–97.

The supremacy of Renaissance perspectival space had already been challenged by the Post-Impressionists' new concern for the structural quality of form and color and the Cubists' redefinition of the picture surface. These new conceptions encouraged Fry's reconsiderations of the organization of pictorial space. He was probably familiar with Hildebrand's *Problem of Form in Figurative Art* (1893), in which unity of the surface was stressed over the spatial fields.

Fry maintained that Cézanne's spatial construction was always concerned with the way the volume of a form threatens and is threatened by the surface network of design. Fry was not interested in a large-scale system of depth projection that was independent of the individual integer of design; that is, the objective space was not understood except as the individual wedges presented into and capable of prying apart the tesserae of the surface design. These wedges Fry understood as planes.

In the hierarchy of formal values, Fry appeared to view two-dimensional design, integral to painting, as superior to evocations of three-dimensional space, the vehicle of representation.

Clive Bell, like Fry, believed that meaning was to be found in pure form. Both critics maintained that a work must have "significant form" or "plasticity," the expressive quality of form, which can be measured by the magnitude of aesthetic response.

Roger Fry dramatized the search for these forms. Cézanne, Fry implied, was caught in the heroic sacrifice of subjective inclinations and in the crises of decisions which in the past had been relegated to moral or religious issues. Fry conveyed the immense seriousness of paintings without manifest content by attributing to Cézanne's search for plastic form a quasi-ethical value corresponding to the scientist's search for truth.

Fry employed the term "musicality" as a descriptive metaphor to denote pure form and its power to evoke aesthetic emotion. The notion of musicality had become quite popular from the eighteenth century onward. It prevailed in the 1900's among the Symbolist painters and writers, particularly in the aesthetic of Stephane Mallarmé, one of Fry's patron saints. Musicality as a concept was intended to evoke the idea of authentic absolute reality which finds its outward appearance in depicted reality. Concrete reality was of a distinctly lower order in the hierarchy of values that Mallarmé and Fry shared.

As Fry wrote to Robert Bridges in 1924: "It seems to me that the emotions resulting from the contemplation of form were [. . .] more profound and significant spiritually than any of the emotions which had to do with life." [26] Fry characterized Cézanne's quest in his 1927 essay as "this desperate search for reality hidden beneath the veil of appearance." And of his own task Fry wrote: "I find myself like a mediaeval mystic before the divine reality, reduced to negative terms."

Fry contended that underlying the work of every Classical artist there is a suppressed Romantic strain; thus, Fry observed that Romanti-

[26] Cited in Virginia Woolf, *Roger Fry* (New York, 1927), pp. 229–230.

cism underwent a series of renunciations in assuming the rigors of Classicism. Yet the very notion of aesthetic sacrifice is a central Romantic metaphor. The meaning which Fry attached to pure form strongly suggests a new expression of Romanticism and neo-Platonism in its quest for significance in the forms underlying reality. One manifestation of this new Romanticism was the search for a hierarchical system which would provide art with a sense of order and values. Fry's new system replaced the previous emphasis on the evocation of sentiment with a new concern for plastic values intrinsic to the medium of painting. This new approach purified the intensity of emotion associated with "concrete reality" into "aesthetic emotion."

Elements of neo-Platonic thinking phrased in mystical language form a curious undercurrent to Fry's empirical formalism. His is an aesthetic notion of asceticism or an ascetic notion of aestheticism.

D. H. Lawrence reacted vehemently to Roger Fry's disdain for concrete reality. Cézanne was important in Lawrence's view precisely because he affirmed the concrete and the physical. Imaginative vision in Lawrence's opinion should include physical and intuitional perception. Cézanne, he wrote, had brought painting back "to form and substance and thereness, instead of delicious nowhereness." Referring to the critical approach of Fry and Bell, Lawrence wrote:

> And I find myself equally mystified by the cant phrases like Significant Form and Pure Form. They are as mysterious to me as the Cross and the Blood of the Lamb. They are just the magic jargon of invocation, nothing else. If you want to invoke an æsthetic ecstasy, stand in front of a Matisse and whisper fervently under your breath: "Significant Form! Significant Form!"—and it will come. It sounds to me like a form of masturbation, an attempt to make the body react to some cerebral formula.[27]

NEW FACTORS IN CÉZANNE RESEARCH

The publication in 1936 of Lionello Venturi's monumental catalogue raisonnée, *Cézanne, son art; son oeuvre*, marked a new era in Cézanne research. For the first time, all the known paintings, watercolors, drawings, lithographs and etchings were reproduced. Only six paintings had definite dates. In order to establish a chronology, Cézanne's style and development had to be reassessed with great care. While much of Venturi's dating has since been challenged (by John Rewald, Adrien Chappuis, Gertrude Berthold, Theodore Reff and Wayne Andersen) his enormous contribution to Cézanne research has been acknowledged by all.

[27] "Introduction to These Paintings," *The Paintings of D. H. Lawrence* (London, 1929). Reprinted in *Phoenix I* (New York, 1972), p. 567.

Up to the time of Venturi's catalogue raisonnée Cézanne had been viewed almost exclusively as a precursor of new movements. His attitude toward representation and his relation to past art other than the Neoclassical seemed to his interpreters of less consequence than his effect on new art. The publication of Venturi's catalogue raisonnée, and the major retrospective exhibition in 1936 of Cézanne's paintings and drawings, most never shown before, called for a revaluation of Cézanne's painting, and especially his drawing. The various critical aesthetic biases, such as the Symbolist or Neoclassical, were unveiled. But above all, his drawings were considered seriously for the first time.

When Roger Fry wrote his essay on Cézanne, a significant aspect of the painter's work was almost inaccessible to the public, for Cézanne's drawings, long dismissed as inept in comparison with their academic counterparts, were rarely exhibited or seriously discussed in the literature. In 1924 Maurice Denis, in one of the first articles devoted to Cézanne's drawings, reproved the artist's maladroit handling of line.[28] Underlying the prejudice against Cézanne's drawing was a bias toward the role of color in Cézanne's composition and a corresponding lack of serious attention to his use of line.

The drawings were highly revealing of Cézanne's process of recording from nature, his choice of subject matter and, particularly, his copying from the old masters. Adrien Chappuis did for Cézanne's drawings what Venturi had done for the paintings. In his books of 1938, 1957, 1962, 1965, 1966 and 1973, Chappuis published the known drawings of Cézanne, setting them in chronological groupings and correcting Venturi's dating.

The study of Cézanne's drawings led to the first serious evaluations of his relationship to tradition. The pioneering studies were made by John Rewald in his 1935 and 1936 articles "Cézanne au Louvre" and "Source d'inspiration de Cézanne." [29] The considerable subsequent research in the 1950's will be discussed later.

Research into the way Cézanne transformed a motif from nature was also a result of the new availability of Cézanne's paintings and drawings. Between 1930 and 1944 Erle Loran Johnson, Fritz Novotny and John Rewald undertook separate studies, all three photographing the sites of certain Cézanne works in order to compare the original location with Cézanne's rendering of the scene.[30]

[28] "Le Dessin de Cézanne," *L'Amour de l'Art*, V, February, 1924, pp. 37–38. André Salmon in "Dessin Inédits de Cézanne," *Cahiers d'art*, Vol. 1, no. 10, 1926, p. 263–265 praised the unacademic quality of Cézanne's drawings from a Cubist bias.

[29] "Cézanne au Louvre," *L'Amour de l'Art*, October, 1935; "Une copie par Cézanne d'apres le Greco," *Gazette des Beaux-Arts*, February, 1936; "Source d'inspiration de Cézanne," *L'Amour de l'Art*, May, 1936.

[30] See Erle Loran Johnson, "Cézanne's Country," *The Arts*, April, 1930. (Erle Loran Johnson later published under the name Erle Loran). Fritz Novotny, *Cézanne und das Ende der wissenschaftlichen Perspektive* (Vienna, 1938). John Rewald, "As Cézanne Recreated Nature," *Art News*, February 15–30, 1944; "The Camera Verifies Cézanne's Watercolors," *Art News*, September 1–30, 1944; "Proof of Cézanne's Pygmalion Pencil," *Art News*, October 1–15, 1944.

Along with Venturi's and Chappuis' catalogues, the biographical studies and the publication of Cézanne's letters by John Rewald were a major contribution to the broadening of perspective on Cézanne.[31] Rewald prepared the way for later considerations of the bearing of Cézanne's life on his art. Though Rewald did not draw any far-reaching conclusions regarding the interconnection between Cézanne's painting style and the events of his life, Rewald's highly documented biography informs us of Cézanne's work as a whole.

NEW CONSIDERATIONS OF
CÉZANNE'S PERCEPTION AND
COMPOSITION OF SPACE

Roger Fry's essay continued to serve as a model of excellence in formal analysis while the questions he did not raise provided fertile ground for further research—informed by a new awareness of the scope of Cézanne's work. Though every interpreter had been struck by Cézanne's idiosyncratic spatial construction, the specific nature of his deviations from Renaissance perspective had never been closely examined.

Fritz Novotny first came to his study of the distortions in Cézanne's use of space in 1932, in order to explain the quality of "aloofness" and the lack of mood or atmosphere which he observed in Cézanne's landscapes.[32] In his book of 1938, *Cézanne und das Ende der wissenschaftlichen Perspektive,* Novotny questioned whether the renunciation of illusory space and the distortions of scientific perspective were determined only by the demands of pictorial composition of the surface or whether they reflected a deeper meaning, a change in perception of visual reality (*Anschauungsrealität*). Novotny observed the growing attention to the picture surface in the nineteenth century and the increased importance of pictorial formation. This was balanced by waning fidelity to the object in reality (*Wirklichkeitserscheinung*). As the image character (*Gebilde*) of a picture became more pronounced, Novotny held, the values of representation, especially the constitutive elements of illusionary space, became of necessity more problematical.

Novotny observed that the reduction of any expressive quality in the choice and rendering of Cézanne's portraits and landscapes signaled a new attitude toward the object world. The new emphasis on the picture surface had far-reaching effects on the construction of pictorial space

[31] Paul Cézanne, *Correspondence,* edited by John Rewald (Paris, 1937; London, 1941); John Rewald, *Cézanne et Zola* (Paris, 1936); *Cézanne, sa vie, son oeuvre, son amitié pour Zola* (Paris, 1939). See also the later publication, *Cézanne, Geffroy et Gasquet, suivi de Souvenirs sur Cézanne de Louis Aurenche et de lettres inédites* (Paris, 1959).

[32] "Das Problem des Menschen Cézanne im Verhältnis zu seiner Kunst," *Zeitschrift für Ästhetik und allgemeine Kunstwissenschaft,* XXVI, 1932.

and affected the way objects underwent transformation. Cézanne's art, Novotny observed, thus led away from the European pictorial tradition of independent objects and forms and moved toward a predominance of both formal and chromatic combinations.

Cézanne, however, did not actually break with scientific perspective, Novotny contended. By retaining the rudiments of a perspectival system, he guaranteed a degree of objectivity in space. Novotny observed that Cézanne's paintings produce the impression that the objects are forming themselves before our eyes, an idea subsequently developed by Maurice Merleau-Ponty and by Meyer Schapiro. Cézanne's painting should not be viewed as abstract, Novotny stated, because he maintained an equilibrium between the represented object and the picture structure. It was only with Cubism, according to Novotny, that scientific perspective died.

Novotny's contemporary Hans Sedlmayr, an ardent Catholic, nationalist and traditionalist, took issue with the implications of Cézanne's "expressionless" quality in his book *Verlust der Mitte, die bildende Kunst des 19 und 20 Jahrhunderts als symbol der Zeit* (*Art in Crisis*), published in 1948. Sedlmayr developed Novotny's observation that Cézanne's art is divorced from life (*lebensfern*). But in a spirit antagonistic to Novotny, Sedlmayr contended that Cézanne's art was "contrary to human nature [in excluding] from the art of perception all other functions of the human mind in favor of pure seeing." Sedlmayr could not perceive that the human spirit could be expressed in other than representational form.

Erle Loran's analysis of Cézanne's composition revealed an almost exclusive interest in pictorial structure. Unlike Novotny, he did not raise questions of expression and effect. In his 1943 book *Cézanne's Composition,* Loran used a series of line and shade diagrams to demonstrate how Cézanne structured his paintings. Loran's aim was to articulate the principles of drawing and composition utilized by Cézanne, principles, Loran maintained, which had didactic value and should be adopted in art education.

Loran attributed Cézanne's greatness in the history of painting to three major contributions: the mastery over structural planes; the synthesis of abstraction and reality; and the importance of the surface. Loran was the first to assert the crucial role of line in Cézanne's painting, which defines both objects and planes. Color had always been considered the principal compositional factor in Cézanne's work. Loran, however, maintained that Cézanne's line was underestimated, and he demonstrated its structural importance through diagrams. In doing so Loran underplayed the role of color in the structuring of planes, despite the evidence in Cézanne's painting and maxims. The use of black and white photographs and line diagrams artificially flattened the view of nature while emphasizing the contours which distinguished the objects.

Despite Loran's recognition of the structural role of line, he, like previous critics, viewed Cézanne's drawing as inept. The distortion of Cézanne's line in *Les Baigneurs au Repos* (*Bathers Resting*) (V. 276) he judged as "clumsiness, lack of dexterity and manual skill. The dis-

tortions are merely the butchering of naturalistic appearances and serve
no plastic purpose." [33]

Loran's concern with the process of painting was limited to the
elements of pictorial composition and not with Cézanne's perceptual
process. Loran may have conceived of the picture space as a stage filled
with discrete, consistent, complete combinations of shapes. His diagrams
imply a sequential reading of the picture appropriate to a self-contained
image rather than a composition based on successive perceptions.

Creative phenomena cannot be reduced to definable and diagram-
matical elements without considerable loss of richness and complexity.
Loran did not fully explore the distortions in the synthesis between real-
ism and abstraction, vision and design. Though intentionally limited, his
work provided one example of how one might proceed in a careful
structural analysis.

The complexity and radical nature of Cézanne's art were compre-
hended from a philosophical standpoint by Maurice Merleau-Ponty, the
French phenomenologist. Merleau-Ponty saw Cézanne's painting as a
paradigm of the balance between objective reality and subjective per-
ception. In his essay of 1948, "Le Doute de Cézanne" ("Cézanne's
Doubt"), he explained that Cézanne's way of organizing a painting was
predicated not on abstract composition but on the continual struggle to
paint the world as it appeared to him: "He wanted to depict matter as
it takes on form." [34] Cézanne's spatial deviations were perceptually more
accurate than those ordered according to an a priori system. The per-
spective we see is neither geometric nor photographic, wrote Merleau-
Ponty. Cézanne's distortions, he observed, gave the impression of an
object "in the act of appearing." If his paintings looked peculiar, it was
because we had become accustomed to seeing things according to our
use of them. Cézanne's painting, Merleau-Ponty explained, suspended
such habits of thought. "Cézanne's difficulties are those of the first
word." [35]

Cézanne was described as a vital link in the development of paint-
ing by Clement Greenberg in 1951.[36] Greenberg, the leading proponent
of modernist criticism, advocated that painting and sculpture should de-
velop according to a logic determined by the media themselves. Clear
distinctions were made between elements that were considered to be
intrinsic and extrinsic to those art forms. In "Cézanne and the Unity of
Modern Art," Greenberg argued that Cézanne was responsible for the
shift from pictorial illusion to "the picture itself as an object, as a flat
surface." Surface pattern was endowed by Greenberg with "superior

[33] *Cézanne's Composition* (Berkeley and Los Angeles, 1943, 1950, 1963, 1970), p. 94.

[34] "Cézanne's Doubt," *Sense and Non-Sense*, translated by H. L. and P. A. Dreyfus
(Northwestern University Press, 1964), p. 13; first published as *Sens et non-sens*
(Paris, 1948).

[35] Merleau-Ponty, *Op. cit.*, p. 19.

[36] Clement Greenberg, "Cézanne and the Unity of Modern Art," *Partisan Review*,
May–June 1951, pp. 323–330.

pictorial rights" because it was seen as intrinsic to painting while the representation of the third dimension was understood as illusionary. Cézanne was depicted by Greenberg as one of the first modernist painters.

Hilton Kramer, another contemporary critic, observed that as the Cubists completed what Cézanne had begun, so Greenberg completed what Fry had initiated.[37] Greenberg, like Fry, indicated priorities of formal arrangements which were believed by both critics to have meaning in themselves. These guidelines or strategies participated in the spirit of the painting in question, but were limited by their formalist parameters. Priorities were often phrased as a kind of historical inevitability in the progression of the formal aspect of art. At no point was the art work considered in its totality. The formal issues were isolated and the formal pursuit characterized as a kind of moral and spiritual quest.

MEYER SCHAPIRO: NEW CRITERIA FOR INTERPRETATION

Meyer Schapiro attacked formalism in its citadel when he interpreted Cézanne with an eye toward subject matter in his 1952 book *Paul Cézanne*. For the first time, Cézanne's choice of objects, motifs and subjects was studied for meaning and correspondence to form. Schapiro converted the task of formalism from a method of justifying the object in compositional terms to a method of investigation. His approach can be characterized as a historical and psychological translation of the formal model, seeing in its elements the kernels of other levels of analysis.

Schapiro began with a formal appreciation of Cézanne, stimulated by Roger Fry and Fritz Novotny. In 1928 he wrote about Cézanne:

> Except in certain erotic themes, which attracted his youth and old age, he was indifferent to the practical meanings or associations of the subject and sought only the possibilities of coherent visual combination.[38]

Two years later, Schapiro's growing concern with iconography and the history of style was apparent in the published version of his thesis of 1929, *The Romanesque Sculpture of Moissac*, in which he supplemented the formal descriptions and analyses with a discussion of the subject matter.

Part of the breakdown of Schapiro's incipient formalism may be

[37] Hilton Kramer, "A Critic on the Side of History: Notes on Clement Greenberg," *Arts,* October 1962, pp. 60–63.

[38] "Art in the Contemporary World," *Introduction to Contemporary Civilization in the West,* (Columbia University Press, 1928), p. 284.

attributed to his concern with social context. Influenced by Marxist thinking in the early 1930's, from then on his writings reflected a historical and contextual perspective. Modern art (or any other art, for that matter) could not be considered independent of historical conditions, he argued, and pure form could not be considered independent of content.[39]

Five years after Schapiro's initial statement on Cézanne, he cited the painter as an example par excellence of one who was misunderstood when his dicta were applied out of context.[40] Cézanne's work, which attracted formal interpretation and served as a precursor for abstract painting, became a case in point for Schapiro's aesthetic.

It may be objectionable to some, Schapiro noted, to consider the themes of a painter as having to do with the value or character of his art. Nevertheless, he asked us to see Cézanne's paintings as images of the real world which are highly selective, idiosyncratic and often tied metaphorically to questions of style.

Schapiro explained that it was (and is) important to understand the contemporary attitude toward the role and nature of objects in painting. Even the taste for "pure painting" depended on a passive attitude to things, he pointed out. Cézanne's individual sensibility, his special response to observed forms caused his attitude toward objects to differ from that of Manet and the Impressionists.

In Schapiro's view, what was unique about Cézanne's line, color and composition was the revelation of the artist's process. Schapiro's description of Cézanne's perceptual process and the way he painted objects as they emerged through perception parallels the formulations of Maurice Merleau-Ponty. Schapiro observed that the activity of balance between the subjective perceiver (Cézanne) and the objective reality (objects, landscapes, people) was laid before us. Still-lifes were both a source of empirical knowledge and vehicles for perception. Cézanne did not paint the object as he knew it to be in some objective, utilitarian or logical framework, but, rather, as it became "visible" to him through repeated looking.

Schapiro was the first scholar to demonstrate a continuity in Cézanne's choice of subject matter and its execution in relation to his life. Schapiro pointed out the development from Cézanne's early, often erotically charged works, strong in their naive forms and distinctive sense of color, to the last paintings, such as *Les Grandes Baigneuses* (*Women Bathers* or *The Large Bathers*) (V. 719; fig. 21). The repeated agitated lines of the Bathers suggested an ambivalent attitude toward the naked female body at the same time that they signified the fitting together of forms to reveal the painter's perceptual process.

Schapiro explored documentary evidence from Cézanne's life—his

[39] "The Nature of Abstract Art," *Marxist Quarterly,* no. 1, 1937, pp. 77–98.
[40] "Über den Schematismus in der romanischen Kunst," *Kritische Berichte zur kunstgeschichtlichen Literatur,* Jahrgang 1932–33, pp. 1–21.

poetry, sketchbooks, letters, the literary and pictorial sources with which he was familiar—and also introduced psychoanalytic theory for the first time to the Cézanne literature in order to elucidate further Cézanne's subject matter.

Through his perceptive analyses of form and content Schapiro suggested that the apparent coolness and neutrality of Cézanne's landscapes, still- lifes, portraits and group paintings at the same time convey a highly charged emotional state brought under constructive control in the service of the unity of the painting. Cézanne's choice and manner of representing objects was bound up with the formal development of his painting.

Schapiro maintained that still- life as a genre offered a rich sphere for latent personal symbols. In an argument diametrically opposed to Roger Fry's position that still-lifes were purely compositional in value, Schapiro asserted that "once established as a model domain of the objective in art, still-life is open to an endless variety of feelings and thoughts, even of a disturbing intensity." [41]

In his essay of 1968, "The Apples of Cézanne: An Essay on the Meaning of Still-Life," Schapiro began with an iconographic analysis of the problematic subject matter of "The Amorous Shepherd" and the "Judgment of Paris." Schapiro saw the apples in these paintings as having a highly charged content. He went on to connect the emotional significance of the apples as used here to their function in the still lifes. In this process he used psychoanalytic interpretation extensively, but he did not maintain that such an interpretation alone provided a full explanation. He pointed out that we do not really know the effects of Cézanne's personal life on the choice of subject:

> The painting of apples may also be regarded as a deliberately chosen means of emotional detachment and self-control; the fruit provided at the same time an objective field of colors and shapes with an apparent sensuous richness lacking in his earlier passionate art and not realised as fully in the later paintings of nudes. To rest with the explanation of the still-life as a displaced sexual interest is to miss the significance of still-life in general as well as important meanings of the objects on the manifest plane. In the work of art the latter had a weight of its own and the choice of objects is no less bound to the artist's consciously directed life than to an unconscious symbolism; it also has vital roots in social experience. [42]

Schapiro considered Cézanne in a more complex way than any previous critic had. His formal analysis of the paintings made possible a convincing elucidation of their perceptual, psychological and historical elements. In turn, his awareness of the complexity of Cézanne's art allowed him to see the formal composition in a new, more meaningful way. Schapiro's insistence on an acute characterization of content, then, came

[41] "The Apples of Cézanne," *Art News Annual*, XXXIV, 1967, pp. 33–53, p. 44.
[42] "The Apples of Cézanne," p. 40.

from a sense of the reciprocal metaphors of form and content—facing mirrors which merged into an infinite series of analogies.

CÉZANNE RESEARCH SINCE 1952

Since Meyer Schapiro's book, three lines of Cézanne research have been pursued to date: First, the religious existentialist interpretation advanced by Kurt Badt in 1956. Second, the work on chronology and sources, continuing the task of dating undertaken by Venturi and Chappuis—since the late 1950's, Wayne Andersen, Gertrude Berthold, Adrien Chappuis, Douglas Cooper, Lawrence Gowing, Robert Ratcliffe, Theodore Reff, John Rewald, and Carl Schniewind have revaluated the criteria for dating through considerations of Cézanne's copies and working methods. Third, psychoanalytic considerations, initiating a major trend in subsequent research developed further in publications by Kurt Badt in 1956, by Theodore Reff in articles from 1959 to 1966 and by Schapiro himself in 1968.

Kurt Badt in his 1956 book *Die Kunst Cézannes* (*The Art of Cézanne*), dealt with Cézanne's compositional structure, watercolor technique, use of blue as dominant color, choice of subject matter, psychological causes for symbolic content, historical position and metaphysics. He was concerned with the "ultimate aims" of Cézanne's art, contending that they were not the formal problems many critics claimed them to be. Rather, for Cézanne, "every subject became a symbolic representation of his own apprehension of the whole."

Kurt Badt's approach to Cézanne was distinguished from previous Cézanne criticism by the introduction, however cursory, of a Jungian interpretation of *The Cardplayers* and, more emphatically, a religious existentialist interpretation based on Karl Jaspers' "Existenz" philosophy.

Refuting the notion that Cézanne was a "pure painter," Badt maintained that Cézanne's technique was a cipher, his emphasis on the overall picture composition reflecting his attitude toward the world: "The merely graphic means absolutely nothing." [43] For example, Cézanne used blue as the "common ground for all coloration," creating both the sensation of nearness and distance, because in the equalizing of foreground and background "the eternal order of the world" was implied.

Badt described the "mystery" of Cézanne's paintings as "their perfect transcendence in thereness," a notion predicated on Jaspers' philosophy.[44] According to Jaspers, existence, the state of continually coming into "being," can only be realized directly through experiencing the particular in the world as part of an encompassing and unifying whole—in other words, through transcendence.

Badt believed that Cézanne's minimization of the objective nature

[43] *The Art of Cézanne* (Berkeley and Los Angeles, 1965), p. 123.

[44] Karl Jaspers, *Philosophy of Existence* (New York, 1971). After lectures delivered in 1937.

of his objects, in their self-containment as form, revealed the objects as "existing together" in a unity and harmony which transcended their individual nature.

Gertrude Berthold's *Cézanne und die alten Meister*, 1958, is the most comprehensive documentary study of Cézanne's relation to tradition. Three hundred and fifty drawings after old-master sources were catalogued. The stylistic significance and the character of Cézanne's copies were studied, a chronology of the drawings presented and the use of the models from old masters, particularly for the bather compositions, reviewed. Berthold's approach was basically that of analysis of the forms apparent in the copies without studying the significance of Cézanne's recurrent choices.[45] The predominant number of Baroque works which Cézanne copied put his relation to the classical masters into perspective; he copied Rubens' work far more often than Poussin's.

In his 1960 article, "Cézanne and Poussin," Theodore Reff unveiled the myth of Cézanne's "redoing Poussin from nature." Reff reviewed extensively the early critical literature on Cézanne and demonstrated that the advocacy of Poussin was not really a function of Cézanne's painting but of the Neoclassical movement in which Bernard, Denis and other of Cézanne's interpreters participated.

Reff observed in his dissertation of 1958, "Studies in the Drawings of Cézanne," that Cézanne's interest in traditional art was more pervasive and profound than that of any of his contemporaries; one-third of all his drawings were copies after other works of art. Reff identified the sources for Cézanne's copies and speculated as to the motivations and reasons behind the choices and transformations of known motifs. He developed Schapiro's idea that the choice of object or subject matter was related to changes in style. While Cézanne chose to copy predominantly Baroque works, Reff claimed that in the process of copying them he denied many of the qualities that must have attracted him initially, namely "extreme naturalism, completeness and intensity of expression." On the contrary, Cézanne's drawings tended to be "cool, colorless and fragmentary." Though Cézanne admired the power and completeness of Baroque art, his possibilities were "determined by his own time and temperament."

In subsequent research, Reff placed increasing emphasis on the affective content of Cézanne's motifs. Methods of psychoanalytic inquiry were applied to the study of a problematic figure, set of figures or subject, such as the Bathers motif in its various guises.[46] The paintings were discussed almost as dreams, in accordance with the model established by Freud in his *Interpretation of Dreams*. Motifs were traced through antecedents and subsequent transformations, with recurrent patterns in the

[45] See Theodore Reff, "New Sources for Cézanne's Copies," *The Art Bulletin*, XLII, June 1960, pp. 147–149.

[46] See, for example, Cézanne's "The Enigma of the Nude," *Art News*, LVIII, November, 1959, pp. 26–29; "Cézanne, Flaubert, St. Anthony, and The Queen of Sheba," *The Art Bulletin*, XLIV (1962), pp. 113–125; Cézanne's "Dream of Hannibal," *The Art Bulletin*, XLV (1963), pp. 148–152; "Cézanne and Hercules," *The Art Bulletin*, XLVIII (1966), pp. 35–44.

sketchbooks, poems, dreams and letters carefully noted, in order to gain insight into Cézanne's conscious goals and unconscious motives and inclinations. Reff's emphasis, like Freud's, was on the relationship between manifest and latent content—the syntax of the unconscious. Cézanne's deviations from such traditional subjects as "The Temptation of St. Anthony" were viewed against the background of historical and contemporary prototypes of the motif, in order to demonstrate that his departure from the known texts and established iconographic types was revealing of the personal content that Cézanne had invested in these motifs.

While it is impossible to definitively establish Cézanne's unconscious associations with various images and motifs, the questions and issues raised by Reff contribute to our understanding of the complex relationship between Cézanne's art and his life.

Wayne Andersen who has been lecturing in and researching on Cézanne's subject matter from a psycho-sexual point of view, has focused in his book (*Cézanne's Portrait Drawings*, 1970) and articles, on the drawings and copies in order to establish a more precise chronology. Andersen introduced a "topographical" method, based on the use of external criteria. For example, in his article on the sketchbook owned by the Art Institute of Chicago, Andersen observed that the sketches were aligned right side up or upside down depending on whether Cézanne opened the sketchbook from front or back.[47] Using evidence gleaned from various topographical analyses of the sequence of drawings, and taking into account the age of Cézanne's son at the time the boy drew in his father's sketchbook, Andersen postulated a range of dates in which the sketchbook drawings were executed. He then applied his findings to the existing chronologies. Andersen warned that one should not assume a neat linear progression through "logical stages in Cézanne's drawings since he often returned after a time to a previous motif."

Interpretations prior to Schapiro's book tended to address Cézanne's work as a whole. A more focused scholarly study of a specific issue or aspect of Cézanne's work is characteristic of the post-Schapiro literature. (Badt's comprehensive book is an exception). Recent studies have ranged from analyses of Cézanne's color, his copies from past art and chronologies of the drawings to the interpretation of an image in one of Cézanne's poems or paintings. At the same time, most of these current studies reflect a broad perspective on Cézanne. The relationship between Cézanne's art and his life is increasingly taken for granted. As Schapiro observed, "An art of personal expression has a universal sense." Or, as Picasso noted, "It's not what the artist *does* that counts, but what he *is*."

Cézanne has not been cited as a major precursor of new developments in art for nearly half a century. Yet he continues to have an impact on present artistic concerns. Questions of pictorial structure, unity and process, as Cézanne defined them, still prevail and underlie con-

[47] "Cézanne's Sketchbook in the Art Institute of Chicago," *The Burlington Magazine*, CIV, (May, 1962), pp. 196–201. See also, "Cézanne's *Carnet violet-moiré*," *The Burlington Magazine*, CVII, (June, 1965), pp. 313–318.

temporary movements in painting and sculpture. Cézanne made painting the record of his perceptual, conceptual and compositional experience. This major contribution has remained relevant. However, while Cézanne rendered the interface of the process of perception and object of perception, recent movements in art have tended to focus on a single dimension of his work.

Abstract Expressionist painters have been concerned with the procedural aspects of Cézanne's work, and not with the quality of his formal composition. This expression of process in recorded gesture takes precedence over object in the construction of action painting. For example, the dramatic gesture of the painter flinging and pouring paint on canvas insists that the final work will embody the process by which it came to be. The process has become the painting.

Modernist painters of the 1960's have pursued questions of unity. Cézanne created cohesiveness in the small structural elements of his paintings by relating part to part, color to color. Now a simpler solution of unity is posited in the reduction of color areas to a large field, unambiguously lying on the surface of the canvas without the complex affinity with illusory depth.

Modernist painting has found the problem of representing images and objects extraneous. On the other hand sculpture, concerned as it must be with objects, has created work which intersects with Merleau-Ponty's phenomenological view of Cézanne. Thus, the space we conceive is in direct relation to the space we perceive. In order to articulate this relationship the artist and spectator must become acutely aware of their experience of space and not fall back on their knowledge of how to construct an illusory space. Sculptors such as Robert Morris, Bruce Nauman, Richard Serra and Keith Sonnier make objects which occupy the space of the spectator in such a way that seeing becomes a process of interaction between the perceiver's body and the perceived sculpture. Robert Morris reflects:

> As ends and means are more unified, as process becomes part of the work instead of prior to it, one is involved more directly with the world in art making because forming is moved further into the presentation.[48]

In summary, Cézanne continues to be significant to artists, critics and historians. Once again New Realist painting raises the problem of bringing the world back into the picture without resorting to previous solutions which may have less meaning for our time. Thus, Cézanne's own deviations from naturalistic representation need no longer be read as formal abstraction. His emphasis on recording the process of his perception of the natural world was his way of expressing that world in his painting. Cézanne's art is unsentimental and therefore acceptable to the contemporary sensibility. Beyond this, his art serves as a model for

[48] "Some Notes on the Phenomenology of Making: The Search for the Motivated," *Artforum,* April, 1970, vol. VIII, no. 8, pp. 62–66, p. 66.

the present generation precisely because his revolutionary canvases expressed his conviction that vision is subjective. Cézanne, above all, makes us conscious of the way he sees and in the process dramatically extends *our* field of vision, our possibility of seeing. The perceptual process was primary for Cézanne. He did not, even more, he could not accept a preconceived set of rules for painting his vision of nature. Once we understand Cézanne's art in this light, we can no longer accept the notion that our seeing an object is only a function of that object itself—any more than we can accept that the object is perceived solely in a culturally determined pattern.

Cézanne's insistence on the primacy of the artist's vision revolutionized art. He also profoundly altered the ways in which the rest of us, artists or not, would thereafter view our world.[49]

[49] A similar view has been expressed by John Berger, "The Sight of Man," *The New Society*, April 16, 1970, pp. 646–647; and by Gabriel Laderman, in "Problems of Criticism VIII: Notes from the Underground," *Artforum*, September, 1970, pp. 59–61.

PART ONE / Reactions of Some Contemporary Painters and Critics: 1874-1907

Marc de Montifaud

From "The Exhibition of the
Boulevard des Capucines" (1874)

The Sunday public saw fit to sneer in the face of a fantastic figure who is revealed in an opiated sky, to a smoker of opium [Fig. 3]. This apparition of a little pink and nude flesh which is being pushed before him in an empyrean cloud, by a kind of demon or incubus, like a voluptuous vision, this corner of artificial paradise, has suffocated the most courageous, it is necessary to say, and M. Cézanne only gives the impression of a kind of madman who paints in delirium tremens. People have refused to see in this creation inspired by Baudelaire a dream, an impression caused by oriental mists which it was necessary to render under the bizarre framework of the imagination. Is not incoherence the nature, the special characteristic of praiseworthy sleep? Why look for an indecent jest, a motive of scandal in the Olympia? In reality, it is only one of the extravagant forms of hashish borrowed from a swarm of amusing dreams which must still be hidden in the corners of the Hotel Pilmoden. . . .

Marc de Montifaud, "L'Exposition du Boulevard des Capucines," *L'Artiste*, May, 1874, pp. 307–313; this excerpt, p. 310.

Jean Prouvaire
From "The Exhibition of the
Boulevard des Capucines" (1874)

Can we speak of Cézanne as other than his legend? Of all known juries, none could even in a dream entertain the possibility of accepting any pictures of this painter, who presents himself at the Salon, carrying his canvases on his back, as Jesus Christ his cross. A too exclusive love of yellow has, until now, compromised the future of M. Cézanne.

Jean Prouvaire, "L'Exposition du Boulevard des Capucines," *Le Rappel,* April 20, 1874. Cited and translated by John Rewald, *Paul Cézanne* (Schocken Books, Inc., New York, 1968); this excerpt, p. 101. By permission of the publisher.

A. P. (Alexandre Pothey)
From "Fine Arts" (1877)

M. Paul Cézanne is a veritable intransigent, a chimerical hot-head. In looking at his "Bathers," his "Head of a Man," his "Figure of a Woman," we have the impression that our view of nature is not the same as that which the artist experiences.

A. P. (Alexandre Pothey), "Beaux-Arts," *Le Petit Parisien,* April 17, 1877.

Georges Rivière

From "The Impressionists'
Exhibition" (1877)

The artist most attacked and most mistreated by the press and by the public, for the past fifteen years, has been M. Cézanne. There is no outrageous epithet which has not been attached to his name, and his works have obtained a success in ridicule which still sustains.

One newspaper called the portrait of a man, exhibited this year, "Billoir en Chocolat." [1] These laughs and outcries stem from a bad faith which they do not even attempt to dissimulate. They come before the paintings of M. Cézanne "to laugh their heads off." For my part, I do not know any painting less laughable than this.

Cézanne is, in his works, a Greek of the great period; his canvases have a calm, a heroic serenity of the paintings and terra cottas of antiquity, and the ignorant who laugh before his "Bathers" for example, impress me as barbarians criticizing the Parthenon.

Cézanne is a painter and a great painter. Those who have never held a brush or a crayon claim that he does not know how to draw, and reproach him for "imperfections" which are only refinements obtained by enormous learning. . . .

The painting of M. Cézanne has the inexpressible charm of Biblical and Greek antiquity, the movements of his figures are simple and grand as in the sculptures of antiquity, the landscapes have an imposing majesty, and his still lifes so beautiful, so exact in the relationships of tones, have something of solemnity in their truth. In all his paintings, the artist produces emotion, because he himself experiences before nature a violent emotion which his craftsmanship transmits to the canvas. . . .

"I do not know, [said a] friend before "The Bathers," I do not know what qualities one could add to this picture to make it more moving, more impassioned, and I search in vain for the defects with which they reproach him. The painter of the "Bathers" belongs to the race of giants. . . . If the present will not render him justice, the future will class him among his equals, near the demigods of art."

Georges Rivière, "L'Exposition des Impressionnistes," *L'Intransigeant*, no. 2, April 14, 1877; this excerpt, pp. 1–7. Reprinted in Lionello Venturi, *Les Archives de l'Impressionnisme*, vol. II (Paris, 1939), pp. 315–317.

[1] As Rewald has pointed out, this was Chocquet's portrait; Billoir was a famous murderer. John Rewald, *Paul Cézanne* (New York, 1968), p. 105.

Emile Zola
From "Parisian Notes. An Exhibition:
The Impressionist Painters" (1877)

Mr. Paul Cézanne . . . is certainly the greatest colorist of the group. There are, in the exhibition, some Provencal landscapes of his which have the most beautiful character. The canvases of this painter, so strong and so deeply felt, may cause the bourgeois to smile, but they nevertheless contain the elements of a very great painting.

1969), "Parisian Notes. An Exhibition: The Impressionist Painters," Vol. 12, p. 974.

Emile Zola
From "Naturalism at the Salon"
(1880)

The real misfortune is that no artist of this group has achieved powerfully and definitely the new formula which, scattered through their works, they all offer.

M. Paul Cézanne has the temperament of a great painter who still struggles with problems of technique and remains closest to Courbet and Delacroix.

Emile Zola, "Le Naturalisme au Salon," *Le Voltaire,* June 18–22, 1880. Reprinted in Lionello Venturi, *Les Archives de l'Impressionnisme,* II; this excerpt, p. 280.

Paul Gauguin
To Camille Pissarro (1881)

Has Cézanne found the exact formula for a work acceptable to everyone? If he discovers the prescription for compressing the intense expression of all his sensations into a single and unique procedure, try to make him talk in his sleep by giving him one of those mysterious homeopathic pills and come immediately to Paris to share it with us.

Cited and translated in John Rewald, *Paul Cézanne* (Schocken Books, Inc., New York, 1968), p. 119. By permission of the publisher.

Paul Gauguin
From a Letter to
Emile Schuffenecker (1885)

Look at Cézanne, the misunderstood, an essentially mystic Eastern nature (he looks like an old man of the Levant). In his methods, he affects a mystery and the heavy tranquillity of a dreamer; his colours are grave like the character of orientals; a man of the South, he spends whole days on the mountain top reading Virgil and looking at the sky. So his horizons are lofty, his blues most intense, and with him red has an amazing vibration. Virgil has more than one meaning and can be interpreted as one likes; the literature of his pictures has a parabolic meaning with two conclusions; his backgrounds are equally imaginative and realistic. To sum up: when we look at one of his pictures, we exclaim "Strange." But he is a mystic, even in drawing.

Paul Gauguin, Letter to Emile Schuffennecker, January 14, 1885. Reprinted by permission of the World Publishing Company from *Paul Gauguin: Letters to His Wife and Friends,* edited by Maurice Malingue, translated by Henry J. Sterning (The World Publishing Company, Cleveland and New York, 1949); this excerpt, p. 34. Copy © 1949 by The World Publishing Company.

Camille Pissarro
To J. K. Huysmans (1883)

Why is it that you do not say a word about Cézanne whom all of us recognize as one of the most astounding and curious temperaments of our time and who has a very great influence on modern art?

J. K. Huysmans
Response to Camille Pissarro (1883)

Let's see, I find Cézanne's personality congenial, for I know through Zola of his efforts, his vexations, his defeats when he tries to create a work! Yes, he has temperament, he is an artist, but in sum, with the exception of some still lifes, the rest is, to my mind, not likely to live. It is interesting, curious, suggestive in ideas, but certainly he is an eye case, which I understand he himself realizes. . . . In my humble opinion, the Cézannes typify the impressionists who didn't make the grade. You know that after so many years of struggle it is no longer a question of more or less manifest or visible intentions, but of works which are real childbirth, which are not monsters, odd cases for a Dupuytren museum of painting [Dupuytren was the founder of a medical museum of anatomy].

Cited and translated by John Rewald, *Paul Cézanne* (Schocken Books, Inc., New York, 1968), p. 129. By permission of the publisher.

J. K. Huysmans
From "Cézanne" (1889)

In full light, in porcelain fruit dishes or on white tablecloths, rough, un-polished pears and apples are fashioned with a trowel, brushed up with the touch of a thumb. Close up, a wild rough-cast of vermilion and yellow, of green and blue; at a distance, in focus, fruit intended for the showcases of chevets, ripe and succulent fruit, the object of envy.

And truths omitted until they can be perceived, strange but real tones, patches of singular authenticity, nuances of line, subordinated to the shadows which spread around the fruit and scatter, giving a plausible and charming blue tinge which make these canvases initiatory works, whereas one is accustomed to the usual still-life paintings dashed off with a bituminous repoussoir against unintelligible backgrounds.

Then sketches of landscapes outdoors, tentative retardation of branches, attempts with their freshness spoiled by retouching, childish and barbaric sketches, in short, disarming disequilibrium; houses perched on one side, like drunkards, fruit all askew in tipsy pottery; naked women bathers, encircled by crazy, but exciting lines for the glory of one's eyes, with the fiery passion of a Delacroix, without refinement of vision and without a fine touch, whipped up by a fever of dissipated colors, hurled, in relief, against the heavy canvas which curves!

In short, a revealing colorist who contributed more than the late Manet to the impressionist movement, an artist with diseased eyes who, in the exasperated apperception of his sight, discovered the preambles of a new art, so it seems that one sums up this too much forgotten painter, Cézanne.

He did not exhibit again after 1877, when he showed in rue le Pelle-tier sixteen canvases, of which the perfect honesty of art served to enliven the crowd for a long time.

J. K. Huysmans, "Cézanne," *Certains* (Paris, 1889), pp. 42–43.

Gustave Geffroy

From "Paul Cézanne" (1894)

One would not realize it, although the works of Cézanne state it openly, manifest the tension toward the real—that patience, that length of time, that nature of an upright artist, that conscience satisfied with such difficulty. It is obvious that the painter is frequently incomplete, that he has been unable to conquer the difficulty, that the obstacle to realization is revealed to all eyes. It is a little bit, apart from the technique, like the touching efforts of the primitives. There are absences of atmosphere, of the fluidity through which the planes must be separated and the farthest depths be placed at their proper distance. The forms become awkward at times, the objects are blended together, the proportions are not always established with sufficient rigor.

But these remarks cannot be made before each canvas of Cézanne. He has laid out and completely materialized infinitely expressive pages. In these he unfolds animated skies, white and blue, he erects, within a limpid atmosphere, his dear hill of Sainte-Victoire, the straight trees which surround his Provençal home of the Jas de Bouffan, a hillock of colored and golden foliage, in the countryside near Aix, a weighty inlet of the sea in a rocky bay where the landscape is crushed beneath an atmosphere of heat.

The arbitrary distribution of light and shade which might otherwise be surprising is no longer noticeable. One is in the presence of a unified painting which seems all of a piece and which is executed over a long period of time, in thin layers, which has ended up by becoming compact, dense, velvety. The earth is solid, the carpet of grass is thick, of that green with bluish nuances which belongs so much to Cézanne, that he distributes in precise strokes in the mass of leafage, that he spreads out in large, grassy stretches on the ground, that he mingles with the mossy softness of tree trunks and rocks. His painting then takes on the muted beauty of tapestry, arrays itself in a strong, harmonious weft. Or else, as in the *Bathers,* coagulated and luminous, it assumes the aspect of a piece of richly decorated faïence. . .

That Cézanne has not realized with the strength that he wanted the dream that invades him before the splendor of nature, that is certain, and that is his life and the life of many others. But it is also certain that

Gustave Geffroy, "Paul Cézanne," *La Vie artistique,* III (Paris, 1894), pp. 249–260. English translation from Linda Nochlin, *Impressionism and Post-Impressionism, 1874–1904: Sources and Documents* (Prentice-Hall, Inc., Englewood Cliffs, New Jersey, 1966); these excerpts, pp. 106, 107. By permission of the publisher.

his idea has revealed itself, and that the assemblage of his paintings would affirm a profound sensitivity, a rare unity of existence. Surely this man has lived and lives a beautiful interior novel, and the demon of art dwells within him.

Arsène Alexandre

From "Claude Lantier" (1895)

When *L'Oeuvre,* the romantic epic of painting, appeared, with its exaggeration of types, its willful distortion of facts, and its lyricism, it seemed to describe very simple things, and some moderately well-informed critics wrote that Claude Lantier, the chief character in the novel, the neurotic and miserable painter who ends by hanging himself in front of his picture, was a portrait of Cézanne. This was all that was necessary for the public, who were interested in the anecdotes and unpublished facts of artistic life, to spread the strangest ideas about the painter who could and moreover would do nothing to contradict them. One might have doubted whether, like Homer, Cézanne really existed.

The opportunity has arisen for stating that he really does exist, and even that his existence has not been useless to some people. . . . Today it has suddenly been discovered that Zola's friend, the mysterious man from Provence, the painter simultaneously incomplete and inventive, sly and uncivilized, is a great man.

Great man? Not altogether, if one remains aloof from the enthusiasms of a season, but one of the strangest temperaments, from whom a great deal in the new school has been borrowed, knowingly or not. The interesting thing about this exhibition is the influence he exerted on artists who are now well known: Pissarro, Guillaumin, and later, Gauguin, van Gogh, and others.

Arsène Alexandre, "Claude Lantier," *Le Figaro,* December 9, 1895. Cited and translated in John Rewald, *Paul Cézanne* (Schocken Books, Inc., New York, 1968); this excerpt, pp. 181–182. By permission of the publisher.

Camille Pissarro

From Letters to His Son Lucien

(1895)

PARIS, NOVEMBER 21, 1895

How rarely do you come across true painters, who know how to balance two tones. I was thinking of H., who looks for noon at midnight, of Gauguin, who, however, has a good eye, of Signac, who also has something—all of them more or less paralyzed by theories. I also thought of Cézanne's show in which there are exquisite things, still lifes of irreproachable perfection, others, *much worked on* and yet unfinished, of even greater beauty, landscapes, nudes, and heads that are unfinished but yet grandiose, and so *painted*, so supple. . . . Why? Sensation is there! Curiously enough, while I was admiring this strange, disconcerting aspect of Cézanne, familiar to me for many years, Renoir arrived. But my enthusiasm was nothing compared to Renoir's. Degas himself is seduced by the charm of this refined savage. Monet, all of us. . . . Are we mistaken? I don't think so. The only ones who are not subject to the charm of Cézanne are precisely those artists or collectors who have shown by their errors that their sensibilities are defective. They properly point out the faults we all see, which leap to the eye, but the charm—that they do not see. As Renoir said so well, these paintings have I do not know what quality, like the frescoes of Pompeii, so crude and so admirable! Degas and Monet have bought some marvelous Cézannes; I exchanged a poor sketch of Louveciennes for an admirable small canvas of bathers and one of his self-portraits.

PARIS, NOVEMBER 22, 1895

Mauclair has published an article [on Cézanne] which I am sending you. You will see that he is ill informed like most of those critics who understand nothing. He simply doesn't know that Cézanne was influenced like all the rest of us, which detracts nothing from his qualities. People forget that Cézanne was first influenced by Delacroix, Courbet, Manet and even Legros, like all of us; he was influenced by me at Pontoise, and I by him. You may remember the sallies of Zola and Béliard in this regard. They imagined that artists are the sole inventors of their styles and that

Camille Pissarro, Letters to His Son Lucien, edited by John Rewald (Kegan Paul, Trench, Trubner and Co., Ltd., London, 1943, and Pantheon Books, New York, 1943), pp. 275–276. By permission of the publishers.

to resemble someone else is to be unoriginal. Curiously enough, in Cézanne's show at Vollard's there are certain landscapes of Auvers and Pontoise [painted in 1871–74] that are similar to mine. Naturally, we were always together! But what cannot be denied is that each of us kept the only thing that counts, the unique "sensation"!—This could easily be shown.

Thadée Natanson
From "Paul Cézanne" (1895)

As to his mastery, which captures the charm of nature rather than arranging it, which only wishes to owe to the execution and not to the attitude of the model the deep attraction of the composition, it manifests itself by the possession of a secret. I mean the secret of the dispositions and of combinations of form which are the charm of the most beautiful works of art. Doubtless they obey, outside us, laws of our organs, the mathematical formula of which will perhaps some day be established, but which so far enlighten only the privileged unconsciously: those who have the genius of lay-out, the gift of assembling colours, or those who are able to set down movements.

But, without looking so far, already a certain casualness, careless of what is not his characteristic preoccupation, disdainful of pleasing, is indicative of a master. In addition to the purity of his art, which is devoid of any base seduction, another quality of precursors, so essential, proves his mastery: he dares to be unpolished and as it were uncivilized and only allows himself to be swept along right to the end, to the scorn of all the rest, by the only concern which impels initiators, to create new signs.

There is no longer any need to foresee his influence: it is obvious, revealed not only by those who have copied him, but already even indirectly, in the case of others, younger, who perhaps have never seen him. So much so that this incomplete artist, creator of a work that resembles nothing that could have been seen before it and only in those things which, clearly, have issued from it, has not only, like some of his illustrious contemporaries, met with pilferers and plagiarists and had a notable influence on his epoch. Perhaps he alone, in any case he more

Thadée Natanson, "Paul Cézanne," *La Revue Blanche,* December 1, 1895, pp. 496–500; this excerpt, pp. 499–500.

than any of them, has the glory of having trained pupils and formed a school, in the best and most profound sense of these words.

• • •

Paul Cézanne has the right not only to this title of precursor.

He deserves another.

Already in the French school he is occupying the position of a new master of still life.

For the love he has put into painting them and which has made him summarize all his gifts in this, he is and remains the painter of apples. He is the painter of apples, of smooth, round, fresh, weighty, vivid apples whose colour seems to undulate, not those that we should like to eat and whose trompe l'oeil holds the gourmands, but forms which ravish. It is he who has given them these shining yellow and red wrappers, who has chequered their roundness with a touch of love, who has created of them a definitive, savoury image.

He has made apples his own. For the future, through his masterly manipulation, they belong to him. They are his just as much as the object belongs to its creator.

Some who will find his share belittled will smile.

Is it then true that there must be, as much as a hierarchy of qualities, a hierarchy of subjects? And as, without its being reasonably possible to realise it, grandeur prevails over delicacy or grace yields to majesty, must one create ranks of importance? Is one to place after a painter who has portrayed only generals, one who has taken his models from the ranks? Is one to subordinate to the latter another who has been attracted only by the forms of gourds?

Of Paul Cézanne, it can be said again that he loved painting passionately, that to paint he limited his effort for the love of a few forms which he had the gift to establish.

Camille Mauclair

From "Matters of Art" (1896)

It is very late to mention the Cézanne exhibition that Vollard gave in the rue Lafitte and I can say nothing about it that has not been known here

Camille Mauclair, "Choses d'Art," *Mercure de France,* vol. XVII, no. 73, January, 1896; this excerpt, p. 130.

for a long time. Conscientious, simple, frank, but heavy and monochrome, very remarkable in still-life and landscape, almost shapeless in his figures, uncouth and naive, ignoring everything and becoming everything, this lonely initiator of the "final manner" of impressionism rises up again, leaving an impression of barbarism, but of cleanness. Decidedly, this peasant, strangely *anti-intellectual* production occupies a place very much apart among Whistler, Gustave Moreau and Manet. Gauguin has come entirely from Cézanne, and the Pissarros of 1885 also. But Gauguin has put philosophy as a Noah's ark in painted wood into his Cézanne, and Pissarro has put into it what alteration it needed to sell the pictures. Cézanne has presented Cézanne pure and simple, and I like that better.

Henri Rochefort

From "The Love of Ugliness"

(1903)

The crowd was particularly amused by the head of a man, dark and bearded, whose cheeks were sculptured with a trowel and who seemed to be the prey of an eczema. The other paintings by the same artist all had an air of defying no less directly Corot, Théodore Rousseau, and also Hobbema and Ruysdael.

Pissarro, Claude Monet, and the other more eccentric painters of the plein-air and of pointillism—those who have been called "confetti painters"—are academicians, almost members of the Institute, by comparison with this strange Cézanne whose productions Zola had picked up.

The experts in charge of the sale themselves experienced a certain embarrassment in cataloguing these fantastic things and attached this reticent note to each one of them: "Work of earliest youth!"

If M. Cézanne was still being nursed when he committed these daubs, we have nothing to say; but what is to be thought of the head of a literary school, as the squire of Médan considered himself to be, who propagates such pictorial madness? And he wrote Salon reviews in which he pretended to rule French art!

Had the unfortunate man never seen a Rembrandt, a Velasquez, a Rubens, or a Goya? For if Cézanne is right, then all those great brushes

Henri de Rochefort, "L'Amour du laid," *L'Intransigeant*, March 9, 1903, translated by John Rewald, *Paul Cézanne* (Schocken Books, Inc., New York, 1968); this excerpt, pp. 185–186. By permission of the publisher.

were wrong. Watteau, Boucher, Fragonard, and Prud'hon no longer exist and nothing remains as supreme symbol of the art dear to Zola but to set fire to the Louvre.

We have often averred that there were pro-Dreyfus people long before the Dreyfus case. All the diseased minds, the topsy-turvy souls, the shady and the disabled, were ripe for the coming of the Messiah of Treason. When one sees nature as Zola and his vulgar painters envisage it, naturally patriotism and honor take the form of an officer delivering to the enemy plans for the defense of his country.

The love of physical and moral ugliness is a passion like any other.

Anonymous

From a Review in *La Lanterne*

(1904)

Cézanne! A name which, in the heroic days of realism, was the signal of pitched battles. Alas! I fear this exhibition will put an end to the quarrel by demonstrating in a most peremptory fashion that Cézanne is nothing but a lamentable failure. Perhaps he has ideas, but he is incapable of expressing them. He seems not to know even the first principles of his craft.

Anonymous, *La Lanterne*, October 15, 1904. Translation quoted in Ambroise Vollard, *Paul Cézanne, His Life and Art* (New York, 1923); this excerpt, pp. 188–189.

FROM "PAUL CÉZANNE" (1904)

Emile Bernard

They [the Impressionists] have purified the vision of their eye and the logic of their spirit, that is why the work which they have accomplished has been excellent, and despite its simple documentary appearance, is of capital importance.

Paul Cézanne was not the first to enter upon this path. He gladly recognizes that it is to Monet and Pissarro that he owes his having set himself free from the over-preponderant influence of the museums to place himself under that of nature. Despite this proximity, his work does not show it. Only, however great they could have been with pleasure, the primitively sombre and rough canvases of Cézanne came down to restricted proportions, an exigency of working after nature. The master leaves his studio, goes morning and evening to his motif, follows the effect of the atmosphere on the forms and the locations, and analyzes, searches, finds. Soon it is no longer Pissarro who is advising him, it is he who is acting on the pictorial evolution of the latter. Thus he did not adopt Monet's or Pissarro's manner of working; he remained what he was, that is to say a painter with an eye which clarifies and educates itself, exalts itself before the sky and the mountains, in the presence of things and beings. According to his own expression, he has made a fresh optic for himself, for his was obliterated and led away by a limitless passion towards too many images, engravings, pictures. He wanted to see too much; his insatiable desire for beauty has made him search into the multiform volume of art too closely; henceforth he finds that it is necessary to restrict himself, to shut himself away in a conception and an ideal that are aesthetic; thus if he goes to the Louvre, if he concentrates his gaze for a long time on Veronese, this time it is to strip its appearances and scrutinize its laws; in it he learns the contrasts, the tonal oppositions and distills his taste, ennobling and elevating it. If he goes to look at Delacroix again, it is to follow in his work the flowering of the effect in the colored sensation; for he declares: "Delacroix was, in regard to colors, imaginative and sensitive"—a most powerful and exceptional gift; in

Emile Bernard, "Paul Cézanne," *L'Occident,* July, 1904, pp. 17–30; these excerpts, pp. 19–28.

fact, the artist sometimes possesses a brain and not an eye, sometimes an eye and not a brain; and Cézanne immediately quotes Manet as an example: the nature of a painter, the intelligence of an artist, but mediocrely sensitive to color.

It was at Auvers, near to Pissarro, that Cézanne retired in order to disengage himself from all influence before nature after having painted grand and forceful works under the sway of Courbet; and it was at Auvers that he began his astonishing creations of an art sincere and so naively knowing that he has since developed. . . .

From the day when Paul Cézanne set himself face to face with nature with the firm resolution to *forget everything*, he began these discoveries which, being spread by superficial imitation from that time onwards, have had the finality of a revolution on contemporary comprehension.

But all this happened without his being aware of it, for heedless of glory, reputation, success, dissatisfied with himself, the painter plunged into the absolute of his art without ever wishing to listen to anything from the outside world, pursuing the occult deepening of his analysis, giving slowly and with reflexion and power the thrusts with his spade which would one day come in contact with the marvelous vein whence all splendour would emerge.

● ● ●

Such was his method of work: primarily, complete submission to the model; using care, establishing the setting, the search for the contours, the relations of proportions; then, in very meditative sessions, the exaltation of the sensations of colour, the elevation of the form towards a decorative conception; of colour towards the most musical pitch. Thus the more the artist works, the more remote his work becomes from the objective; the farther he removes himself from the opacity of the model serving him as his starting point, the more he enters into unalloyed, absolute painting, without any other purpose than itself; the more he abstracts his picture, the more he simplifies and amplifies it, after having brought it into being, narrow, conforming, hesitant.

Gradually the work has grown, has reached the result of a pure conception. In this attentive and patient procedure, every part is brought into operation simultaneously, accompanies the others, and it can be said that each day a more exasperated vision comes to superimpose itself on that of the day before, until the artist grows weary, feels his wings melting at the sun's approach, that is, leaves off at the highest point to which he has been able to raise his work; so that if he had taken as many canvases as he has spent sessions, there would result from his analysis a sum total of ascending visions, gradually living, singing, abstract, harmonious, the most *supernatural* of which would be the most definitive; but in taking only a single canvas for this slow and fervent elaboration, Paul Cézanne shows us that analysis is not his objective, that it is not his means, that he is using it as a pedestal, and that all he cares about is the destructive and conclusive synthesis. This method of working which is peculiar to him, he advocates as the only one which must lead to a

serious result, and he condemns mercilessly any deliberate bias in favour of simplification which does not pass through submission to Nature, through thoughtful and progressive analysis. If a painter is satisfied with little, it is, according to Paul Cézanne, because his vision is mediocre, his temperament of poor value. . . .

The expressive syntheses of Cézanne are detailed and submissive studies. Taking nature as a focal point he conforms to the phenomena and transcribes them slowly and attentively until he has discovered the laws which produce them. Then, logically, he takes possession of them and completes his work by an imposing and living synthesis. His conclusion, in harmony with his southerner's expansive nature, is decorative; that is, free and exalted.

Madame de Staël wrote in her book on Germany: "The French consider external objects as the motive power of all ideas and the Germans, ideas as the motive power of all impressions." Paul Cézanne justifies this opinion of Madame de Staël on the French but he knows how to go to a depth of art which is not common to our contemporaries. As a good traditionalist, he maintains that Nature is our focal point, that one must draw nothing out, except from her alone, at the same time giving oneself liberty to improvise with what we borrow from her. . . .

What the painter primarily needs, according to Cézanne, is a personal optic, and such an optic can only be obtained from persistent contact with the vision of the universe.

Of course it is essential to have frequented the Louvre, the museums —in order to realise the elevation of Nature to art. "The Louvre is a good book to consult, but it should not be more than an intermediary; the real and major study to be undertaken is the diversity of the picutre of Nature." [1]

Without the vision of Art, the copy of Nature would become a mere stupidity, that is obvious, but one must fear about limiting one's invention to repetitions or pastiches, about losing one's foothold in abstractions or useless repetitions; it is essential to maintain oneself on the ground of analysis and observation, to forget the works already completed in order to create unforeseen ones, drawn from the heart of the work of God.

Paul Cézanne considers that there are two plastic arts, the one sculptural or linear, the other decorative or colorist. What he calls sculptural plasticity would be amply signified by the type of the Venus de Milo. What he calls decorative plasticity is linked with Michelangelo and Rubens: the one of these plasticities is servile, the other free; in the one the contour prevails, in the other the projection, colour, and fire. Ingres belongs to the first category, Delacroix to the second. . . .

• • •

Here are some opinions of Cézanne:

"Ingres is a pernicious classicist, and so in general are all those who deny nature or copy it with their minds made up and look for style in the imitation of the Greeks and Romans.

[1] These are Cézanne's own words.

"Gothic art is deeply inspiring; it belongs to the same family as we do.

"Let us read nature; let us realize our sensations in an aesthetic that is at once personal and traditional. The strongest will be he who sees most deeply and realizes fully like the great Venetians.

"Painting from nature is not copying the objective, it is realizing one's sensations.

"There are two things in the painter, the eye and the mind; each of them should aid the other. It is necessary to work at their mutual development, in the eye by looking at nature, in the mind by the logic of organized sensations which provides the means of expression.

"To read nature is to see it, as if through a veil, in terms of an interpretation in patches of colour following one another according to a law of harmony. These major hues are thus analysed through modulations. Painting is classifying one's sensations of colour.

"There is no such thing as line or modelling; there are only contrasts. These are not contrasts of light and dark, but the contrasts given by the sensation of colour. Modelling is the outcome of the exact relationship of tones. When they are harmoniously juxtaposed and complete, the picture develops modelling of its own accord.

"One should not say model, one should say modulate.

"Shadow is a colour as light is, but less brilliant; light and shadow are only the relation of two tones.

"Everything in nature is modelled on the sphere, the cone and the cylinder. One must learn to paint from these simple forms; it will then be possible to do whatever one wishes.

"Drawing and colour are not separate at all; in so far as you paint, you draw. The more the colour harmonises, the more exact the drawing becomes. When the colour achieves richness, the form attains its plenitude. The contrasts and connections of tones—there you have the secret of drawing and modelling.

"The effect is what constitutes a picture. It unifies the picture and concentrates it. The effect must be based on the existence of a dominating patch.

"It is necessary to be workmanlike in art. To get to know one's way of realisation early. To paint in accordance with the qualities of painting itself. To use materials crude and pure.

"It is necessary to become again classical by way of nature, that is to say through sensation.

"It is all summed up in this: to possess sensations and to read nature.

"In our period there are no more true painters. Monet has given a vision. Renoir has made the woman of Paris. Pissarro was very close to nature. What follows doesn't count, composed only of bluffers who feel nothing, who do acrobatics. . . . Delacroix, Courbet, Manet made paintings.

"Work without regard for anyone, and become strong—that is the aim of the artist. . . .

"The artist must disregard opinion which isn't based on intelligent

observation of character. One must eschew the literary spirit, which is so often divergent from the true voice of painting: the concrete study of nature in order not to get lost too long in intangible speculations.

"The painter must devote himself entirely to the study of nature and to try to produce pictures which can become a lesson. Causeries on art are almost useless. Work which realises its progress in its proper medium is a sufficient compensation for the incomprehension of imbeciles. The man of letters expresses himself in abstractions while the painter concretises his sensations, his perceptions by means of drawing and colour.

"One cannot be too scrupulous, too sincere, too submissive to nature, but one is more or less master of one's model, and above all one's means of expression. Penetrate that which is before you, and persevere to express it as logically as possible."

• • •

Such is Cézanne, such is the lesson of his art. As one can see, it is essentially differentiated from Impressionism, from which it derives but in which he could not imprison his nature. Far from being spontaneous, Cézanne is a man who reflects, his genius is a flash in depth. It thus follows that his typically painter's temperament has led him to new decorative creations, to unexpected syntheses; and these syntheses have in truth been the greatest progress that has sprung from modern apperceptions; for they have overthrown the routine of the schools, maintained tradition and condemned the hasty fantasy of the excellent artists of whom I have spoken. In short, Cézanne, through the reasonableness of his works, has proved himself the only master on whom the art of the future could graft its fruition. Yet how little appreciated were his discoveries. Wrongly considered by some, because of their unfinished state, as research which has not come to fruition; by others as strange studies without a future, due to the unique fantasy of an unhealthy artist; by himself confronted with an ideal of the absolute as bad rather than good, doubtless with resentment at seeing himself betrayed (he destroyed a large number of his works and showed none), such as they are they constitute nevertheless the finest effort towards a pictorial and colourist renaissance that France has been able to see since Delacroix.

I do not hesitate to declare that Cézanne is a painter with a mystical temperament and one is mistaken to have always classified him in the deplorable school inaugurated by M. Zola, who, despite his blasphemies against nature, hyperbolically attributed to himself the title of naturalist. I say that Cézanne is a painter with a mystical temperament by reason of his purely abstract and aesthetic vision of things. Where others, to express themselves, are concerned with creating a subject, he is content with certain harmonies of lines and tones taken from just any objects, without troubling about these objects in themselves, like a musician who, disdainful of embellishing on a score, would be satisfied with making series of chords whose exquisite nature would infallibly plunge us into something beyond art, inaccessible to his skillful colleagues. Cézanne is

a mystic precisely by this scorn for any subject, by the absence of a material vision, by a taste which his landscapes, his still-life, his portraits show to be the most noble and the highest style. And the very nature of his style confirms what I was saying by a quality of candour and grace that is wholly of Giotto, showing things in their essential beauty. Take any painting by the master, it is in its knowledge and truly superlative quality a sensitive and conscious lesson of interpretation. . . .

Thus, among the painters who are great, Paul Cézanne can be placed as a mystic, for that is the lesson of art which he gives us, he sees things not in themselves, but through their direct relationship with painting. That is to say, with the concrete expression of their beauty. He is contemplative, he regards aesthetically, not objectively; he expresses himself by sensibility, that is to say with an instinctive and conscious perception of relationships and affinities. And since his work is thus akin to music it can quite definitely be repeated that he is a mystic, this last means being the supreme one, that of heaven. Every art which becomes musical is on the way to its absolute perfection. In language it becomes poetry, in painting it becomes beauty.

This word "beauty" used about Paul Cézanne's work demands an explanation. In this case I should like it to be understood as follows: *Absolute expansion of the art used.* Certainly in his portraits, for instance, the master painter has scarcely troubled to choose a model. He has worked on the first person of good will whom he found near him, his wife, his son, and, more often than not, ordinary folk, a laborer, or a dairymaid, in preference to a dandy or some civilized person whom he abhors for his corrupt tastes and his worldly sham.

Here, of course, it is no longer a question of seeking beauty outside the means of painting; lines, values, colouring, brush-stroke style, presentation, character. We are certainly far from an agreed or material beauty and the work will only be beautiful for us to the extent that we possess a very high sensitivity, capable of making us lose sight of the thing represented, to enjoy it artistically. "It is indeed essential to see one's model, to perceive it very accurately, and even to express oneself with distinction and force. Taste is the best judge. It is rare. Art is only addressed to an exceedingly limited number of individuals." These are the words of the master, corroborated by his work; they express his preoccupations. Taste is the special sense (so little and so badly cultivated, alas!) to which he addresses himself.

● ● ●

The master is pleased to appeal to tradition. He knows the Louvre better than any painter, he has even, according to his own view, looked at the old pictures too much. What he thinks should be asked of the ancients is their classical and serious fashion of organizing their work logically. Nature intervening in the artist's work will animate what reason would leave dead. He recommends above all to start from Nature.

Surely one should be a theorist to enter into possession of oneself and bring one's work to a successful conclusion, but one should be so in

regard to one's feelings and not only in regard to the means. One's sensation demands that the means be constantly transformed, re-created, to express them in their intensity. One must thus not try to make the sensation enter into a pre-established means, but to put one's genius which is inventive of expressions at the service of the sensation. On the one hand it would be the École des Beaux-Arts which would bring everything to a uniform mold, whereas on the other it is a constant renewal. Organize one's sensations, that is then the first precept of Cézanne's doctrine, doctrine which is not at all sensualist, but sensitive. The artist will then gain in logic without losing in expression; he will be able to produce the unforeseen while remaining classical in Nature.

FROM "INQUIRY INTO CURRENT TENDENCIES IN THE PLASTIC ARTS" (1905)

Charles Morice

From PART I

CHARLES CAMOIN

Cézanne is a genius by the novelty and importance of his contribution. He is among those who determine an evolution. He is the primitive of open air. He is profoundly classical, and he often repeats that he is only seeking to *vivify Poussin through nature*. He does not see objectively and by the stroke as do the Impressionists, he deciphers nature slowly, by shadow and light, which he expresses in his sensations of color. However, he has no other aim than "to make an image."

Charles Morice, "Enquête sur les tendances actuelles des arts plastique," *Mercure de France*, vol. LVI, no. 195, August 1, 1905, pp. 346–359; these excerpts, pp. 353–355. By permission of the publisher.

E. SCHUFFENECKER

Cézanne is the great and rugged ingenue. He is a temperament. But he has made neither a painting nor a body of work.

From PART II

GEORGE ROUAULT

Artists such as Gustave Moreau, Rodin, Toulouse-Lautrec, Cézanne have on the movement which interests you [new directions in painting] an infinitely superior influence from the point of view of development of a new poetry.

Mercure de France Vol. LVI, no. 196, August 15, 1905, pp. 538–550; these selections from pp. 538, 544, 548.

PAUL SÉRUSIER

Cézanne has managed to strip pictorial art of all the mould accrued in the course of time. He showed clearly that imitation is merely a means and that the only aim is to arrange lines and colours on a given surface in such a way as to charm the eye, speak to the spirit, and finally to create a language by purely plastic means, or even to rediscover the universal language. He is accused of roughness and dryness; these are the externals of his power, apparent faults! His thought is so clear in his own mind, his desire to express himself is so compelling! If—as I dare to hope it will—a tradition is born of our times it will be born of Cézanne. Others will then come along, skillful cooks who will accommodate his remains with more modern sauces; he will have furnished the substantive marrow. We have here, not a new art, but the resurrection of all the solid, pure, *classical* arts.

RAOUL DUFY

As to Whistler and Fantin-Latour, they are painters, purely painters, who have dawdled neither in a literary sense nor in the sense of technique in their art.

Cézanne, on the contrary, is delighted to affirm very strongly his exclusive preoccupations with technique.

FROM "ON PAUL CÉZANNE" (1906)

Jean Royère

This painter who analyzed nature to the point of decomposing colors, tones and lights, aspired to so exalted a synthesis that it was impossible for him, as it is for us. He wished to fathom the living being right to the soul, to remain *objective* and true, all to perpetuate the landscape in a reflection of humanity. For him, the complete *subject* was man in nature; but between nature and people he dreamt of a deep harmony. He wanted an intimate resemblance, an expressive correspondence between them, so that the picture should reveal an *entity* superior to the appearances in which the genius of the painter himself would show through. For painting is an art of eternity. Human life and sensitive nature are in constant change: *landscape* is immutable. Unless, then, one is *opposing* it to what is real in an ineluctable contradiction, the artist must disengage from man and nature the FORM, WHICH DOES NOT CHANGE. He must raise his work, so to speak, out of time into HARMONY.

Paul Cézanne's painting, like Mallarmé's poetry, is *in a sense* metaphysical.

Jean Royère, "Sur Paul Cézanne," *La Phalange,* November 15, 1906, pp. 277–382; this excerpt, p. 380.

FROM "PAUL CÉZANNE" (1907)

Charles Morice

One would be mistaken if one inferred that the intellectual quality of Cézanne's work was weak. Very much to the contrary, it was miraculously intense. But it was specialised. Art was its sole object. Beings and things fascinated and absorbed him as objects to paint. And it was from painting that he took all his joy—only the joy of painting, not that of penetrating spiritually, sentimentally, sensually into the life of nature. His art is no more sensual than it is spiritual and sentimental in the general sense of those words. It is sensorial.

It is an art of separation. Painting in the view of this painter exists in itself, for itself. . . .

This is too little. There is not there the wherewithal to create Mozart on the basis of Beethoven. The initial and overall thought is lacking, a broadly human motive which puts and keeps the artist in touch with living universals. . . . In the case of this artist, a principle of humanity is lacking. . . .

And he has called everything in question.

No one will have suggested more clearly than he the absolute present necessity of a new Symbolism. He has indicated where this Symbolism should be sought, not in knowledge, but in the interpretation of nature according to its own laws. To be a very great painter he lacked being more than a painter and lacked understanding the necessity of a New Pictorial Symbolism, the necessity of a New Reasoned Tenderness.

His work—which he doubted, as I have said, without one ever having observed that he doubted his method—remains a sublime gesture of indication.

Charles Morice, "Paul Cézanne," *Mercure de France,* February 15, 1907, pp. 577–594; these excerpts, pp. 592, 593, 599.

FROM "CÉZANNE" (1907)

Maurice Denis

I have never heard an admirer of Cézanne give me a clear and precise reason for his admiration; and this is true even among those artists who feel most directly the appeal of Cézanne's art. I have heard the words— quality, flavour, importance, interest, classicism, beauty, style. . . . Now of Delacroix or Monet one could briefly formulate a reasoned apprecia- tion which would be clearly intelligible. But how hard it is to be precise about Cézanne! . . .

At the moment of his death, the articles in the press were unanimous upon two points; and, wherever their inspiration was derived from, they may fairly be considered to reflect the average opinion. The obituaries, then, admitted first of all that Cézanne influenced a large section of the younger artists; and secondly that he made an effort towards style. We may gather, then, that Cézanne was a sort of classic, and that the younger generation regards him as a representative of classicism.

Unfortunately it is hard to say without too much obscurity what classicism is. . . .

. . . one of the certain characteristics of the classic, [is] namely, *style,* that is to say synthetic order. In opposition to modern pictures, a Cézanne inspires by itself, by its qualities of unity in composition and colour, in short by its painting. . . . Good or bad, Cézanne's canvas is truly a *picture.*

Suppose . . . we put together three works of the same family, three *natures-mortes,* one by Manet, one by Gauguin, one by Cézanne. We shall distinguish at once the objectivity of Manet; that he imitates nature "as seen through his temperament," that he translates an artistic sensation. Gauguin is more subjective. His is a decorative, even a hieratic interpretation of nature. Before the Cézanne we think only of the picture; neither the object represented nor the artist's personality holds our atten-

First appeared in *L'Occident,* September 1907, reprinted in Maurice Denis, *Théories* (Paris, 1912), pp. 245–261. This translation by Roger E. Fry appeared in *The Bur- lington Magazine,* vol. XVI, 1910; these excerpts, pp. 207–219, 275–280. Reprinted by permission of *The Burlington Magazine.*

tion. We cannot decide so quickly whether it is an imitation or an interpretation of nature. We feel that such an art is nearer to Chardin than to Manet and Gauguin. And if at once we say: this is a picture and a classic picture, the word begins to take on a precise meaning, that, namely, of an equilibrium, a reconciliation of the objective and subjective. . . .

Thus we arrive at our first estimate of Cézanne as reacting against modern painting and against Impressionism. . . .

In the first period one sees what Courbet, Delacroix, Daumier and Manet became for him, and by what spontaneous power of assimilation he transmuted in the direction of style certain of their classic tendencies. . . .

The same interesting conflict, this combination of style and sensibility, meets us again in Cézanne's second period, only it is the Impressionism of Monet and Pissarro that provides the elements, provokes the reaction to them and causes the transmutation into classicism. With the same vigour with which in his previous period he organised the oppositions of black and white, he now disciplines the contrasts of colour introduced by the study of open air light, and the rainbow iridescences of the new palette. At the same time he substitutes for the summary modelling of his earlier figures the reasoned colour-system found in the figure-pieces and *natures-mortes* of this second period, which one may call his "brilliant" manner. . . .

. . . there is in a fine Cézanne as much simplicity, austerity and grandeur as in Manet, and the gradations retain the freshness and lustre which give their flower-like brilliance to the canvases of Renoir. Some months before his death Cézanne said: "What I wanted was to make of Impressionism something solid and durable, like the art of the museums." It was for this reason also that he so much admired the early Pissarros, and still more the early Monets. Monet was, indeed, the only one of his contemporaries for whom he expressed great admiration.

Thus at first guided by his Latin instinct and his natural inclination, and later with full consciousness of his purpose and his own nature, he set to work to create out of Impressionism a certain classic conception.

In constant reaction against the art of his time, his powerful individuality drew from it none the less the material and pretext for his researches in style; he drew from it the sustaining elements of his work. At a period when the artist's sensibility was considered almost universally to be the sole motive of a work of art, and when improvisation—"the spiritual excitement provoked by exaltation of the senses"—tended to destroy at one blow both the superannuated conventions of the academies and the necessity for method, it happened that the art of Cézanne showed the way to substitute reflexion for empiricism without sacrificing the essential *rôle* of sensibility. Thus, for instance, instead of the chronometric notation of appearances, he was able to hold the emotion of the moment even while he elaborated almost to excess, in a calculated and intentional effort, his studies after nature. He *composed* his *natures-mortes*, varying intentionally the lines and the masses, disposing his draperies according

to premeditated rhythms, avoiding the accidents of chance, seeking for plastic beauty; and all this without losing anything of the essential *motive*—that initial motive which is realised in its essentials in his sketches and water colours. I allude to the delicate symphony of juxtaposed gradations, which his eye discovered at once, but for which at the same moment his reason spontaneously demanded the logical support of composition, of plan and of architecture.

. . . For him it is not a question of imposing style upon a study as, after all, Puvis de Chavannes did. He is so naturally a painter, so spontaneously classic. . . . Just as the writer determined to owe the whole expression of his poem to what is, except for idea and subject, the pure domain of literature—sonority of words, rhythm of phrase, elasticity of syntax—the painter has been a painter before everything. Painting oscillates perpetually between invention and imitation: sometimes it copies and sometimes it imagines. These are its variations. But whether it reproduces objective nature or translates more specifically the artist's emotion, it is bound to be an art of concrete beauty, and our senses must discover in the work of art itself—abstraction made of the subject represented—an immediate satisfaction, a pure aesthetic pleasure. The painting of Cézanne is literally the essential art, the definition of which is so refractory to criticism, the realization of which seems impossible. It imitates objects without any exactitude and without any accessory interest of sentiment or thought. When he imagines a sketch, he assembles colours and forms without any literary preoccupation; his aim is nearer to that of a Persian carpet weaver than of a Delacroix, transforming into coloured harmony, but with dramatic or lyric intention, a scene of the Bible or of Shakespeare. A negative effort, if you will, but one which declares an unheard of instinct for painting.

He is the man who paints. Renoir said to me one day: "How on earth does he do it? He cannot put two touches of colour on to a canvas without its being already an achievement."

It is of little moment what the pretext is for this sampling of colour: nudes improbably grouped in a non-existent landscape, apples in a plate placed awry upon some commonplace material—there is always a beautiful line, a beautiful balance, a sumptuous sequence of resounding harmonies. The gift of freshness, the spontaneity and novelty of his discoveries, add still more to the interest of his slightest sketches.

"He is" said Sérusier, "the pure painter. His style is a pure style; his poetry is a painter's poetry. The purpose, even the concept of the object represented, disappears before the charm of his coloured forms. Of an apple by some commonplace painter one says: I should like to eat it. Of an apple by Cézanne one says: How beautiful! One would not peel it; one would like to copy it. It is in that that the spiritual power of Cézanne consists. I purposely do not say idealism, because the ideal apple would be the one that stimulated most the mucous membrane, and Cézanne's apple speaks to the spirit by means of the eyes."

"One thing must be noted," Sérusier continues: "that is the absence of subject. In his first manner the subject was sometimes childish: after

his evolution the subject disappears, there is only the *motive*." (It is the word that Cézanne was in the habit of using.)

That is surely an important lesson. Have we not confused all the methods of art—mixed together music, literature, painting? In this, too, Cézanne is in reaction. He is a simple artisan, a primitive who returns to the sources of his art, respects its first postulates and necessities, limits himself by its essential elements, by what constitutes exclusively the art of painting. He determines to ignore everything else, both equivocal refinements and deceptive methods. In front of the *motive* he rejects everything that might distract him from painting, might compromise his *petite sensation* as he used to say, making use of the phraseology of the aesthetic philosophy of his youth: he avoids at once deceptive representation and literature.

The preceding reflections allow us to explain in what way Cézanne is related to Symbolism. Synthetism, which becomes, in contact with poetry, Symbolism, was not in its origin a mystic or idealist movement. It was inaugurated by landscape-painters, by painters of still-life, not at all by painters of the soul. Nevertheless it implied the belief in a correspondence between external forms and subjective states. Instead of evoking our moods by means of the subject represented, it was the work of art itself which was to transmit the initial sensation and perpetuate its emotions. Every work of art is a transposition, an emotional equivalent, a caricature of a sensation received, or, more generally, of a psychological fact.

"I wished to copy nature," said Cézanne, "I could not. But I was satisfied when I had discovered that the sun, for instance, could not be *reproduced,* but that it must be *represented* by something else . . . by colour." There is the definition of Symbolism such as we understood it about 1890. The older artists of that day, Gauguin above all, had a boundless admiration for Cézanne. I must add that they had at the same time the greatest esteem for Odilon Rédon. . . .

It is a touching spectacle that a canvas of Cézanne presents; generally unfinished, scraped with a palette-knife, scored over with *pentimenti* in turpentine, many times repainted, with an *impasto* that approaches actual relief. In all this evidence of labour, one catches sight of the artist in his struggle for style and his passion for nature; of his acquiescence in certain classic formulae and the revolt of an original sensibility; one sees reason at odds with inexperience, the need for harmony conflicting with the fever of original expression. Never does he subordinate his efforts to his technical means; "for the desires of the flesh," says St. Paul, "are contrary to those of the spirit, and those of the spirit are contrary to those of the flesh, they are opposed one to another in such wise that ye do not that which ye would." It is the eternal struggle of reason with sensibility which makes the saint and the genius.

Let us admit that it gives rise sometimes, with Cézanne, to chaotic results. We have unearthed a classic spontaneity in his very sensations, but the realization is not reached without lapses. Constrained already by his need for synthesis to adopt disconcerting simplifications, he deforms

his design still further by the necessity for expression and by his scrupulous sincerity. It is herein that we find the motives for the *gaucherie* with which Cézanne is so often reproached, and herein lies the explanation of that practice of naïveté and ungainliness common to his disciples and imitators. . . .

What astonishes us most in Cézanne's work is certainly his research for form, or, to be exact, for deformation. It is there that one discovers the most hesitation, the most *pentimenti* on the artist's part. The large picture of the *Baigneuses*, left unfinished in the studio at Aix, is from this point of view typical. Taken up again, numberless times during many years, it has varied but little in general appearance and colour, and even the disposition of the brush-strokes remains almost permanent. On the other hand the dimensions of the figures were often readjusted; sometimes they were life-size, sometimes they were contracted to half; the arms, the torsos, the legs were enlarged and diminished in unimaginable proportions. It is just there that lies the variable element in his work; his sentiment for form allowed neither of silhouette nor of fixed proportions.

For, to begin with, he did not comprehend drawing by line and contour. In spite of the exclamation reported by M. V. during the sittings for his portrait, "Jean Dominique is strong!" it is certain that he did not love M. Ingres. He used to say, "Degas is not enough of a painter; he has not enough of *that!*"—and, with a nervous gesture, he imitated the stroke of an Italian decorator. He often talked of the caricaturists, of Gavarni, of Forain, and above all of Daumier. He liked exuberance of movement, relief of muscular forms, impetuosity of hand, bravura of handling. He used to draw from Puget. He demanded always ease and vehemence in execution. He preferred, one cannot doubt, the *chic* drawing of the Bolognese to the conciseness of Ingres.

On the walls of Jas de Bouffan, covered up now with hangings, he has left improvizations, studies painted as the inspiration came, and which seem carried through at a sitting. They make one think, in spite of their fine pictorial quality, of the fanfaronnades of Claude in Zola's "L'Œuvre," and of his declamations upon "temperament." The models of his choice at this period are engravings after the Spanish and Italian artists of the seventeenth century. When I asked him what had led him from this vehemence of execution to the patient technique of the separate brush-stroke, he replied, "It is because I cannot render my sensation at once; hence I put on colour again, *I put it on as best I can.* But when I begin I endeavour always to paint with a full impasto like Manet, *giving the form with the brush.*"

"There is no such thing as line," he said, "no such thing as modelling, there are only contrasts. When colour attains its richness form attains its plentitude." (Quoted by Emile Bernard).

Thus, in his essentially concrete perception of objects, form is not separated from colour; they condition one another, they are indissolubly united. And in consequence in his execution he wishes to realize them as he sees them, by a single brush-stroke. If he fails it is certainly in part from the imperfection of his craft, of which he used to complain,

but also and above all from his scruples as a colorist, as we shall see presently.

All his faculty for abstraction—and we see how far the painter dominates the theorist—all his faculty for abstraction permits him to distinguish only among notable forms "the sphere, the cone and the cylinder." All forms are referred to those which he is alone capable of thinking. The multiplicity of his colour schemes varies them infinitely. But still he never reaches the conception of the circle, the triangle, the parallelogram; those are abstractions which his eye and brain refuse to admit. *Forms* are for him *volumes*.

Hence all objects were bound to tell for him according to their relief, and to be situated according to planes at different distances from the spectator within the supposed depth of the picture. A new antinomy, this, which threatens to render highly accidental "that plane surface covered with colours arranged in a determined order." Colorist before everything, as he was, Cézanne resolves this antinomy by chromatism— the transposition, that is, of values of black and white into values of colour.

"I want," he told me, following the passage from light to shade on his closed fist—"I want to do with colour what they do in black and white with the stump." He replaces light by colour. This shadow is a colour, this light, this half-tone are colours. The white of this table-cloth is a blue, a green, a rose; they mingle in the shadows with the surround- ing local tints; but the crudity in the light may be harmoniously trans- lated by dissonant blue, green and rose. He substitutes, that is, contrasts of tint for contrasts of tone. He disentangles thus what he used to call "the confusion of sensations." In all this conversation, of which I here report scraps, he never once mentioned the word values. His system assuredly excludes relations of values in the sense accepted in the schools.

Volume finds, then, its expression in Cézanne in a gamut of tints, a series of touches; these touches follow one another by contrast or analogy according as the form is interrupted or continuous. This was what he was fond of calling *modulating* instead of modelling. We know the result of this system, at once shimmering and forcible; I will not attempt to describe the richness of harmony and the gaiety of illumination of his pictures. It is like silk, like mother-of-pearl and like velvet. Each *modulated* object manifests its contour by the greater or less exaltation of its colour. If it is in shadow its colour shares the tints of the back- ground. This background is a tissue of tints sacrificed to the principal motive which they accompany. But on any and every pretext the same process recurs of chromatic scales where the colours contrast and inter- weave in tones and half-tones. The whole canvas is a tapestry where each colour *plays* separately and yet at the same time fuses its sonority in the total effect. The characteristic aspect of Cézanne's pictures comes from this juxtaposition, from this mosaic of separate and slightly fused tones. "Painting," he used to say, "is the registration of one's coloured sensations" (E. Bernard). Such was the exigence of his eye that he was compelled to have recourse to this refinement of technique in order to

preserve the quality, the flavour of his sensations, and satisfy his need of harmony. . . .

The fruit-pieces of Cézanne and his unfinished figures afford the best examples of this method, the idea of which was perhaps taken from Chardin: a few decisive touches declare the roundness of the form by their juxtaposition with softened tints, the contour does not come till the last, as a vehement accent, put in with turpentine to underline and isolate the form already realized by the gradation of colour.

In this assemblage of tints with an aim at grandeur of style, perspective disappears; values too (in the school of art sense) and values of atmosphere are attenuated and equalized. The decorative effect and the balance of the composition appear all the more complete owing to this sacrifice of aerial perspective. Venetian painting with a more enveloping chiaroscuro offers frequently this fine aspect of unity of plane. It is curious that it is this which most struck the first symbolists, Gauguin, Bernard, Anquetin—those, in fact, who were the first to love and imitate Cézanne. Their synthetic system admitted only flat tints and a hard contour; thence arose a whole series of decorative works which I, certainly, do not wish to decry; but how much more synoptic, how much more concrete and vital were the syntheses of Cézanne!

Synthesis does not necessarily mean simplification in the sense of suppression of certain parts of the object; it is simplifying in the sense of *rendering intelligible*. It is, in short, creating a hierarchy: submitting each picture to a single rhythm, to a dominant; sacrificing, subordinating —generalizing. It is not enough to *stylize* an object (as they say in the school of Grasset), to make some sort of copy of it, and then to underline the external contour with a thick stroke. Simplification so obtained is not synthesis.

"Synthesis," says Sérusier, "consists in compressing all forms into the small number of forms which we are capable of thinking—straight lines, certain angles, arcs of circles and ellipses; outside these we are lost in the ocean of variety." That, no doubt, is a mathematical conception of art; it does not, however, lack grandeur. But that is not, whatever Sérusier says, the conception of Cézanne. He certainly does not lose himself in the ocean of variety; he knows how to elucidate and condense his impressions; his formulae are luminous and concise; they are never abstract.

And this, again, is one of the points wherein he touches the classics; he never compromises by abstraction the just equilibrium between nature and style. All his labour is devoted to preserving his sensation; but this sensation implies the identity of colour and form; his sensibility implies his style. Naturally and instinctively he unites, in his spirit if not on his canvas, the grace and brilliance of modern colorists with the robustness of the old masters. Doubtless the realization is not reached without labour nor without lapses. But the order which he discovers is for him a necessity of expression.

He is at once the climax of the classic tradition and the result of the great crisis of liberty and illumination which has rejuvenated modern

art. He is the Poussin of Impressionism. He has the fine perception of a Parisian, and he is splendid and exuberant like an Italian decorator. He is orderly as a Frenchman and feverish as a Spaniard. He is a Chardin of the decadence and at times he surpasses Chardin. There is something of El Greco in him and often the healthfulness of Veronese. But such as he is he is so naturally, and all the scruples of his will, all the assiduity of his effort have only aided and exalted his natural gifts.

"CÉZANNE'S ATELIER" (1907)

R. P. Rivière and J. F. Schnerb

There are legends about Cézanne, according to which he was a misanthrope, a kind of unapproachable bear. Long before his death, people said that this painter had given up painting, that the works he formerly produced had to be dragged out of him. Those best informed could only vaguely give information as to the master's residence, to his kind of life. Even an ironical man could have said that Cézanne was a mythical being without positive existence.

It will thus perhaps be interesting to relate some of the painter's remarks, from notes taken in the course of a visit. Moreover it was Cézanne's intention, which he probably did not carry out, to write down his thoughts on painting. And then, so many foolish things have been said about his works, and among painters, even among those whom he has inspired, there are so few who have understood the true scope and influence of his work, that as accurate as possible an account of the ideas of such a researcher has its usefulness.[1]

When one pulled M. Cézanne's bell at No. 23 in the peaceful rue Boulegon in Aix, one was welcomed in Provençal fashion, unceremoniously, with the handshake of a colleague who was asking for news of the capital, who did not allow you to call him master and who said when questioned about his works: "I am an old man, I used to paint, what can you expect from me?"

He was a painter. He never troubled about his works; and in the

R. P. Rivière and J. F. Schnerb, "L'Atelier de Cézanne," *La Grande Revue*, December 25, 1907, pp. 811–817. This article is translated in its entirety.

[1] These notes were three parts written when M. Emile Bernard's *Souvenirs* appeared in the *Mercure de France*. After his review of *Hommes d'Aujourd'hui* (Vanier 8th Vol., No. 387), after his article in the *L'Occident* (July, 1904) in which he gave proof of an increasingly far-sighted precursory judgment, M. Emile Bernard today tells us of his stay in Aix, in Provence, with his master. He should be thanked for these pages on the man and the artist. In spite of some hesitation, we think we ought to bring our modest contribution, in the form of remarks specially limited to Cézanne's technique, to the artist's biography.

corners canvases were left about, still stretched on their frames or rolled up. The rouleaux had been left on chairs, crushed. His studios, the one in the rue Boulegon and that in the Chemin de l'Aubassane, in the country, were in great unaffected disorder. The walls were bare, the light harsh. Half-empty tubes of paint, brushes with the bristles stiffened by the colour which had long since dried on them, leftovers from lunches which were becoming subjects of still-life, covered the tables. In a corner a whole collection of landscape-painters' parasols, whose clumsy frames doubtless came from some merchant in the town and their iron-tipped spike from the neighbouring blacksmith, next to them were hunter's bags for carrying one's food into the fields.

As visitors were rare and Cézanne had scarcely any close friends in Aix with whom to discuss painting, he expressed himself in the elliptic and sometimes obscure language of solitaries.[2] Certain of his axioms were replies that he had sought for a long time to questions that the difficulties of his art had forced him to put to himself, questions of which his interlocutor had not dreamt.

To throw more light on ideas that Cézanne enunciated without any apparent connection, it will be to the point to recount in turn those dealing with design, with colour, with composition and finally with general ideas on art.

• • •

As to the design properly so-called, that which can be arbitrarily separated from colour, Cézanne eagerly declared his horror of the photographic eye, of the design of automatic accuracy taught in that *École des Beaux-Arts,* where he said he had twice presented himself unsuccessfully. It was not that he defended the superficial inaccuracies of his design, an inaccuracy that is neither neglect nor powerlessness, but that comes rather from an excessive sincerity—if it is permissible to group these two words together—from an excessive mistrust of purely manual skill, mistrust of any movement in which the eye would direct the hand without reason intervening. Thus Cézanne made no pretense of unawareness of the asymmetry of his bottles, the defective perspective of his plates. Showing one of his watercolours, he corrected a bottle that was not vertical with the tips of his fingers saying, as if excusing himself for it: "I am a primitive, I have a lazy eye. I have twice presented myself to the École, but I do not get the proportions right: a head interests me, I make it too big."

But as Cézanne, rightly or wrongly, would not allow himself the least insincerity, although he was distressed that his bottles were not balanced, he would not correct them; just as if parts of his canvas had remained bare in the course of his work, he left them so rather than rub on just any colour.

[2] Cézanne as a painter was almost unknown to his fellow townsmen. Let us draw attention, however, to a communication made to the Aix Academy in April 1907, in which M. Lucas de Montigny rightly refused to rank Cézanne among the Impressionists.

Cézanne did not try to represent forms by a line. The contour only existed for him as a place where one form ended and another began. We have only to look at his unfinished canvases; the objects of a previous plan are often left white and their outline is only indicated by the background against which they are profiled. In principle there is no outline, a form only exists by the adjacent forms. For Cézanne, the black lines which often encircle his paintings were not an element destined to be added to colour, but simply a way of more easily correcting the proportion of a form by the contour before modelling it with colour.

For the colour and the relief were for him inseparable and, from the technical point of view, this was perhaps the part of his art which he elaborated most deeply, that in which his persistent studies truly made him a master.

"I am applying myself," he said, "to portraying the cylindrical side of objects." And one of his favourite axioms, that his Provençal accent made resound with unforgettable music was: "Everything is spherical and cylindrical." This calls for an explanation.

In enunciating this formula, Cézanne would indifferently show an apple or an object that was positively spherical or cylindrical, as a flat surface such as a wall or a floor. One has only to look at his paintings: it could be confirmed that one of the causes of their appearance of solidity comes from the knowledge of flat surfaces that he has brought to the relief, whether it be a meadow or the table on which some fruit is placed.

To complete the enunciation of this theory, it should be added that in relation to the painter's eye, which is assumed to be stationary, the light rays coming from any surface, flat or not, are such that the sum total of light that the eye reflects is not the same for any of the points on this surface. A surface only seems to us even in tone and value because our eye is moved to perceive it as a whole and if the painter, to represent it extends a coat of single colour over his canvas, he will reproduce it without truth.

I am not a "valoriste," Cézanne used to say; and, in fact, he modeled more by colour than by value. For him, strong contrasts of light and shade were primarily contrasts in tones that observation and reasoning allowed the painter to reproduce. Parts directly struck by the light and those lighted only by reflection were coloured differently, but according to a uniform law whatever might be their local tonality. It is by the juxtaposition of warm and cold tones that the colours at the painter's disposal, without any absolute luminous quality in themselves, come to reproduce the light and shade. The lightest colour on the palette, white, for instance, will become darker in tone if the painter can set a lighter tone beside it. That is why Cézanne liked to repeat: "One does not make light, one reproduces it. One merely reproduces its colouring effects."

Cézanne knew what an exceptional colourist's eye Claude Monet possessed and to recall how his friend knew how to colour shadow, that is, those parts which, deprived of the direct light of the sun, receive

only a reflection of the sky, Cézanne would say: "The sky is blue, isn't it?; and it is Monet who has discovered that."

Cézanne thus saw the strong contrast between tone of light and shade even on flat surfaces of tone as unified in appearance. Thus certain of his watercolours, where his analytical processes are particularly visible, resemble badly registered proofs of three-colour impressions such as isochromatic photography obtains. One can see in these proofs, in which the blending by superimposition is imperfect, that each of the three fundamental colours is found again in all the tones. The proportion alone differs.

Cézanne's whole manner is determined by this chromatic conception of the relief. If he mixed his tones on the palette and placed them on the canvas simply by juxtaposing them, if he avoided blending two tones by an easy stroke of his brush, it was because he conceived relief as a succession of tints going from warm to cold, because for him all the interest lay in determining exactly each of these tints and to replace one of them by the mixture of two neighbouring tints would have seemed to him without art. There was certainly no a priorist method there with a view to conserving more freshness in his colour; it is, however, this freshness, this lustre, which is only a result, that his imitators have above all tried to borrow from him, without going back to the cause, more fruitful in what it has to teach, which is logical observation substituted for empiricism.

Cézanne had acquired this knowledge of colour by both theoretical and practical research. "It is necessary to reflect; the eye is not sufficient; reflection is necessary," he advised. Relief through colour, which was, in short, his language, obliges one to employ a very high scale of tones, in order to be able to observe the contrasts even in the half-tone, in order to avoid the white lights and the black shadows. Rivière was astonished to see Cézanne paint in green the grey-white wall that was behind his model: "The work and reasoning," replied the artist, "must develop the feeling for colour. Look at Veronese: the work of his youth is grey; later we have the *Pilgrims of Emmaus,* how warm it is."

Thus Cézanne preferred to work in the hours when the low sun lights up the objects with a very warm light. As early as ten o'clock in the morning he would stop painting: "The daylight is beginning to fade," he would say.

Yet he was less devoted to painting the violent contrasts that the unfiltered sun gives, than the delicate transitions which model the objects by almost imperceptible gradations. He would paint the light, more general than the sun. For him, who worked several months on the same motif, a patch of sunlight or a reflection were only rather restricting accidents of secondary importance. With his glance eager to seize the form and so to speak the weight of things, he pierced the atmosphere and did not stop to contemplate its multiple variations as the Impressionists did.

As to the composition, no concern for it is found in Cézanne's paintings, if by composition is understood the premeditated assembling

of the elements that will constitute the subject of the picture, their arrangement with a view to an harmonious ensemble of lines, values, colours, whether the artist is working objectively before a motif from which he will derive advantage by choosing the point of view, or whether his imagination supplies him with this motif subjectively. But is not this arrangement rather than composition?

According to Cézanne, the composition should be the result of the work. Every motif copied just as it falls under the painter's eye should become, by studying it, a whole perfectly equilibrated, not by the choice of it, nor by the elimination inspired by the taste in decoration, but by the logic of the reproduction, by the study of the balancing of the luminous parts and those in shadow. It was here that the theory of the sphericity of objects in regard to the eye found its full application, the motif being considered as a portion of nature enveloped by one's view of it and by that very fact isolating itself, making a whole of what is a fragment. "It is essential," Cézanne would say, "that the picture should be made according to nature." It is thus logic, which observation could not entirely replace, that composes the picture, that considers that two points of the same visual ensemble, any more than two points of the same form, could not reflect the same sum total of light, and that deduces by reasoning the maximum point of intensity of light in the picture.

When Cézanne had thus found the laws that made him master of his subject, the rest could seem to him a work outside his research, primarily theoretical. Is not all his work analysis with a view to synthesis, observation directed to an aim that is scientific rather than decorative? For the Provençal master the canvas was nothing more than the blackboard on which a geometrist searches for the solution of a problem and it is perhaps as much on this conception of his work as on the little trouble he took to make it known that determines the large number of paintings that Cézanne left unfinished.

For him, the indispensable condition to true work was to be able to accomplish it without material preoccupations. "Excuse me, you are independent?" he would ask the young artist who came to listen to his advice. "Well! Work, without that, it is essential to live." Certainly, all his life he will consider himself as a student, and his modesty is shown in these lines that he wrote to M. Roger Marx to thank him for the perspicacious judgment that the latter had devoted to him on the occasion of the autumn Salon of 1904:[3] "With a painter's temperament and an artist's ideal, that is to say a conception of nature, it is necessary that means of execution are sufficient to be intelligible to the average public and to occupy a fitting place in the history of Art."

We have already said how, after having studied the masters in museums, he had sought to find a direct vision of nature. "Pissarro," he recounted, "said that it would be necessary to burn the Louvre, he was

[3] *Gazette des Beaux-Arts,* December 1904. We are grateful to M. Roger Marx for having communicated this letter to us, a letter so important for completing the portrait of Cézanne.

right, but we must not do it!" and he would stop you with a gesture as if to avoid a misfortune that he would have been the first to deplore. Thus both his hatred for the conventional manner of working and his love for the masters were expressed. Veronese was one of those of whom he thought most at the end of his life. In his house he had also hung a photograph of the *Bergers d'Arcadie,* the beauty of the subject pleased him. He liked Poussin, in whose case reason made up for facility. Other preferences were surprising: "What a wonderful picture," he said, speaking of Gerard Dow's *Femme hydropique.* He also had his hatreds: "Jules Lefevre, these pupils of the École, I abhor them!" and the blood would rise to his face.

The visit we are relating dates back to January 1905. At that time there could be seen in the studio of the Chemin de l'Aubassane a large picture of female bathers, almost life-size, on which Cézanne was still working. "I scarcely dare to admit it," he said. "I've been working at it since 1894. I wanted to paint with a full brush, like Courbet." He seemed to have gone back from his first admiration for the Franche-Comte master whom he qualified as a "fine clod." Cézanne also painted the portrait of a man in profile, wearing a peaked cap; moreover, he said he had always practised study from nature parallel with practical work. He seemed to attach great importance to this painting. "If I succeed with this fellow," he said, "it will be the proof that my theory is true."

FROM *PAUL CÉZANNE* (1914)

Ambroise Vollard

Very few people ever had the opportunity to see Cézanne at work, because he could not endure being watched while at his easel. For one who has not seen him paint, it is difficult to imagine how slow and painful his progress was on certain days. In my portrait there are two little spots of canvas on the hand which are not covered. I called Cézanne's attention to them. "If the copy I'm making at the Louvre turns out well," he replied, "perhaps I will be able tomorrow to find the exact tone to cover up those spots. Don't you see, Monsieur Vollard, that if I put something there by guesswork, I might have to paint the whole canvas over starting from that point?" The prospect made me tremble.

Ambroise Vollard, *Paul Cézanne, His Life and Art*; first appeared in French as *Paul Cézanne*, 1914, authorized English translation by Harold L. Van Doren (Frank-Maurice, Inc., New York, 1926); this excerpt, p. 126.

FROM LETTERS TO CLARA RILKE (1907)

Rainer Maria Rilke

OCTOBER 9, 1907

. . . today I wanted to tell you a little about Cézanne. As far as work was concerned, he maintained he had lived like a Bohemian until his fortieth year. Only then, in his acquaintance with Pissarro, did the taste for work open up to him. But then so much so, that he did nothing but work for the thirty latter years of his life. Without joy really, it seems, in continual fury, at variance with every single one of his works, none of which seemed to him to attain what he considered the most indispensable thing. La réalisation, he called it, and he found it in the Venetians whom he used to see and see again in the Louvre and had unconditionally acknowledged. The convincing quality, the becoming a thing, the reality heightened into the indestructible through his own experience of the object, it was that which seemed to him the aim of his innermost work; old, sick, every evening exhausted to the point of faintness by the regular daily work (so much so that he would often go to bed at six, as it was growing dark, after an insensibly eaten supper), ill-tempered, distrustful, laughed at every time on the way to his studio, jeered at, mistreated,—but observing Sunday, hearing Mass and vespers like a child, and very politely asking his housekeeper, Madame Brémond, for somewhat better fare—: he still hoped from day to day, perhaps, to reach the successful achievement he felt to be the only essential thing. In so doing (if one may believe the reporter of all these facts, a not very congenial painter who went along for a while with everybody), he had increased the difficulty of his work in the most obstinate way. In the case of landscapes or still life, conscientiously persevering before the subject, he nevertheless made it his own by extremely complicated detours. Starting with the darkest coloring, he covered its depth with a

Letters of Rainer Maria Rilke, 1892–1910, translated by Jane Bannard Greene and Herter Norton (W. W. Norton and Co., Inc., New York, 1946), pp. 304–308, 310–311, 313–314. Reprinted by permission of W. W. Norton and Company, and Insel-Verlag.

layer of color which he carried a little beyond that and so on and on, extending color upon color, he gradually came to another contrasting pictorial element, with which he then proceeded similarly from a new center. I think that in his case the two procedures, of the observant and sure taking over and of the appropriation and personal use of what he took over, strove against each other, perhaps as a result of becoming conscious; that they began to speak at the same time, as it were, interrupted each other continually, constantly fell out. And the old man bore their dissension, ran up and down in his studio, which had bad light because the builder didn't deem it necessary to listen to the eccentric old man, whom they had agreed not to take seriously in Aix. He walked back and forth in his studio, where the green apples lay about, or in despair seated himself in the garden and sat. And before him lay the little city, unsuspecting, with its cathedral; the city for respectable and modest citizens, while he, as his father, who was a hatmaker, had foreseen, had become different; a Bohemian, as his father saw it and as he himself believed. This father, knowing that Bohemians live and die in misery, had taken it upon himself to work for his son, had become a kind of small banker to whom ("because he was honest," as Cézanne said) people brought their money, and Cézanne owed it to his providential care that he had enough later to be able to paint in peace. Perhaps he went to the funeral of this father; his mother he loved too, but when she was buried, he was not there. He was "sur le motif," as he expressed it. Work was already so important to him then and tolerated no exception, not even that which his piety and simplicity must certainly have recommended to him.

In Paris he gradually became even better known. But for such progress as he did not make (which others made and into the bargain *how*—), he had only distrust; too clearly there remained in his memory what a misunderstood picture of his destiny and of his intent Zola (who knew him from youth and was his compatriot) had sketched of him in *Oeuvre*. Since then, he was *closed* to writing of all sorts: "travailler sans le souci de personne et devenir fort—," he screamed at a visitor. But in the midst of eating he stood up, when this person told about Frenhofer, the painter whom Balzac, with incredible foresight of coming developments, invented in his short story of the *Chef d'Oeuvre inconnu* (about which I once told you), and whom he has go down to destruction over an impossible task, through the discovery that there are actually no contours but rather many vibrating transitions—, learning this, the old man stands up from the table in spite of Madame Brémond, who certainly did not favor such irregularities, and, voiceless with excitement, keeps pointing his finger distinctly toward himself and showing himself, himself, himself, painful as that may have been. It was not Zola who understood what the point was; Balzac had sensed long ahead that, in painting, something so tremendous can suddenly present itself, which no one can handle.

But the next day he nevertheless began again with his struggle for mastery; by six o'clock every morning he got up, went through the city to his studio and stayed there until ten; then he came back by the same

way to eat, ate and was on his way again, often half an hour beyond his studio, "sur le motif" in a valley, before which the mountain of Sainte Victoire with all its thousands of tasks rose up indescribably. There he would sit then for hours, occupied with finding and taking in *plans* (of which, remarkably enough, he keeps speaking in exactly the same words as Rodin). He often reminds one of Rodin anyway in his expressions. As when he complains about how much his old city is daily being destroyed and disfigured. Only that where Rodin's great, self-confident equilibrium leads to an objective statement, fury overcomes this sick, solitary old man. Evenings on the way home he gets angry at some change, arrives in a rage and, when he notices how much the anger is exhausting him, promises himself: I will stay at home; work, nothing but work.

From such alterations for the worse in little Aix he then deduces in horror how things must be going elsewhere. Once when present conditions were under discussion, industry and the like, he broke out "with terrible eyes": Ça va mal . . . C'est effrayant, la vie!

Outside, something vaguely terrifying in process of growth; a little closer, indifference and scorn, and then suddenly this old man in his work, who no longer paints his nudes from anything but old drawings he made forty years ago in Paris, knowing that Aix would allow him no model. "At my age," he said—"I could get at best a fifty-year-old, and I know that not even such a person is to be found in Aix." So he paints from his old drawings. And lays his apples down on bedspreads that Madame Brémond certainly misses one day, and puts his wine bottles among them and whatever he happens to find. And (like Van Gogh) makes his "saints" out of things like that; and compels them, *compels* them to be beautiful, to mean the whole world and all happiness and all glory, and doesn't know whether he has brought them to doing that for him. . . .

OCTOBER 13, 1907

From the amount Cézanne gives me to do now, I notice how very different I have grown. I am on the road to becoming a worker, on a long road perhaps and probably just at the first milestone; but nevertheless I can already comprehend the old man who has gone on somewhere far ahead, alone, only with children after him who throw stones (as I once described it in the fragment on the Lonely). I went to see his pictures again today; it is remarkable what a company they form. Without looking at any single one, standing between the two rooms, one feels their presence joining in a colossal reality. As if those colors took away one's irresolution once and for all. The good conscience of those reds, of those blues, their simple truthfulness educates one; and if one places oneself among them as ready as possible, they seem to do something for one. One also notices better each time how necessary it was to go even beyond love; it is of course natural for one to love each of these things, when one makes it: but if one shows that, one makes it less well; one

judges it instead of *saying* it. One ceases to be impartial; and the best, the love, stays outside the work, does not go into it, remains unconverted beside it: that is how mood-painting arose (which is in no way better than subject-painting). One painted: I love this; instead of painting: here it is. Whereupon everyone must then look well for himself whether I have loved it. That is in no way evident, and many will even declare there is no question of love. So without residue is it consumed in the act of making. This consuming of love in anonymous work, out of which such pure things arise, no one perhaps has so fully achieved as this old man; his inner nature, which had become mistrustful and sullen, supported him in this. He would certainly never again have shown his love to any human being, if he had had to love; but with this disposition, which had been fully developed through his isolated eccentricity, he now turned to Nature too and knew how to repress his love for each single apple and to store it in a painted apple forever. Can you conceive how that is and how one experiences it through him?

OCTOBER 18, 1907

This work, which had no preferences any more, no inclinations, no fastidious indulgences; whose smallest component had been tested on the scales of an infinitely sensitive conscience and which with such integrity reduced the existent to its color content that it began, beyond color, a new existence, without earlier memories. It is this unlimited objectivity, which declines to interfere in any other sphere, that makes Cézanne's portraits so outrageous and absurd to people. They apprehend, without realizing, that he was reproducing apples, onions, and oranges with sheer color (which to them may still seem a subordinate device of pictorial practice), but when they come to landscape, they miss interpretation, judgment, superiority, and where portraiture is concerned, why, the rumor of intellectual conception has been passed on even to the most bourgeois, and so successfully that something of the kind is already noticeable even in Sunday photographs of engaged couples and families. And here Cézanne naturally seems to them quite inadequate and not worth discussing at all. He is actually as alone in this salon as he was in life, and even the painters, the young painters, already pass him by more quickly because they see the dealers on his side. . . .

OCTOBER 21, 1907

. . . But I really wanted to say further about Cézanne: that it has never before been so demonstrated to what extent painting takes place among the colors themselves, how one must leave them completely alone so that they may come to terms with each other. Their intercourse with one another: that is the whole of painting. Whoever interrupts, whoever arranges, whoever lets his human deliberation, his wit, his advocacy, his intellectual agility deal with them in any way, has already disturbed and troubled their performance. The painter (any artist whatever)

should not become conscious of his insights: without taking the way round through his mental processes, his advances, enigmatic even to himself, must enter so swiftly into the work that he is unable to recognize them at the moment of their transition. For him, alas, who watches for them, observes, delays them, for him they change like the fine gold in the fairy tale which can no longer remain gold because some detail went wrong. . . .

PART TWO / Reflections of Some Major Painters: 1908-1943

Henri Matisse

From "Notes of a Painter" (1908)

COMPOSITION: FIGURES

For me all is in the conception—I must have a clear vision of the whole composition from the very beginning. I could mention the name of a great sculptor who produces some admirable pieces but for him a composition is nothing but the grouping of fragments and the result is a confusion of expression. Look instead at one of Cézanne's pictures: all is so well arranged in them that no matter how many figures are represented and no matter at what distance you stand, you will be able always to distinguish each figure clearly and you will always know which limb belongs to which body. If in the picture there is order and clarity it means that this same order and clarity existed in the mind of the painter and that the painter was conscious of their necessity. Limbs may cross, may mingle, but still in the eyes of the beholder they will remain attached to the right body. All confusion will have disappeared.

Henri Matisse
From a Letter to Raymond Escholier,
Director of the Petit Palais (1936)

NICE, NOVEMBER 10, 1936

Yesterday I consigned to your shipper Cézanne's *Baigneuses*. I saw the picture carefully packed and it was supposed to leave that very evening for the Petit Palais.

Allow me to tell you that this picture is of the first importance in the work of Cézanne because it is a very solid, very complete realization of a composition that he carefully studied in various canvases, which, though now in important collections, are not the studies that culminated in the present work.

I have owned this canvas for thirty-seven years and I know it fairly well, I hope, though not entirely; it has sustained me spiritually in the critical moments of my career as an artist; I have drawn from it my faith and my perseverance: for this reason allow me to request that it be placed so that it may be seen to the best advantage. For this it needs both light and perspective. It is rich in color and surface and only when it is seen at a distance is it possible to appreciate the sweep of its lines and the exceptional sobriety of its relationships.

I know I do not need to tell you this but nevertheless I think it is my duty to do so; please interpret my remarks as a pardonable testimony of my admiration for this work which has grown ever greater since I first acquired it.

Let me thank you for the care you will give it for I hand it over to you with the deepest confidence. . . .

Wassily Kandinsky
From *Concerning the Spiritual
in Art* (1912)

It is interesting to note three nearly contemporary and quite different movements in painting:
1) Rossetti and his pupil Burne-Jones, with their followers;
2) Böcklin with his scion Stuck, and their school;
3) Segantini, and his worthless train of formal imitators.

I have chosen these three groups to illustrate the search for the abstract in art. Rossetti sought to revive the abstract form of the Pre-Raphaelites. Böcklin busied himself with mythological and legendary scenes but, in contrast to Rossetti, gave a strongly corporeal form to his legendary figures. Segantini, outwardly the most material of the three, selected the most ordinary objects (hills, stones, cattle, etc.), often painting them with the minutest realism, but he never failed to create a spiritual as well as a material value, so that he is really the most non-material of the trio.

These men sought for the "inner" by way of the "external."

By another road, and one more painterly, a great seeker after a new sense of form approached the same problem. Cézanne made a living thing out of a teacup, or rather, in a teacup he realized the existence of something alive. He raised still life to the point where it ceased to be inanimate.

He painted things as he painted human beings, because he was endowed with the gift of divining the internal life in everything. He achieved expressive color and a form that harmonizes this color with an almost mathematical abstraction. A man, a tree, an apple, are not *represented*, but used by Cézanne in building up a painterly thing called a "picture."

Wassily Kandinsky, "Über das Geistige in der Kunst," 1912; *Concerning the Spiritual in Art,* a version of the Sadleir translation with considerable re-translation by Francis Golffing, Michael Harrison, Ferdinand Ostertag (Wittenborn, Schultz, Inc., New York, 1944); this excerpt, p. 36. By permission of the publisher.

A. Gleizes and J. Metzinger
From "Cubism" (1912)

People have tried to make Cézanne into a sort of genius *manqué:* they say that he knew admirable things but that he stuttered instead of singing out. The truth is that he was in bad company. Cézanne is one of the greatest of those who orient history, and it is inappropriate to compare him to Van Gogh or Gauguin. He recalls Rembrandt. Like the author of the *Pilgrims of Emmaus,* disregarding idle chatter, he plumbed reality with a stubborn eye and, if he did not himself reach those regions where profound realism merges insensibly into luminous spirituality, at least he dedicated himself to whoever really wants to attain a simple, yet prodigious method.

He teaches us how to dominate universal dynamism. He reveals to us the modifications that supposedly inanimate objects impose on one another. From him we learn that to change a body's coloration is to corrupt its structure. He prophesies that the study of primordial volumes will open up unheard-of horizons. His work, an homogeneous block, stirs under our glance; it contracts, withdraws, melts, or illuminates itself, and proves beyond all doubt that painting is not—or is no longer—the art of imitating an object by means of lines and colors, but the art of giving to our instinct a plastic consciousness.

He who understands Cézanne, is close to Cubism. From now on we are justified in saying that between this school and the previous manifestations there is only a difference of intensity, and that in order to assure ourselves of the fact we need only attentively regard the process of this realism which, departing from Courbet's superficial realism, plunges with Cézanne into profound reality, growing luminous as it forces the unknowable to retreat.

A. Gleizes and J. Metzinger, *Du Cubisme,* Paris, 1912; English translation in Robert L. Herbert, *Modern Artists on Art* (Prentice-Hall, Inc., Englewood Cliffs, N.J., 1964); this excerpt, p. 4. Based on translation published in 1913 by the firm of T. Fisher Unwin. Reprinted by permission of Prentice-Hall, Inc. and Ernest Benn Ltd., successors to T. Fisher Unwin.

Roger Allard
From "The Signs of Renewal
in Painting" (1912)

Cézanne's art is the arsenal from which modern painting drew weapons for the primary struggle to drive naturalism, false literature and pseudo-classicism from the field.

"Die Kennzeichen der Erneuerung in der Malerei," *Der Blaue Reiter*, Munich, 1912, (2nd edition, 1914), p. 35. Translation in Edward Fry, *Cubism* (McGraw-Hill Book Company, New York, Toronto, 1966); this excerpt, p. 70. By permission of the publisher.

Fernand Léger
From "The Origins of Painting and
Its Representational Value" (1913)

Visual realism, as I have said, necessarily involves an object, a subject, and perspective devices that are now considered negative and anti-realist.

Realism of conception, neglecting all this cumbersome baggage, has been achieved in many contemporary paintings.

Among the impressionists one painter, Cézanne, fully understood what was incomplete about impressionism. He felt the necessity of renewing *form* and *design* to match the new *colour* of the impressionists. His life and his work were devoted to the quest for this new synthesis. . . .

Fernand Léger, "Les Origines de la Peinture et sa Valeur représentative," *Montjoie!*, no. 8, Paris, May 29, 1913, p. 7; Edward Fry, *Cubism* (McGraw-Hill Book Company, New York, Toronto, 1966); this excerpt, p. 123. By permission of the publisher.

Fernand Léger
From "Contemporary Achievements
in Painting" (1914)

In many pictures of Cézanne's one can see—barely hinted at—this restless sensitivity to plastic contrasts. Unfortunately . . . the thoroughly impressionist circle he belonged to, and his whole period, which was less condensed and less fragmented than ours, could not lead him as far as the concept of multiple contrast; he felt it, but he did not understand it. All his pictures are painted in the presence of a subject, and in those landscapes of his, with the houses jammed awkwardly among the trees, he had sensed that the truth lay there. He did not manage to formulate it and create the concept. . . .

 Cézanne, through his sensitivity to contrasts of form, was the only one of the impressionists to lay his finger on the deeper nature of the plastic contrasts inherent in a work of art.

Fernand Léger, "Les Réalisations picturales actuelles," *Soirées de Paris,* June 15, 1914, pp. 349–354 (a lecture given at the Academie Wassilieff). Translated in Edward Fry, *Cubism* (McGraw-Hill Book Company, New York, Toronto, 1966), pp. 138–139. By permission of the publisher.

Juan Gris
Statement (1921)

I consider the architectural element in painting is mathematics, the abstract side; I want to humanize it. Cézanne turns a bottle into a cylinder, but I begin with a cylinder and create an individual of a special type: I made a bottle—a particular bottle—out of a cylinder. Cézanne tends

Juan Gris, *L'Esprit nouveau,* no. 5, Paris, February, 1921. English translation by Douglas Cooper in D. H. Kahnweiler, *Juan Gris His Life and Work* (Thames and Hudson, London, 1969); this excerpt p. 193. By permission of the publisher.

towards architecture. I tend away from it. That is why I compose with abstractions (colors) and made my adjustments when these colors have assumed the form of objects.

Picasso
Statement

The main thing about modern painting is this. A painter like Tintoretto, for example, begins work on a canvas, and afterward he goes on and, finally, when he has filled it and worked it all over, then only is it finished. Now, if you take a painting by Cézanne (and this is even more clearly visible in the watercolors), the moment he begins to place a stroke of paint on it, the painting is already there.

Hélène Parmelin, *Picasso: The Artist and His Model, and Other Recent Works* (Harry N. Abrams, Inc., New York, 1965); this excerpt, p. 150. By permission of the publisher.

Picasso
Statement

One doesn't pay enough attention. If Cézanne is Cézanne, it's precisely because of that: when he is before a tree he looks attentively at what he has before his eyes; he looks at it fixedly, like a hunter lining up the animal he wants to kill. If he has a leaf, he doesn't let go. Having the leaf, he has the branch. And the tree won't escape him. Even if he only had the leaf it is already something. A picture is often nothing but that. . . . One must give it all one's attention. . . . Ah, if only everyone were capable of it!

Jaime Sabartes, *Picasso, documents iconographiques* (Cailler, Geneva, 1954), p. 72. Translation from Dore Ashton, *Picasso on Art* (The Viking Press, Inc., New York, 1972); this excerpt, p. 161. By permission of the publisher.

Picasso
Statement

Furthermore, it is the realization alone that counts. From this point of view it is true that cubism is Spanish in origin and that it was I who invented cubism. We should look for Spanish influence in Cézanne. He was well on the way; observe El Greco's influence on him, a Venetian painter. But he is cubist in his construction.

Dor de la Souchère, *Picasso in Antibes* (Lund Humphries, London, 1960), pp. 14–15. By permission of the publisher.

Picasso
Statement (1935)

It's not what the artist *does* that counts, but what he *is*. Cézanne would never have interested me a bit if he had lived and thought like Jacques Émile Blanche, even if the apple he painted had been ten times as beautiful. What forces our interest is Cézanne's anxiety—that's Cézanne's lesson; the torments of Van Gogh—that is the actual drama of the man. The rest is a sham.

From "Statement by Picasso: 1935," in *Picasso: Fifty Years of His Art,* by Alfred H. Barr, Jr. Translation based on one by Myfarwy Evans, copyright 1946 by The Museum of Modern Art, New York. All rights reserved. Reprinted by permission of The Museum of Modern Art.

Picasso
Statement (1943)

"He had no gift, no skill at all for imitation. Every time he tried to copy other arists, it was a Cézanne he painted. You can wrap up your 'family Cézanne.' . . ."

Even after the young man has left, Picasso is still grumbling: "As if I didn't know Cézanne! He was my one and only master! Don't you think I looked at his pictures? I spent years studying them. . . . Cézanne! It was the same with all of us—he was like our father. It was he who protected us. . . ."

Gyula H. Brassaï, *Picasso and Co.* (Doubleday and Company, Inc., New York, 1966); this excerpt, p. 79. By permission of the publisher.

FROM *PAUL CÉZANNE* (1910)

Julius Meier-Graefe

We must give in a few words a pointer to the most important obstacle in the way of an all too simple conception of Cézanne's style and of the most important property of his ornamentation in every period: the three-dimensional power of this Baroque. The content of profundity of every picture opposes all premature conclusions. We are accustomed to ornament in only one dimension, in the surface, and this limitation of its magic is the father of most of our troubles. Cézanne's masses, ragged and tattered as they may be, go back into space uncannily and somehow make secure a third dimension, the volume, which not only the craftsmen of our day, but also modern masters of painting who are rich in tangible vitality, renounce compulsorily to a very far-reaching extent. Cézanne's masses secure this volume without any nonsense, without any petty modelling, without any inhibition of his confession, and they enable this ideated space to be the bearer, if not of men and things which are familiar to us and thus of a ghostly life, but at any rate of extraordinarily probable existence.

Nature apparently does not exist for this man to be reproduced by a rendering of its matter, and art is not of value to him because it provides pictorial equivalents for flesh and hair; all that lies behind him. He would like to give a rendering of himself, when he sees something which moves him: motion.

Julius Meier-Graefe, *Paul Cézanne* (Munich, 1910), translated by J. Holroyd-Reece (Scribner and Sons, New York, 1927); this excerpt, p. 28. By permission of the publisher. Meier-Graefe's earlier publication on Cézanne, which reflects the same outlook, appeared in 1904 in *Entwicklungsgeschichte* and in *Cézanne und sein Kreis*, 1918.

FROM "THE DEBT TO CÉZANNE" (1914)

Clive Bell

Cézanne is the Christopher Columbus of a new continent of form. . . .

At Aix-en-Provence came to him a revelation that has set a gulf between the nineteenth century and the twentieth: for, gazing at the familiar landscape, Cézanne came to understand it, not as a mode of light, nor yet as a player in the game of human life, but as an end in itself and an object of intense emotion. Every great artist has seen landscape as an end in itself—as pure form, that is to say; Cézanne has made a generation of artists feel that compared with its significance as an end in itself all else about a landscape is negligible. From that time forward Cézanne set himself to create forms that would express the emotion that he felt for what he had learnt to see. Science became as irrelevant as subject. Everything can be seen as pure form, and behind pure form lurks the mysterious significance that thrills to ecstasy. The rest of Cézanne's life is a continuous effort to capture and express the significance of form. . . .

It was in what he saw that he discovered a sublime architecture haunted by that Universal which informs every Particular. He pushed further and further towards a complete revelation of the significance of form, but he needed something concrete as a point of departure. It was because Cézanne could come at reality only through what he saw that he never invented purely abstract forms. Few great artists have depended more on the model. Every picture carried him a little further towards his goal—complete expression; and because it was not the making of pictures but the expression of his sense of the significance of form that he cared about, he lost interest in his work so soon as he had made it express as much as he had grasped. His own pictures were for Cézanne nothing but rungs in a ladder at the top of which would be complete expression. The whole of his later life was a climbing towards an ideal. For him every picture was a means, a step, a stick, a hold, a stepping-

Clive Bell, *Art* (Chatto & Windus, Ltd., London, 1914, and G. P. Putnam Sons, New York, 1958); these excerpts, pp. 139–142. By permission of Quentin Bell, Chatto & Windus, G. P. Putnam.

stone—something he was ready to discard as soon as it had served his purpose. He had no use for his own pictures. To him they were experiments. He tossed them into bushes, or left them in the open fields to be stumbling-blocks for a future race of luckless critics.

Cézanne is a type of the perfect artist; he is the perfect antithesis of the professional picture-maker, or poem-maker, or music-maker. He created forms because only by so doing could he accomplish the end of his existence—the expression of his sense of the significance of form. When we are talking about aesthetics, very properly we brush all this aside, and consider only the object and its emotional effect on us; but when we are trying to explain the emotional effectiveness of pictures we turn naturally to the minds of the men who made them, and find in the story of Cézanne an inexhaustible spring of suggestion. His life was a constant effort to create forms that would express what he felt in the moment of inspiration. The notion of uninspired art, of a formula for making pictures, would have appeared to him preposterous. The real business of his life was not to make pictures, but to work out his own salvation. Fortunately for us he could only do this by painting. Any two pictures by Cézanne are bound to differ profoundly. He never dreamed of repeating himself. He could not stand still. That is why a whole generation of otherwise dissimilar artists have drawn inspiration from his work. That is why it implies no disparagement of any living artist when I say that the prime characteristic of the new movement is its derivation from Cézanne.

FROM CÉZANNE: A STUDY OF HIS DEVELOPMENT (1927)

Roger Fry

For [Cézanne], as I understand his work, the ultimate synthesis of a design was never revealed in a flash; rather he approached it with infinite precautions, stalking it, as it were, now from one point of view, now from another, and always in fear lest a premature definition might deprive it of something of its total complexity. For him the synthesis was an asymptote towards which he was for ever approaching without ever quite reaching it; it was a reality, incapable of complete realization.

. . . It is in his colour that we must look, perhaps, for the most fundamental quality and the primary inspiration of his plastic creation. His colour is the one quality in Cézanne which remains supremely great under all conditions. This picture [*The Banquet*] is perhaps one of the earliest in which Cézanne seems to have anticipated what was destined to be one of his greatest contributions to art; namely, his conception of colour not as an adjunct to form, as something imposed upon form, but as itself the direct exponent of form. . . .

But in all these efforts to rival the triumphant constructions of the Baroque, Cézanne was betrayed, even more than by his defective apparatus, by his instinctive, though as yet unconscious, bias towards severe architectural disposition and an almost hieratic austerity of line.

. . . Not that Cézanne ever doubted the authenticity, even the supremacy of his genius; but he had learned, what was repugnant to his youthful exuberance, that his was a genius that could only attain its true development through the complete suppression of his subjective impulses, and that, slow to arrive at expression, it would be even slower to gain access to the minds of his fellow men. . . .

We find him beginning at last [about 1870] to take advantage of his real gift, the extraordinary sensibility of his reaction to actual vision

Roger Fry, *Cézanne: A Study of His Development* (The Macmillan Company, New York, 1927): these excerpts, pp. 3, 13, 26, 30–31, 35, 39, 41, 42, 43, 48, 49, 51, 53, 58, 68, 69, 78, 82, 87, 88. Copyright 1927 by The Hogarth Press, Ltd. By permission of Mrs. Pamela Diamand, The Hogarth Press, Macmillan Publishing Co., Inc.

of no matter what phenomenon. We are at the beginning of the period of his great still-life pieces. . . .

It is true that the inner vision and the ambition to create *a priori* constructions corresponding to the demands of his subjective imaginative life never ceased to haunt him, but from this moment the "motive," the idea accepted from the visible world, claimed an ever greater proportion of his indefatigable energy. . . .

The revelation of Impressionism was decisive and complete. Cézanne never went back on it. But it was not sufficient. He might follow Pissarro for one or two summers, but not longer. There was too much fervour in Cézanne's nature for him to be satisfied with what the strict Impressionist doctrine could give. He had too many things to bring out of his imagination, things of which Impressionism was innocent. He readily admitted that it was worth while thus to analyse patiently and completely the weft of colour sensations which nature spreads for the practised eye, but his imagination went beyond and behind that, towards profounder and less evident realities. He saw always, however dimly, behind this veil an architecture and a logic which appealed to his most intimate feelings. Reality, no doubt, lay always behind this veil of colour, but it was different, more solid, more dense, in closer relation to the needs of the spirit.

. . . He gave himself up entirely to this desperate search for the reality hidden beneath the veil of appearance, this reality which he had to draw forth and render apparent. And it is precisely this which gives to all his utterances in form their tremendous, almost prophetic, significance. . . .

It is noteworthy that he is distinguished among artists of the highest rank by the fact that he devoted so large a part of his time to this class of picture, that he achieved in still-life the expression of the most exalted feelings and the deepest intuitions of his nature. Rembrandt alone, and that only in the rarest examples, or in accessories, can be compared to him in this respect. For one cannot deny that Cézanne gave a new character to his still-lifes. . . .

[Still-life . . .] guards the picture itself from the misconstructions of those whose contact with art is confined to its effect as representation. In still-life the ideas and emotions associated with the objects represented are, for the most part, so utterly commonplace and insignificant that neither artist nor spectator need consider them. . . .

If the words tragic, menacing, noble or lyrical seem out of place before Cézanne's still-lifes, one feels none the less that the emotions they arouse are curiously analogous to these states of mind. It is not from lack of emotion that these pictures are not dramatic, lyric, etc., but rather by reason of a process of elimination and concentration. They are, so to speak, dramas deprived of all dramatic incident. . . .

We may take as typical of this series and as one of the most completely achieved, the celebrated still-life of the *Compotier* [Figure 7]. Instead of those brave swashing strokes of the brush or palette knife,

we find him here proceeding by the accumulation of small touches of a full brush. These small touches had become a necessity from the moment he undertook the careful analysis of coloured surfaces. To the immediate and preconceived synthesis which in the past he had imposed upon appearances, there now succeeds a long research for an ultimate synthesis which unveils itself little by little from the contemplation of the things seen. Not that he fumbles: each touch is laid with deliberate frankness, as a challenge to nature, as it were, and, from time to time, he confirms the conviction which he has won by a fierce accent, an almost brutal contour, which as often as not he will overlay later on, under stress of fresh discoveries and yet again reaffirm. These successive attacks on the final position leave their traces in the substance of the pigment, which becomes of an extreme richness and density. The paste under his hands grows to the quality of a sort of lacquer, saturated with colour and of an almost vitreous hardness.

So perfect a correspondence of material quality to the idea as this picture shows is by no means of common occurrence in art. . . .

One notes how few the forms are. How the sphere is repeated again and again in varied quantities. To this is added the rounded oblong shapes which are repeated in two very distinct quantities in the *Compotier* and the glass. If we add the continually repeated right lines and the frequently repeated but identical forms of the leaves on the wallpaper, we have exhausted this short catalogue. The variation of quantities of these forms is arranged to give points of clear predominance in the *Compotier* itself to the left, and the larger apples to the right centre. One divines, in fact, that the forms are held together by some strict harmonic principle almost like that of the canon in Greek architecture, and that it is this that gives its extraordinary repose and equilibrium to the whole design.

It is easy to see that with so strong a feeling for volumes and masses, with the desire to state them in shapes of the utmost precision, the contours of objects became almost an obsession to Cézanne. It is evident that for a painter who is mainly occupied in relations of planes those planes which are presented to the eye at a sharp angle, that is to say in strong foreshortening, are the cause of a certain anxiety. The last of this series of planes forms the contour, and is a plane reduced to a line. This poses a terrible question—the plane which has no extension on the surface of the canvas has yet to suggest its full extension in the picture-space. It is upon that that the complete recession, the rotundity and volume of the form depends. The very fact that this edge of the object often appears with exceptional clearness complicates matters by bringing the eye back, as it were, to the surface of the canvas.

For the decorative painter whose main object is the organization of his design upon the surface, this is no difficulty, rather an advantage; but for painters to whom the plastic construction is all-important it becomes serious. For them, the contour becomes at once a fascination and a dread. One can see this for Cézanne in his drawings. He almost always repeats the contour with several parallel strokes as though to avoid any

one too definite and arresting statement, to suggest that at this point there is a sequence of more and more foreshortened planes. . . .

It is this infinitely changing quality of the very stuff of the painting which communicates so vivid a sense of life. In spite of the austerity of the forms, all is vibration and movement. Nothing is less schematic than these works, even when, as here, the general forms have an almost geometrical appearance.

I hope this tiresome analysis of a single picture may be pardoned on the ground that, if one would understand an artist, one must sooner or later come to grips with the actual material of his paintings, since it is there, and nowhere else, that he leaves the precise imprint of his spirit. . . .

One notes at all events how constantly spherical forms absorb his attention. There is a whole series of still-lifes—most of which are little known—devoted to studies of skulls, sometimes a single skull, sometimes three or four together. It is needless to say that for Cézanne at this period a skull was merely a complicated variation upon the sphere. By this time he had definitely abjured all suggestion of poetical or dramatic allusion; he had arrived at what was to be his most characteristic conception, namely, that the deepest emotions could only exude, like a perfume—it is his own image—from form considered in its pure essence and without reference to associated ideas. And not only do the still-lifes give us the clearest insight into his methods of interpreting form, they also help us to grasp those principles of composition which are characteristic of his work henceforth. . . .

We may describe the process by which . . . a picture is arrived at in some such way as this:—the actual objects presented to the artist's vision are first deprived of all those specific characters by which we ordinarily apprehend their concrete existence—they are reduced to pure elements of space and volume. In this abstract world these elements are perfectly co-ordinated and organized by the artist's sensual intelligence, they attain logical consistency. These abstractions are then brought back into the concrete world of real things, not by giving them back their specific peculiarities, but by expressing them in an incessantly varying and shifting texture. They retain their abstract intelligibility, their amenity to the human mind, and regain that reality of actual things which is absent from all abstractions. . . .

The *Portrait of Mme. Cézanne* dates from the end of the 'eighties. . . . The transposition of all the data of nature into values of plastic colour is here complete. The result is as far from the scene it describes as music. There is no inducement to the mind to retrace the steps the artist has taken and to reconstruct from his image the actual woman posing in her salon. We remain too completely held in the enchantment of this deep harmony. Though all comes by the interpretation of actual visual sensations, though the desire to remain absolutely loyal to them was an obsession with Cézanne, the word realism seems as impertinent as idealism would be in reference to such a creation. It belongs to a world of spiritual values incommensurate but parallel with the actual world.

It is an example of what Jules Renard calls *La vérité créatrice d'illu-sions*. . . .

[The] figures [in the *Cardplayers*] [Fig. 15] have indeed the gravity, the reserve and the weighty solemnity of some monument of antiquity. This little café becomes for us, in Cézanne's transmutation, an epic scene in which gestures and events take on a Homeric ease and amplitude.

If, by reason of the helplessness of language, one is forced to search for poetical analogies even to adumbrate at all the emotional effect of this design it is none the less evident that this results from a purely plastic expression. There is here no appeal to any poetical associations of ideas or sentiments. It is a triumph of that pictorial probity which it is the glory of modern art in France to have asserted—its refusal of the assistance which romantic interpretations offer. And the reward of this difficult attempt is seen here, for Cézanne's purely plastic expression reaches to depths of the imaginative life to which consciously poetical painting has scarcely ever attained. What a fortunate fatality it was that barred for Cézanne that ambition which gave rise to his *Lazarus* and *Autopsy* and the other, too deliberately expressive, conceptions of his early years. . .

Once more, at this moment of recrudescent romantic emotion Cézanne was haunted by his old dream of the *a priori* creation of a design which should directly embody the emotions of his inner life. This desire took the form of a vast design of naked women seen under a canopy of foliage. There are several canvases, some of colossal size, devoted to his repeated essays in this direction. [Fig. 21] . . .

Those of us who love Cézanne to the point of infatuation find, no doubt, our profit even in these efforts of the aged artist; but good sense must prevent us from trying to impose them on the world at large, as we feel we have the right to do with regard to the masterpieces of portraiture and landscape. . . .

But the persistence of such emotions throughout his life, their increasing attraction towards its close, throw an interesting light on the character of his genius. Cézanne counts pre-eminently as a great classic master. We may almost sum him up as the leader of the modern return to Mediterranean conception of art—his saying that he wished to "do Poussin again after nature" is no empty boast. Cézanne then was a Classic artist, but perhaps all great Classics are made by the repression of a Romantic. In this respect we find a curious parallel to Cézanne in Flaubert. . . .

In this essay I have tried to press as far as I could the analysis of some typical works of Cézanne. But it must always be kept in mind that such analysis halts before the ultimate concrete reality of the work of art, and perhaps in proportion to the greatness of the work it must leave untouched a greater part of its objective. For Cézanne, this inadequacy is particularly sensible and in the last resort we cannot in the least explain why the smallest product of his hand arouses the impression of being a revelation of the highest importance, or what exactly it is that gives it its grave authority.

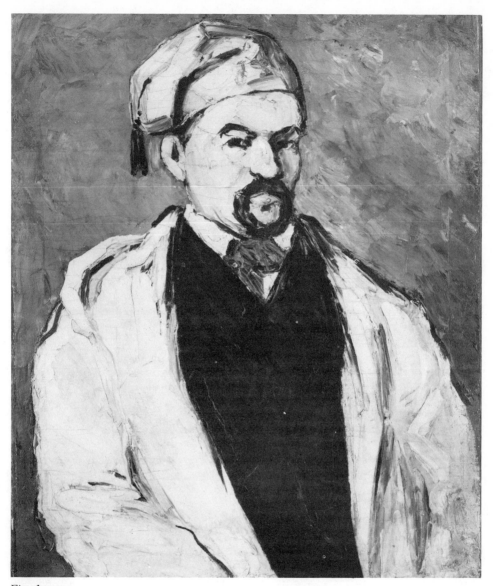

Fig. 1
CÉZANNE:
Man in a Blue Cap (Uncle Dominic). 1865–1867.
(The Metropolitan Museum of Art; Wolf Fund, 1951;
from The Museum of Modern Art, New York; Lillie P. Bliss Collection.)

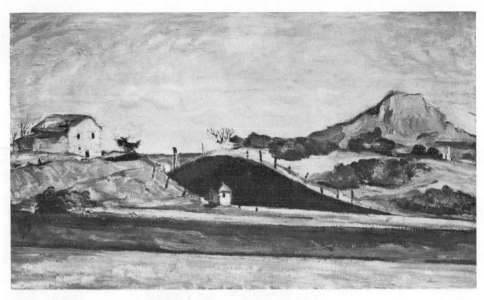

Fig. 2
CÉZANNE:
The Railway Cutting. 1870.
(Bayerische Staatsgemäldesammlungen, Munich.)

Fig. 3
CÉZANNE:
Modern Olympia. c. 1872.
(The Louvre, Paris; Photo, National Museum, Paris.)

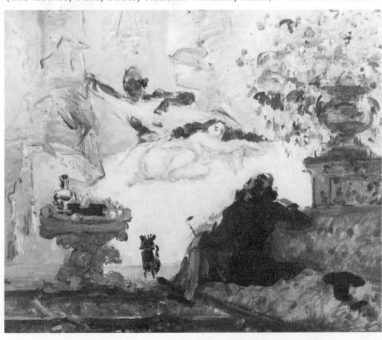

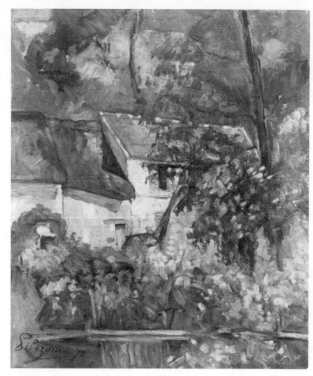

Fig. 4
CÉZANNE:
House of Père Lacroix. 1873. (National Gallery of Art,
Washington, D.C.; Chester Dale Collection.)

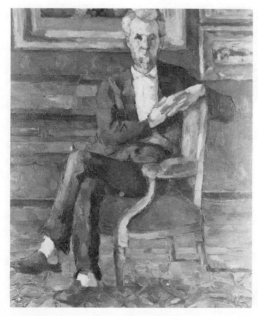

Fig. 5
CÉZANNE:
Portrait of Victor Chocquet. c.
1877. (The Columbus Gallery of
Fine Arts, Columbus, Ohio.)

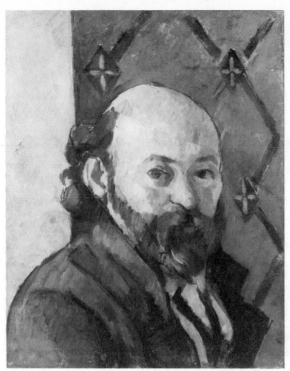

Fig. 6
CÉZANNE:
Self-Portrait. 1879–1882. (The
National Gallery of Art, London.)

Fig. 7
CÉZANNE:
Still Life with Compotier. 1879–1882.
(Mr. and Mrs. René Lecomte, Paris.
Photo, National Museum, Paris.)

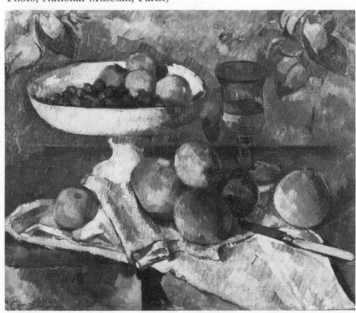

Fig. 8
CÉZANNE:
The Bather. c. 1885. (The Museum
of Modern Art, New York; Lillie
P. Bliss Collection.)

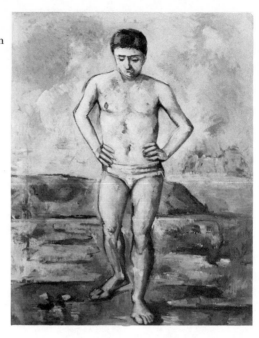

Fig. 9
CÉZANNE:
Bathers. 1890–1900 (Color lithograph). William Rockhill Nelson Gallery of Art,
Kansas City, Missouri; Bequest of Miss Frances Logan.)

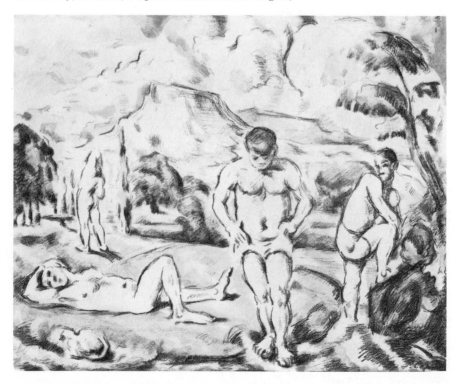

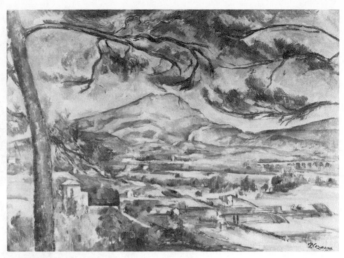

Fig. 10
CÉZANNE:
Montagne Sainte-Victoire. 1885–1887.
(Courtauld Institute Galleries, London.)

Fig. 11
CÉZANNE:
Mme. Cézanne in the Conservatory. c. 1890.
(The Metropolitan Museum of Art, New York;
Bequest of Stephen C. Clark, 1960.)

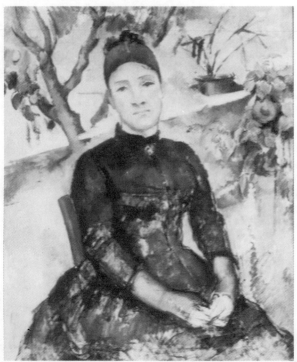

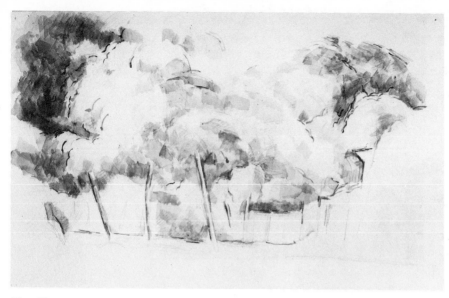

Fig. 12
CÉZANNE:
Trees and Houses (Watercolor). c. 1890.
(Museum Boymans-van Beuningen, Rotterdam.)

Fig. 13
CÉZANNE:
Ginger Pot with Pomegranate and Pears. 1890–1893.
(The Phillips Collection, Washington, D.C.)

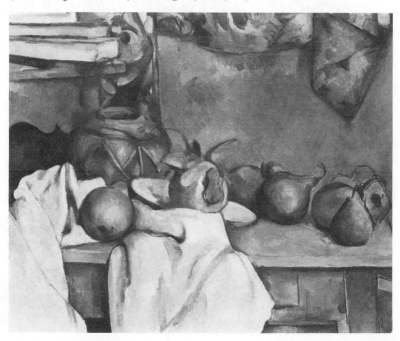

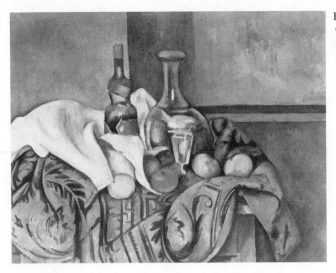

Fig. 14
CÉZANNE:
*Still Life with Peppermint
Bottle.* 1890–1894.
(National Gallery of Art,
Washington, D.C.;
Chester Dale Collection.)

Fig. 15
CÉZANNE:
The Card Players. 1890–1892. (The Louvre, Paris;
Photo, National Museum, Paris.)

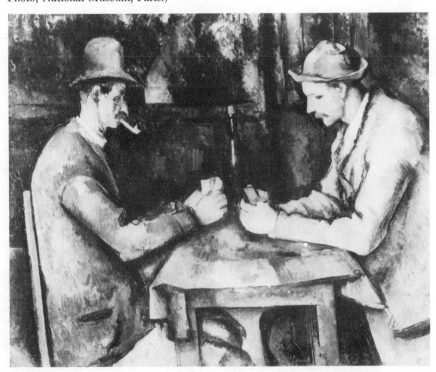

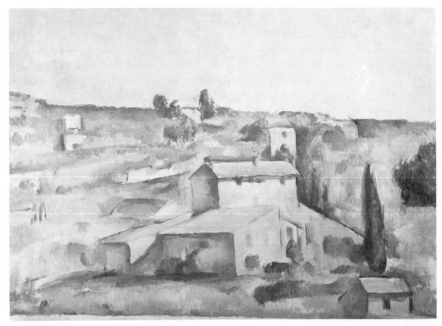

Fig. 16
CÉZANNE:
Farmhouses near Bellevue. 1892–1895.
(The Phillips Collection, Washington, D.C.)

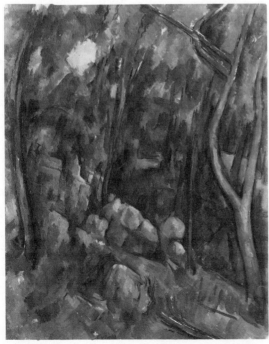

Fig. 17
CÉZANNE:
In the Park of the Chateau Noir.
1900. (The National Gallery
of Art, London.)

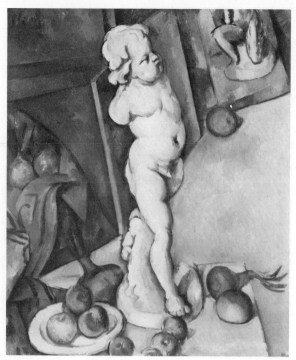

Fig. 18
CÉZANNE:
Still Life with Plaster Cupid. 1895.
(Courtauld Institute Galleries,
London.)

Fig. 19
CÉZANNE:
Still Life: Apples, Bottle and Chair back (Watercolor). 1902–1906.
(Courtauld Institute Galleries, London.)

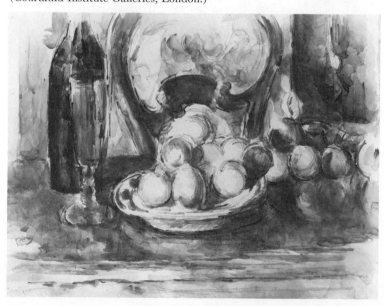

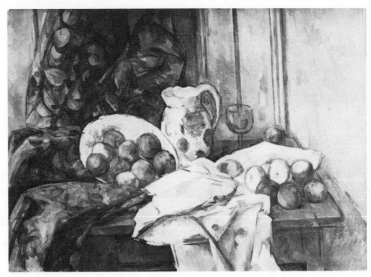

Fig. 20
CÉZANNE:
Still Life with Pot. 1900–1906.
(Oskar Reinhart Collection, Winterthur.)

Fig. 21
CÉZANNE:
The Large Bathers. 1898–1905.
(Philadelphia Museum of Art; The W. P. Wilstach Collection.)

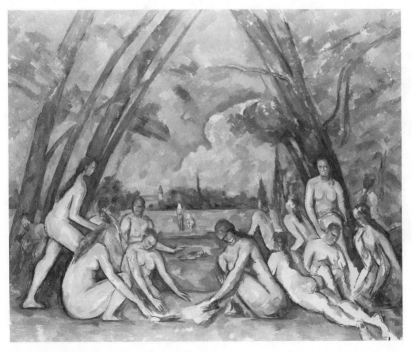

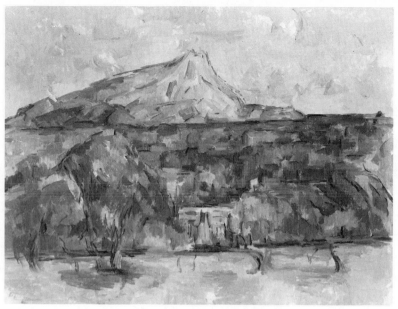

Fig. 22
CÉZANNE:
Montagne Saint-Victoire. 1904–1906.
(William Rockhill Nelson Gallery of Art, Kansas City, Missouri.)

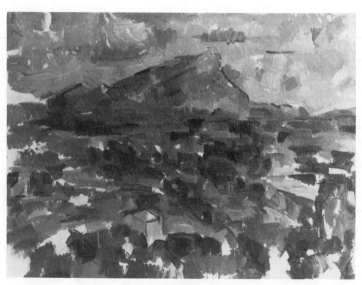

Fig. 23
CÉZANNE:
Montagne Saint-Victoire. 1904–1906.
(Kunsthaus, Zürich.)

FROM "INTRODUCTION TO THESE PAINTINGS" (1929)

D. H. Lawrence

The actual fact is that in Cézanne modern French art made its first tiny step back to real substance, to objective substance, if we may call it so. Van Gogh's earth was still subjective earth, himself projected into the earth. But Cézanne's apples are a real attempt to let the apple exist in its own separate entity, without transfusing it with personal emotion. Cézanne's great effort was, as it were, to shove the apple away from him, and let it live of itself. It seems a small thing to do: yet it is the first real sign that man has made for several thousands of years that he is willing to admit that matter *actually* exists. . . .

Cézanne felt it in paint, when he felt for the apple. Suddenly he felt the tyranny of mind, the white, worn-out arrogance of the spirit, the mental consciousness, the enclosed ego in its sky-blue heaven self-painted. He felt the sky-blue prison. And a great conflict started inside him. He was dominated by his old mental consciousness, but he wanted terribly to escape the domination. . . .

If he wanted to paint people intuitively and instinctively, he couldn't do it. His mental concepts shoved in front, and these he *wouldn't* paint—mere representations of what the *mind* accepts, not what the intuitions gather—and they, his mental concepts, wouldn't let him paint from intuition; they shoved in between all the time, so he painted his conflict and his failure, and the result is almost ridiculous.

Woman he was not allowed to know by intuition; his mental self, his ego, that bloodless fiend, forbade him. Man, other men, he was likewise not allowed to know—except by a few, few touches. The earth likewise he was not allowed to know: his landscapes are mostly acts of rebellion against the mental concept of landscape. After a fight tooth-and-

D. H. Lawrence, "Introduction to These Paintings," *The Paintings of D. H. Lawrence,* (London, 1929). Reprinted in *Phoenix I: The Posthumous Papers of D. H. Lawrence,* edited by Edward D. McDonald, Viking Press (New York, 1972), copyright 1937 by Frieda Lawrence; copyright renewed 1964 by the Estate of Frieda Lawrence Ravagli; these excerpts, pp. 567–571, 575–582. Reprinted by permission of the Estate of the late Mrs. Frieda Lawrence, Laurence Pollinger Ltd., and The Viking Press, Inc.

nail for forty years, he did suceed in knowing an apple, fully; and, not quite as fully, a jug or two. That was all he achieved.

It seems little, and he died embittered. But it is the first step that counts, and Cézanne's apple is a great deal, more than Plato's Idea. Cézanne's apple rolled the stone from the mouth of the tomb, and if poor Cézanne couldn't unwind himself from his cerements and mental winding-sheet, but had to lie still in the tomb, till he died, still he gave us a chance.

. . . Our instincts and intuitions are dead, we live wound round with the winding-sheet of abstraction. And the touch of anything solid hurts us. . . .

So that Cézanne's apple hurts. It made people shout with pain. And it was not till his followers had turned him again into an abstraction that he was ever accepted. Then the critics stepped forth and abstracted his good apple into Significant Form, and henceforth Cézanne was saved. Saved for democracy. Put safely in the tomb again, and the stone rolled back. The resurrection was postponed once more. . . .

The most interesting figure in modern art, and the only really interesting figure, is Cézanne: and that, not so much because of his achievement as because of his struggle. . . .

Cézanne was naïve to a degree, but not a fool. He was rather insignificant, and grandeur impressed him terribly. Yet still stronger in him was the little flame of life where he *felt* things to be true. He didn't betray himself in order to get success, because he couldn't: to his nature it was impossible: he was too pure to be able to betray his own small real flame for immediate rewards. Perhaps that is the best one can say of a man, and it puts Cézanne, small and insignificant as he is, among the heroes. He would *not* abandon his own vital imagination.

. . . I find scientists, just like artists, asserting things they are *mentally* sure of, in fact cocksure, but about which they are much too egoistic and ranting to be *intuitively, instinctively* sure. When I find a man, or a woman, intuitively and instinctively sure of anything, I am all respect. But for scientific or artistic braggarts how can one have respect? The intrusion of the egoistic element is a sure proof of intuitive uncertainty. No man who is sure by instinct and intuition *brags*, though he may fight tooth and nail for his beliefs.

Which brings us back to Cézanne, why he couldn't draw, and why he couldn't paint baroque masterpieces. It is just because he was real, and could only believe in his own expression when it expressed a moment of wholeness or completeness of consciousness in himself. He could not prostitute one part of himself to the other. He *could* not masturbate, in paint or words. And that is saying a very great deal, today; today, the great day of the masturbating consciousness, when the mind prostitutes the sensitive responsive body, and just forces the reactions. The masturbating consciousness produces all kinds of novelties, which thrill for the moment, then go very dead. It cannot produce a single genuinely new utterance.

What we have to thank Cézanne for is not his humility, but for his

proud, high spirit that refused to accept the glib utterances of his facile mental self. He wasn't poor-spirited enough to be facile—nor humble enough to be satisfied with visual and emotional clichés. Thrilling as the baroque masters were to him in themselves, he realized that as soon as he reproduced them he produced nothing but cliché. . . .

Cézanne's early history as a painter is a history of his fight with his own cliché. His consciousness wanted a new realization. And his ready-made mind offered him all the time a ready-made expression. And Cézanne, far too inwardly proud and haughty to accept the ready-made clichés that came from his mental consciousness, stocked with memories, and which appeared mocking at him on his canvas, spent most of his time smashing his own forms to bits. To a true artist, and to the living imagination, the cliché is the deadly enemy. Cézanne had a bitter fight with it. He hammered it to pieces a thousand times. And still it reappeared.

Now again we can see why Cézanne's drawing was so bad. It was bad because it represented a smashed, mauled cliché, terribly knocked about. If Cézanne had been willing to accept his own baroque cliché, his drawing would have been perfectly conventionally "all right," and not a critic would have had a word to say about it. But when his drawing was conventionally all right, to Cézanne himself it was mockingly all wrong. It was cliché. So he flew at it and knocked all the shape and stuffing out of it, and when it was so mauled that it was all wrong, and he was exhausted with it, he let it go; bitterly, because it still was not what he wanted. And here comes in the comic element in Cézanne's pictures. His rage with the cliché made him distort the cliché sometimes into parody, as we see in pictures like *The Pasha* and *La Femme*. "You *will* be cliché, will you?" he gnashes. "Then *be* it!" And he shoves it in a frenzy of exasperation over into parody. And the sheer exasperation makes the parody still funny; but the laugh is a little on the wrong side of the face.

This smashing of the cliché lasted a long way into Cézanne's life; indeed, it went with him to the end. The way he worked over and over his forms was his nervous manner of laying the ghost of his cliché, burying it. Then when it disappeared perhaps from his forms themselves, it lingered in his composition, and he had to fight with the edges of his forms and contours, to bury the ghost there. Only his colour he knew was not cliché. He left it to his disciples to make it so.

In his very best pictures, the best of the still-life compositions, which seem to me Cézanne's greatest achievement, the fight with the cliché is still going on. But it was in the still-life pictures he learned his final method of *avoiding* the cliché: just leaving gaps through which it fell into nothingness. So he makes his landscape succeed.

In his art, all his life long, Cézanne was tangled in a twofold activity. He wanted to express something, and before he could do it he had to fight the hydra-headed cliché, whose last head he could never lop off. The fight with the cliché is the most obvious thing in his pictures. The dust of battle rises thick, and the splinters fly wildly. And it is this

dust of battle and flying of splinters which his imitators still so fervently imitate. If you give a Chinese dressmaker a dress to copy, and the dress happens to have a darned rent in it, the dressmaker carefully tears a rent in the new dress, and darns it in exact replica. And this seems to be the chief occupation of Cézanne's disciples, in every land. They absorb themselves reproducing imitation mistakes. He let off various explosions in order to blow up the stronghold of the cliché, and his followers make grand firework imitations of the explosions, without the faintest inkling of the true attack. They do, indeed, make an onslaught on representation, true-to-life representation: because the explosion in Cézanne's pictures blew them up. But I am convinced that what Cézanne himself wanted *was* representation. He *wanted* true-to-life representation. Only he wanted it *more* true to life. And once you have got photography, it is a very, very difficult thing to get representation *more* true-to-life: which it has to be.

Cézanne was a realist, and he wanted to be true to life. But he would not be content with the optical cliché. With the impressionists, purely optical vision perfected itself and fell *at once* into cliché, with a startling rapidity. Cézanne saw this. Artists like Courbet and Daumier were not purely optical, but the other element in these two painters, the intellectual element, was cliché. To the optical vision they added the concept of force-pressure, almost like an hydraulic brake, and this force-pressure concept is mechanical, a cliché, though still popular. And Daumier added mental satire, and Courbet added a touch of a sort of socialism: both cliché and unimaginative.

Cézanne wanted something that was neither optical nor mechanical nor intellectual. And to introduce into our world of vision something which is neither optical nor mechanical nor intellectual-psychological requires a real revolution. It was a revolution Cézanne began, but which nobody, apparently, has been able to carry on.

He wanted to touch the world of substance once more with the intuitive touch, to be aware of it with the intuitive awareness, and to express it in intuitive terms. That is, he wished to displace our present mode of mental-visual consciousness, the consciousness of mental concepts, and substitute a mode of consciousness that was predominantly intuitive, the awareness of touch. In the past the primitives painted intuitively, but *in the direction* of our present mental-visual, conceptual form of consciousness. They were working away from their own intuition. Mankind has never been able to trust the intuitive consciousness, and the decision to accept that trust marks a very great revolution in the course of human development.

Without knowing it, Cézanne, the timid little conventional man sheltering behind his wife and sister and the Jesuit father, was a pure revolutionary. When he said to his models: "Be an apple! Be an apple!" he was uttering the foreword to the fall not only of Jesuits and the Christian idealists altogether, but to the collapse of our whole way of consciousness, and the substitution of another way. If the human being is going to be primarily an apple, as for Cézanne it was, then you are going to

have a new world of men: a world which has very little to say, men that can sit still and just be physically there, and be truly non-moral. That was what Cézanne meant with his: "Be an apple!" He knew perfectly well that the moment the model began to intrude her personality and her "mind," it would be cliché and moral, and he would have to paint cliché. The only part of her that was not banal, known *ad nauseam,* living cliché, the only part of her that was not living cliché was her appleyness. Her body, even her very sex, was known nauseously: *connu, connu!* the endless chance of known cause-and-effect, the infinite web of the hated cliché which nets us all down in utter boredom. He knew it all, he hated it all, he refused it all, this timid and "humble" little man. He knew, as an artist, that the only bit of a woman which nowadays escapes being ready-made and ready-known cliché is the appley part of her. Oh, be an apple, and leave out all your thoughts, all your feelings, all your mind and all your personality, which we know all about and find boring be-yond endurance. Leave it all out—and be an apple! It is the appleyness of the portrait of Cézanne's wife that makes it so permanently interest-ing: the appleyness, which carries with it also the feeling of knowing the other side as well, the side you don't see, the hidden side of the moon. For the intuitive apperception of the apple is so *tangibly* aware of the apple that it is aware of it *all around,* not only just of the front. The eye sees only fronts, and the mind, on the whole, is satisfied with fronts. But intuition needs all-aroundness, and instinct needs insideness. The true imagination is for ever curving round to the other side, to the back of presented appearance.

So to my feeling the portraits of Madame Cézanne, particularly the portrait in the red dress, are more interesting than the portrait of M. Gef-froy, or the portraits of the housekeeper or the gardener. In the same way the *Card-Players* with two figures please me more than those with four. [Fig. 15].

But we have to remember, in his figure-paintings, that while he was painting the appleyness he was also deliberately painting *out* the so-called humanness, the personality, the "likeness," the physical cliché. He had deliberately to paint it out, deliberately to make the hands and face rudimentary, and so on, because if he had painted them in fully they would have been cliché. He *never* got over the cliché denominator, the intrusion and interference of the ready-made concept, when it came to people, to men and women. Especially to women he could only give a cliché response—and that maddened him. Try as he might, women re-mained a known, ready-made cliché object to him, and he *could not* break through the concept obsession to get at the intuitive awareness of her. Except with his wife—and in his wife he did at least know the appley-ness. But with his housekeeper he failed somewhat. She was a bit cliché, especially the face. So really is M. Geffroy.

With men Cézanne often dodged it by insisting on the clothes, those stiff cloth jackets bent into thick folds, those hats, those blouses, those curtains. Some of the *Card-Players,* the big ones with four figures, seem just a trifle banal, so much occupied with painted stuff, painted

clothing, and the humanness a bit cliché. Nor good colour, nor clever composition, nor "planes" of colour, nor anything else will save an emotional cliché from being an emotional cliché, though they may, of course, garnish it and make it more interesting.

Where Cézanne did sometimes escape the cliché altogether and really give a complete intuitive interpretation of actual objects is in some of the still-life compositions. To me these good still-life scenes are purely representative and quite true to life. Here Cézanne did what he wanted to do: he made the things quite real, he didn't deliberately leave anything out, and yet he gave us a triumphant and rich intuitive vision of a few apples and kitchen pots. For once his intuitive consciousness triumphed, and broke into utterance. And here he is inimitable. His imitators imitate his accessories of tablecloths folded like tin, etc.—the unreal parts of his pictures—but they don't imitate the pots and apples, because they can't. It's the real appleyness, and you can't imitate it. Every man must create it new and different out of himself: new and different. The moment it looks "like" Cézanne, it is nothing.

But at the same time Cézanne was triumphing with the apple and appleyness he was still fighting with the cliché. When he makes Madame Cézanne most *still*, most appley, he starts making the universe slip uneasily about her. It was part of his desire: to make the human form, the *life* form, come to rest. Not static—on the contrary. Mobile but come to rest. And at the same time he set the unmoving material world into motion. Walls twitch and slide, chairs bend or rear up a little, cloths curl like burning paper. Cézanne did this partly to satisfy his intuitive feeling that nothing is really *statically* at rest—a feeling he seems to have had strongly—as when he watched the lemons shrivel or go mildewed, in his still-life group, which he left lying there so long so that he *could* see that gradual flux of change: and partly to fight the cliché, which says that the inanimate world *is* static, and that walls *are* still. In his fight with the cliché he denied that walls are still and chairs are static. In his intuitive self he *felt* for their changes.

And these two activities of his consciousness occupy his later landscapes. In the best landscapes we are fascinated by the mysterious *shiftiness* of the scene under our eyes; it shifts about as we watch it. And we realize, with a sort of transport, how intuitively *true* this is of landscape. It is *not* still. It has its own weird anima, and to our wide-eyed perception it changes like a living animal under our gaze. This is a quality that Cézanne sometimes got marvellously.

Then again, in other pictures he seems to be saying: Landscape is not like this and not like this and not like this and not . . . etc.— and every *not* is a little blank space in the canvas, defined by the remains of an assertion. Sometimes Cézanne builds up a landscape essentially out of omissions. He puts fringes on the complicated vacuum of the cliché, so to speak, and offers us that. It is interesting in a *repudiative* fashion, but it is not the new think. The appleyness, the intuition has gone. We have only a mental repudiation. This occupies many of the later pictures: and ecstasizes the critics.

And Cézanne was bitter. He had never, as far as his *life* went, broken through the horrible glass screen of the mental concepts, to the actual *touch* of life. In his art he had touched the apple, and that was a great deal. He had intuitively known the apple and intuitively brought it forth on the tree of his life, in paint. But when it came to anything beyond the apple, to landscape, to people, and above all to nude woman, the cliché had triumphed over him. The cliché had triumphed over him, and he was bitter, misanthropic. How not to be misanthropic when men and women are just clichés to you, and you hate the cliché? Most people, of course, love the cliché—because most people *are* the cliché. Still, for all that, there is perhaps more appleyness in man, and even in nude woman, than Cézanne was able to get at. The cliché obtruded, so he just abstracted away from it. Those last water-colour landscapes are just abstractions from the cliché. They are blanks, with a few pearly-coloured sort of edges. The blank is vacuum, which was Cézanne's last word against the cliché. It is a vacuum, and the edges are there to assert the vacuity.

And the very fact that we can reconstruct almost instantly a whole landscape from the few indications Cézanne gives, shows what a cliché the landscape is, how it exists already, ready-made, in our minds, how it exists in a pigeon-hole of the consciousness, so to speak, and you need only be given its number to be able to get it out, complete. Cézanne's last water-colour landscapes, made up of a few touches on blank paper, are a satire on landscape altogether. *They leave so much to the imagination!*—that immortal cant phrase, which means they give you the clue to a cliché and the cliché comes. That's what the cliché exists for. And that sort of imagination is just a rag-bag memory stored with thousands and thousands of old and really worthless sketches, images, etc., clichés.

We can see what a fight it means, the escape from the domination of the ready-made mental concept, the mental consciousness stuffed full of clichés that intervene like a complete screen between us and life. It means a long, long fight, that will probably last for ever. But Cézanne did get as far as the apple. I can think of nobody else who has done anything.

FROM *CÉZANNE:*
HIS ART, HIS WORK (1936)

Lionello Venturi

The most serious critical error is not so much to have catalogued Cézanne as a symbolist, neo-impressionist, mystic, neo-classicist or cubist: it is to have proclaimed that he was the precursor of all directions taken by painting after him, a very great precursor, but solely a *precursor.* Anyone proclaiming that reserves a messianic role for himself. It is thus that the original legend of Cézanne's ineffectiveness did all its damage; those who profit from theories about Cézanne lose sight of the absolute value of the artist.

• • •

In his Romantic period, Cézanne had above all imagined scenes with human characters, or portraits. In his impressionist period he dealt especially with landscape. At first he sought to express his imagination independent of his vision; afterwards he returned to the limits of his vision. In his art a new and essential element affirmed itself: objectivity, that is, respect for the object painted. It is understood that it was of course impossible to confuse his vision with another's, that in one way it was necessarily subjective. But a relationship was established between the subject who perceives and the object that is painted. He no longer invents; he studies. He studies tones, that is, the relationship of colors in natural light rather than the chiaroscuro he learned in school. And above all, he seeks the "motive," not the often treated subject, but the very source of natural inspiration. It is thus that the things that were troubling his worried imagination disappear: anguished yearning to do more, romantic emphasis, painting the impossible, the arrogance of that which he could never see. In their place he substitutes the humility of an artist who adores his little piece of nature, the full equilibrium of a man who feels all created things as participants in his intimate life.

He was not less objective than Pissarro, only the object differed.

Lionello Venturi, *Cézanne, son art—son oeuvre* (Paul Rosenberg, Paris, 1936); these excerpts, pp. 14, 15, 30, 31, 32. By permission of Paul Rosenberg and Co., New York.

For Pissarro it was the thing viewed in isolation; for Cézanne, the object is the style. This resulted in that important consequence which one calls the deformations of Cézanne, which are nothing other than the adaption of represented objects to the unity of style. . . .

The moment has come to affirm that Cézanne's spiritual world, until the final hour of his life, was not that of the symbolists, nor of the fauvists, nor of the cubists; rather, that his world is shared with Flaubert, Baudelaire, Zola, Manet, Pissarro. In other words, Cézanne belongs to that heroic period of art and literature in France which discovered a new way to arrive at natural truth, going beyond, realising, and transforming Romanticism itself into an eternal art. In Cézanne's character and in his work there was nothing decadent, nothing abstract, no art for art's sake, nothing other than an indomitable natural impulsion to create art.

FROM CÉZANNE AND THE END OF SCIENTIFIC PERSPECTIVE (1938)

Fritz Novotny

FROM PART I: "THE SPACE FORMATION IN THE REPRESENTATION OF LANDSCAPES OF CÉZANNE"

"MODIFICATIONS OF SCIENTIFIC PERSPECTIVE"

The *size* of the segment of the picture devoted to the distant land-scape brings us to the question of modifications of scientific perspective. For a small-sized segment of distant space is the only one among all the characteristics of the picture segment which can modify the objective appearance of the piece of landscape represented, without deviations from natural linear perspective being necessary. It is a characteristic which arises as a principal effect of the process of selecting the segment, a process which in itself in no way affects the actual spatial construction of the picture, and produces a kind of reduction of space: in the representation, the distant landscape is of lesser depth than the original in nature. This is not to say that the distant landscape contains less space, but that a different landscape is represented, as regards the extending of its depth, from the subject as it is still visible today. Considered in isolation, this means of contracting space is, as we have already noted, a very "discreet" one; its artistic achievement cannot be appreciated by direct reference to the picture alone, but only by comparing it with the original scene in nature. Nonetheless, it is a development which runs parallel to a particular tendency in the treatment of space which finds expression in certain deviations from natural linear perspective.

We have said before that there is an obvious technique of reducing spatial depth, namely the avoiding of long oblique lines of perspective;

Fritz Novotny, *Cézanne und das Ende der wissenschaftlichen Perspektive* (Verlag von Anton Schroll, Vienna and Munich, 1938, 1972), pp. 32–33, 38, 135–136, 141, 143, 144, 158, 161, 162, 177, 179–182, 184, 188, 189. By permission of the publisher. Translated by Dr. Raymond Ockenden.

but, as we noted, this technique is much more rarely used by Cézanne than the superficial and summary impression of his landscape paintings which remains in our memory might lead us to suppose. In fact, Cézanne's landscapes frequently reveal the use of an, as it were, hesitant shifting of perspective lines. An especially striking example of this is the representation of the garden wall in the foreground of "The Railway Cutting" [Figure 2]. The wall is scarcely recognisable as such, not only because the material is only slightly characterised, but also as a result of the lack of those slight tensions and differentiations which usually create or reinforce the perspectival depth character of a picture, even when there is little use of actual depth. (It cannot even be ascertained with complete certainty that this dark brown line, of constant breadth, which runs across the bottom of the picture at a slight angle, represents a vertical plane.) . . .

An interesting case of the modification of perspectives lines, whereby the normal movement of perspective lines is weakened, can be seen in the landscape with Mont Saint Victoire. The picture segment, and the quantitative distribution of foreground, middle ground, background and sky within it, correspond to the normal appearance of the landscape subject (apart from that slight contraction of the angle of the composition in a horizontal direction which we have already mentioned). In the foreground area, however, a considerable modification of a perspective line is apparent. The more distant field-boundary, along which today there is a line of poplar trees, runs parallel to the plane of the eye, just as it does in the painting; the nearer boundary of the field, however, which is apparently formed by a small water-channel, runs in reality at a very oblique line, whereas it becomes in Cézanne's representation an almost horizontal line, running alone just above the bottom picture border.

In the present context, of course, we must leave aside the specific qualities which outline has in Cézanne's paintings in general, and also that characteristic vagueness and especially the lack of tensions which constitutes one of the basic artistic inventions of his painting. This lack of tension, conditioned among other factors by the nature of the object in the outlines of which it is apparent, has an effect which is generally especially striking where perspective lines are concerned, since the latter by their very nature encourage rather the contrary process, namely a *heightening* of movement. . . .

Altogether the lessening of contrasts in quite general terms seems to be a very significant feature of Cézanne's technique of representation. We are concerned with it here first of all in connection with the weakening of perspectival accents.

The weakening of perspectival accents must be recognised as a peculiarity of Cézanne's, underlying those more partial characteristics of his, such as the avoiding of view from below and the intensification of view from above, the stretching of perspective angles, the lessening of the convergence of perspective lines. In its turn this weakening of accents appears to have its roots in a more inclusive and fundamental

characteristic of Cézanne's representation, namely the reduction of contrasts.

This lessening of contrasts, with which all the particular features just listed are connected, is quite generally a reduction of the perspectival size-contrasts of individual objects in the spatial depth. It is of course only another term for the same phenomenon if we speak, on the other hand, of a lessening of the convergence of perspective lines, the stretching of perspective angles and so on, and on the other hand of a lesser degree of diminution in size of individual objects. It would be superfluous to stress particularly this consequence of the basic physical-optic law of perspective, were it not that this consequence allows for various possible interpretations from the *artistic* point of view. . . .

FROM PART II: "THE END OF SCIENTIFIC PERSPECTIVE"

The most immediate of these questions is: what among these phenomena of the formation of perspectival space we have described is specific to Cézanne? This was a question we had previously to neglect in an analysis which in the first instance was bound to eschew comparisons of an historical nature. If similar characteristics appear in individual works or whole periods of painting in the past—and that is what we are investigating here—and hence reveal themselves to be connected with certain basic requirements of painterly representation, then we must not leave out of account above all the fact that, even if these related phenomena of previous periods represent tendencies in representation which may be termed "anti-perspectivist," a radical rejection of scientific perspective only comes about in the wake of Cézanne's work. Of course, we have yet to show how far Cézanne's technique was itself an effective cause of this rejection, and hence how important a role he plays in the breakdown of laws of perspective as having any value for modern painting.

Certainly, Cézanne was not the only painter in the last quarter of the nineteenth century in whose representation of space possibilities for a radical rejection of scientific perspective were created.

• • •

The role which Cézanne played in the development of anti-natural spatiality in the post-Impressionist period must be distinguished from other possibilities; in the first instance these distinctions are purely conceptual ones. Out of the negative limitation which circumscribes the particular treatment of space in Cézanne there arises, quite fundamentally, a second, contrary kind of rejection of the laws of scientific perspective. While Cézanne's manner of representing space, the representing of space in reality, is based on a lessening of intensity of scientific linear perspective, a directly contrary way could equally lead to an abandoning of a perspectivally exact representation of space: namely the way of

over-exaggerating linear perspectival appearances, such as we can find in its earliest form—and in a form which most clearly betrays its origins—in the art of Van Gogh.

• • •

The reshaping of natural perspective, as a means of giving expression to the representation of the experience of space itself, or in the service of expressive contents drawn from other areas of experience—these are two methods which scarcely ever appear separate from one another, and they have in common the *fullness of expression* which characterises all deviations from the natural appearance of space. Both are the complete opposites of the spatial perspective in Cézanne's painting, which is *emptied of expression*.

The emergence of these two fundamentally opposed ways of overcoming scientific perspective in painting occurs in the period between 1880 and 1890; its effect, which was to determine the whole face of European painting in a far-reaching manner, followed two decades later. Cézanne's highly personal treatment of space had developed to its definitive form by the beginning of the eighties. Van Gogh had worked out his spatial expressionism at the start of his stay in Arles in 1888, the new surface style of Gauguin appeared at roughly the same time; in 1886 Ensor produced the first of his works which shows a form of spatial fantasy clearly developed in the etching "The Cathedral"; around 1890 Hodler found his personal style of painting, Munch a few years later.

The transforming of the real appearance of space into an expressive value, as it arose in that period both out of, and as a reaction to, Impressionism, represents, of course, only one new kind of historical development of a principle of form which has constantly reappeared throughout the whole history of painting. This principle, namely the use of expression to determine the shaping of space, has over and over again made its effective appearance alongside the domination of scientific perspective, either in the art of outsiders, or sometimes, as for example in periods of "mannerism," determining the whole development of painterly representation; it has been an almost constant companion of that tendency in representation which has been directed towards the exact recreation of spatial reality. As is well known, it is only in recent times that art-historical analysis has turned its attention to some of its forms of expression and made them the subject of detailed investigations.

• • •

It can clearly be recognised that the disintegration of spatial reality which inheres in the peculiar pictorial structure of Cézanne plays a highly important role in the development of all non-Expressionist forms of absolute painting, right down to Constructivism. An essential element in this development is the weakening of the value of scientific perspective, which has its origins in the structure of the small elements of the picture. The way in which this weakening developed into total negation of perspectival appearance need not concern us here. This latter development is not, of

course, a matter of gradual distortions of perspectival forms to the point of a final break with any perspectival representation of space; it is not, that is to say, a question of a continuing development of some innovation or other in the treatment of spatial illusion, in the sense in which one can trace the development of the depiction of space from the quattro-cento to the High Renaissance, or the development of landscape space in Dutch painting from the sixteenth through to the seventeenth century. Rather, a direct line of development of this kind, leading on to increasing unreality of place, can be observed in individual tendencies of the late nineteenth century which prefigure spatial expressionism. These tend-encies are directly contrary to Cézanne's treatment of space (it is in this latter that Cézanne's fundamental difference is revealed).

• • •

Certainly, and akin to the continuous development of a naturalistic picture-space in the Expressionist manner of representation, we can also discern a gradual increase in the alienating of objects from reality, de-veloping out of Cézanne's late style into full-blown Cubism. Of the two processes which are relevant to a study of the formation of space, for example the breakdown of perspectival fidelity on the one hand, and the reshaping and exaggerating of the dimensions of the small structural elements of the picture on the other, there is no doubt that the second is more closely and decisively connected, in terms of historical develop-ment, with the painterly spatial form of Cézanne than the first.

I have attempted to show that the devaluation of linear perspec-tive has its roots in the formal structure of his paintings, while the rea-sons for its being maintained, that is, the maintenance of a formal schema, are to be found in the more general realm of Cézanne's attitude towards the appearance of reality: namely, in the obligation which he felt to maintain a certain harmony between the form of his pictures and the traditional linear form of projection of an empirical perception of space.

If a perspective is weakened in its integrating character, in its function of making visible in an exact way the space as given by the scaffolding of lines, then it is scarcely a perspective any longer. Thus we may well ask whether the end of scientific perspective does not already occur in Cézanne's painting, before we can see it in a much more striking form in abstract painting.

The answer must be twofold, along the lines of the division just established. From Cézanne's representation of reality to abstract painting, from the diminished value of linear perspective as a means of suggesting space to the radical abolition of linear perspective altogether, was really only a step, in so far as the value of the pictorial structure for indicating space is decisive. From this viewpoint, admittedly, it seems of no great significance whether "only" a schema of scientific perspective is em-ployed, or whether even this schema is rejected in favour of a con-structed picture which is surface-formal, space-constructive, or of any other type; according to this yardstick scientific perspective in painting really does seem to have been abandoned in Cézanne's representation.

With the totally new kind of significance given to painterly pictorial structure, as created by Cézanne, a shift in the balance of forces, so to speak, seems to have taken place in the means of creating space—away from spatially large forms, and hence from linear perspective, towards the structure of small parts; and if this is so, then we can see, when we look back across this development with historical hindsight, that it only needed a very slight increase of weight on one side to make structural compositions into objects of representation in their own right, and hence to abandon entirely the system of recreating space provided by scientific perspective.

• • •

Finally we must consider the circumstance that in Impressionist landscapes broad foreground surfaces of great perspectival intensity are often worked into the picture-segment [*Bildausschnitt*].

When we consider all these characteristics which aid the increase of the perspectival vitality of the landscape segment, we can infer the probability that in Impressionist landscape perspective neither essential modifications of perspectival size-relationships, nor a tendency to any particular kind of modification of the actual dimensions of the segment, like that of Cézanne towards narrowness of the segment, occur in distant landscapes. It is indeed impossible to discover any principle according to which such measures of constructing space could have been undertaken in Impressionism.

There are nonetheless, occasional transformations of the natural appearance of space, determined by the painterly structure, which have the same tendency as the perspectival reshapings we find in Cézanne's painting, that is, towards the diminution of contrasts. Equally probable, of course, are reverse tendencies, namely towards an intensification of contrasts. But at all events such cases are not proof of an anti-perspectival tendency; for even if divergencies from true perspective appear in them, arising from the process of painting, such phenomena are not linked to other characteristics of the forming of space to the extent that one could ever speak of a fundamental attack on the effective power of illusory space: nowhere is there a renunciation, determined in the wider sense by structure, of the principles of scientific linear perspective. Such exceptional cases as these are not to be taken as prefiguring the processes of disintegration of perspective which we find in Cézanne's painting.

• • •

Our present enquiry, limited from the outset by this quantitative restriction, is limited in a much more profoundly significant way by another premise. So far in this book descriptions of the formation of space in Cézanne have been largely based on pictures painted after nature, primarily representations of landscape. Where from time to time I have also considered his freely invented figure-compositions, it was simply in order to show that in this type of painting, too, Cézanne employed basically the same techniques of spatial form, and that this spatiality involves

a considerable devaluation of what in a traditional sense is regarded as the composition of a picture. It is precisely the composition of a picture, the "overall compositional form," made effective in surface and space, which we can distinguish in all painting before Impressionism as having the weight of a dominant formal value. In the periods preceding Expressionism, traditional composition has a significance which is precisely absent from Cézanne's system of painting. This recurrence of traditional composition shows with especial clarity what a fundamental revolution in the painterly reproduction of the world of appearances had taken place, a revolution which was directed against the integrating characteristics of pictorial composition. (Impressionism, by contrast with Cézanne's style, was not actually *opposed* to the dominance of composition in the older sense, it simply bypassed all its problems.) This contrast continued to exist despite all the very significant differentiations in the relationship between the compositional scaffolding and the painting of individual details such as occurred in the course of Baroque painting. It continued to exist, moreover, even though the role of outline composition and space composition had already altered, from the time when colour became available as a consciously employed formal value for creating shape and space, from the time, that is, when such a thing as genuinely painterly structure arrived in painting. But never, before Cézanne, not even when this painterly structure became a "micro-structure" [*Kleinstruktur*], did any serious disturbance of the importance of the role of composition take place, for all the modifications which were made to it. Just as, in painting since Titian, the need for confrontation between composition in a traditional sense and painterly formation of detail led to limitations of the haptic and of clarity of outline as effective compositional values, so in the same way there grew out of this confrontation new styles of colour-decoration or even of a dynamic of space and forms which belongs in the same category as the "overall compositional form."

This brief examination is necessary if we are to observe the place of painterly perspective in pre-Impressionist art from the proper presuppositions. Another way in which overall composition is important may be termed, in the context of a very general survey, the idealistic element; this provides an alternative presupposition for an examination of the limiting of scientific perspective. Even where composition is not an explicit element of style, the degree of immediacy in the relationship to the natural appearances of space is diminished as from the beginnings of Impressionism. If we wanted to start from the same premise in comparing forms of modification of actual perspective, then only natural studies would be appropriate for the comparison. But, we cannot even limit ourselves strictly to particular types of pictures, that is to say above all landscape representations, as a basis for comparison. For just as the whole painterly way of seeing things, employed by the Impressionists, was determined by the spirit in which they approached nature, namely as a landscape, so conversely, in preceding periods of art, even in the landscape art of the seventeenth century, "idealistic" alterations intervene,

through the composition, in the representing of landscape as actually seen. Of course from the outset wide areas of painterly representation, such as religious painting, must be excluded from the comparison; for the rest, the essential determining basis for any categorisation must remain the effective intensity of the painterly micro-structure. This is not just because we have undertaken to follow in retrospect only the manner of representation which we have found to be the cause of the dissolution of spatial perspective; that would be to lead the argument unfairly, since historical developmental starting points for antiperspectival tendencies might precisely be discoverable in *other* methods of representation. It is rather that a type of painting in which composition predominates rules itself out of comparison because even the most superficial review shows that from this standpoint no weakening of the perspectival apprehension of space resulted. The manifold deviations from spatial exactitude in all composed landscapes, whether the heroic landscapes of the seventeenth, or equally those of the early nineteenth century, never intervene in the automatically assumed power and value of perspective in painting. In no case do they lead to any disturbance of scientific perspective as the structural principle of the picture-space.

In another direction, too, the combination of composition, where it is not yet under assault from painterly micro-structure, has an exclusive effect: even the not overly real picture-space of heroic landscapes, the landscapes of Poussin or Lorrain, lies outside the real area of comparison. We started from the proposition, based on experience, that the presence of a painterly micro-structure does not of itself signify any necessity to limit spatial illusion; conversely, however, the absence of such a micro-structure guarantees an autonomy of spatial illusion, which is unaffected by any context of composition, no matter how striking. That is to say, it guarantees a kind of spatial reality which we have found to be negated in the most radical way in Cézanne's painting. This proposition demanded that we limit our investigations to the sphere of developed painterly form with visible colour-structure, and it is from this sphere that the few examples cited above were derived.

• • •

The complex interrelationships of different pictorial values in these kinds of formations of space, the deformations and camouflagings of the mathematical perspectival realities, caused by the requirements of thematic expression or of composition—all these things have rarely been made the subject of detailed analysis. Least of all has there been a thorough investigation of perspective in nineteenth-century painting. This period of art, in particular painting from the beginnings of realism onwards, offers, it is true, scarcely any encouragement to do so. For in this art the exactitude of real space perspective appears to be a presupposition which is taken for granted. Perspective was also respected as far as the composition of the pictures is concerned, to a far greater degree than, for example, in seventeenth-century Dutch landscape painting. There are indeed only two possible ways, short of abandoning the aim

of reproducing reality, in which this perspective could ever become problematic.

In the first place, it does not remain unaffected by modification and arbitrarinesses conditioned by emotions. But if one takes the painting of the middle to latter part of the nineteenth century as a whole, we must conclude that deviations of this kind keep within very modest limits and can only be apprehended conceptually by means of paraphrasing the most obscure relationships. At all events these deviations do not go so far as to reveal any fundamental tendency to oppose the laws of perspective. The forms of scientific perspective always appear to be decisive for the picture-space.

The second, much more significant possibility lies in the way in which the construction and effect of the picture-space is influenced by the plane of the picture and its increasingly pronounced surface structure in the second half of the century. To demonstrate that this influence was of paramount importance for the fate of scientific perspective has been the principal purpose of this present enquiry. Here it is perhaps necessary to go into a question which may have occurred to the reader in the course of this investigation. Is it, we may ask, possible to give an adequate explanation of such a highly important change as the abandonment of scientific perspective—important not only in the history of painting, but much more generally of cultural and historical significance—by reference only to changes occurring essentially only in the realm of painterly problems? Must we not rather look behind these painterly problems and seek out the effective causes of such a change in the much broader area of the perception of objective reality?

When we embark on questions of this kind, however obvious they may seem, we touch on problems and apparent problems which we must now briefly investigate by way of conclusion. To begin with, one might counter the question with doubts as to whether the hiatus between the perspectival and non-perspectival representation of space was really all that profound—as profound, for example, as that between pre-perspectival and perspectival reproductions of space. We touched on this doubt earlier in considering the moment in time at which this hiatus actually occurred, and in asking what it means to talk of the end of scientific perspective in Cézanne's work. It can be admitted that this hiatus was not so decisive as that which, in the realm of the representation of space, occurred in the late Middle Ages, yet it is only less profound in so far as the comparison between painting which depicts real space and abstract painting remains limited to formal considerations. As soon as we consider the general question of the relation of the painting to the appearance of reality, then this hiatus can be seen as a genuine break with a centuries-old tradition. What replaced the realistic painting of the nineteenth century was not an anti-natural conception of the subject in the spirit of perspectival medieval painting, or for example Islamic book illustrations; the turn away from the image of reality came about precisely through the predominance of formal constructs. It was in this sphere that the attack on scientific perspective was also carried out.

A further essential circumstance which must be noted in the context of this question is that the painterly micro-structure, along with all the consequences it had, cannot be regarded as the *unique* reason for the dissolution of perspective. We have already seen that a second essential cause, which appears simultaneously with the first, is the aim of depicting an area of emotion, that is, spatial expressionism. Of these two depictional tendencies, which both lead to a picture-space alienated from reality, the second has a richer and more variable history. All conceivable areas and modes of conceptual and emotional content, from subjects which are derived from or apprehensible in literature, right down to the emotional content which is found in a particular way of looking at objects or space, can become sources of countless modifications of the natural appearance of space.

• • •

Even if we leave on one side the manifold interactions of the exploitation of spatial formalism, which we can find taken to extremes and often becomes mere playfulness, we shall nevertheless still find a great wealth of artistic possibilities within the limits of a direct influence of painterly structure on the picture-space. We must start here from our basic question, whether a development which derives essentially only from the formation of the surface of the picture can lead to a renunciation of the illusion of space, along with its scientific perspective, or whether this development was not preceded by a deeper, primary cause, namely a change in the conception of the reality of vision.

This is one of those basic Either/Ors which cannot be decided. Insight into the causal relationship of the two phenomena is scarcely possible; only in a broader survey of historical developments can we merely recognise the great importance of painterly form in this process of the renunciation of the appearance of reality. We might simply say that it is unjustified, in the light of the process of development of this kind which occurs within nineteenth-century painting, to speak of a development limited "solely" to the painterly formation of the surface of a painting, since after all in the painting of the present century the way leads so clearly towards an ever-increasing formalism. Hence the overriding importance of purely painterly formal problems does not need to be referred yet further back to a fundamental revolution in the perception of reality. This is really one of the most significant basic facts which must be taken into account in any historical-developmental consideration of Cézanne's treatment of space and of the end of scientific perspective which it prefigures. The painter's commitment to the surface of the picture, which becomes increasingly great in the course of the development of painting during the nineteenth century—that "idea of the surface as the fundamental ground of all painting" (Hetzer, *Titian*, p. 47) —causes the "image" character of the picture to become more and more pronounced. Depictional values, in particular the constitutive elements of the illusion of space, become thereby necessarily more and more

problematic. However, and this is extremely important, they do not become more *irrelevant*.

• • •

That in Cézanne's painting a new reality of the surface of the picture is created, this seems to me to be one of his most fundamental achievements. However often, in previous periods of art, the importance of the reality of the surface may have become a problem in a painting, it never before, to the same degree as in Cézanne's painting, affected the representational content of objects and of the whole area of the subject. If we take this reality of the picture surface to be the real basis of the new form of the picture-space, together with all its consequences for the reality value of the representation, then it follows that the problem of the significance of the negation of spatial reality, the whole question of the general cultural background of this developmental change, is shifted out of the realm of representational problems in any immediate sense. It is no longer a question of the manner in which a given reality is artistically conceived and formed into a reproduction, but a question of the significance of the conception of the picture itself. What matters is not what happens within a symbolic world bounded by four straight lines, but the new value which this thing itself, this surface enclosed by four straight lines, possesses within the idea of the picture. The relationship between these two things, between the value of the representation and the value of the picture, which is the object of an *analytical* observation of any work, became one of the most essential of all the problems concerned with representation in the period which marks the end of Impressionism, and above all in the art of Cézanne. This is in truth a basic fact, and one which prevents us from evaluating, in the way in which we might pictures before the time of Cézanne, operations within the spatial illusion, that is, everything that happens to the objects represented within the representational form. On the other hand, it would be a total error to consider these operations as no longer in any way decisive for an historical evaluation of Cézanne's achievement. Let me repeat here something that I have already said elsewhere. Of course we would be mistaken, were we to consider the problem of the formation of space in Cézanne's painting from the same standpoint as we would choose for the painting of his predecessors, to remain tied in our consideration to spatial illusion, so to speak. But it would be equally false, when confronted with Cézanne's new kind of pictorial spatiality, to abandon the more immediate realm of representational problems altogether and limit ourselves to purely formalistic evaluation. The special and peculiar form of the middle way not only characterises Cézanne's art, but is also a determining factor in evaluating and placing it in its historical context.

• • •

I have stressed elsewhere (cf. F. Novotny, "Das Problem des Menschen Cézanne," pp. 276 f) the profound contrast between this animation of landscape at the beginning of modern, genuine landscape art and its

final form in Cézanne's painting, in order to aid a clearer appreciation of his painting. It is a contrast between a perception of landscape which creates "earthly life pictures," rooted entirely in a human sphere, and a perception of landscape which cuts out that human element. At this point another contrast, a contrast within a similarity, can reveal to us once again the special quality of Cézanne's way of composing. In Friedrich's painting the expression of the elemental quality of landscape is to be found in the sphere of object-space, by means of a simplification and monumentalisation of the forms of objects. In Cézanne's painting this elemental quality is expressed in the transvaluation of these object-forms and the space they occupy, and in this fact the path on which landscape painting embarked at the start of the nineteenth century seems to me to have reached its fulfilment.

FROM *CÉZANNE'S COMPOSITION* (1943)

Erle Loran

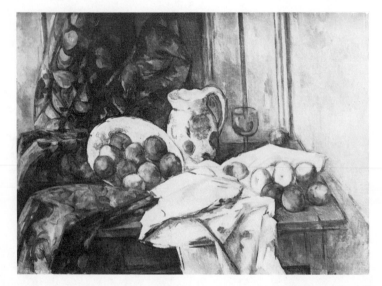

Diagram I is simply a tracing around the outer contours of the large areas of the picture. The essential plane and space relationships are thus established by *outlines*. Although Cézanne certainly did not begin a painting with the completely defined, closed compartments shown in this diagram, it is nevertheless these basic space relationships that he roughly established with pencil and colored outlines in the first stages of most pictures. The fundamental linear structure in Cézanne's painting and his linkage with earlier traditions of composition should be apparent in the light of this tracing.

Erle Loran, *Cézanne's Composition* (University of California Press, Berkeley and Los Angeles, 1943, 1950, 1963, 1970), this excerpt, pp. 40–43. By permission of the author.

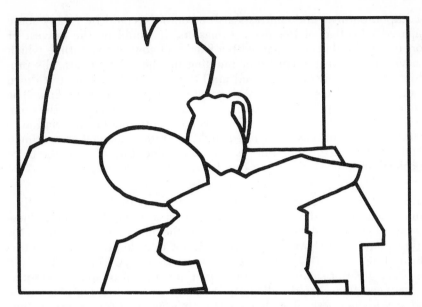

It must surely be clear that this diagram, further elaborated with outlines around all the smaller forms and divisions in the draperies, could serve as the cartoon to be traced with an incising stencil on a Renaissance fresco or tempera surface. Or, for other types of Renaissance tempera or oil painting that were to be toned with an imprimatura, these outer contours would be drawn with dark tempera lines or black ink. Cézanne did not use any of these procedures, of course, and it was only when the painting was entirely finished that his compositional structure,

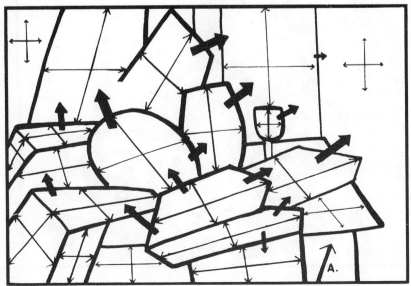

based upon outlines and contrasts at the contours, could be in any sense compared with that of Renaissance masters. It would be the gravest of errors to assume that he began with a fixed and continuous outline which he never altered in the course of building up the color planes. His procedure was infinitely complex, and until the last line had been put down the drawing and composition were continually in a state of flux. The openness of his approach to color, the effect of color on color as the composition crystallized, creating expansions and contradictions in relation to the first sketchy outlines, demanded slight alterations as well as continual reëstablishment of the line; but "as one paints, one draws," and "the more the color harmonizes, the more the drawing becomes precise."

Diagram II reduces the elements of the picture to flat planes. The double-pointed crossbars indicate the long and short axes of the planes. These axis bars help to indicate the position of the planes in relation to the picture plane. The short, heavy arrows point into depth in the direction indicated by the overlapping of one plane over another. Tensions between planes are great or small, depending upon the amount of space, the interval, between them. As the diagram indicates, space and tension can be created with perfectly flat planes when they are made to overlap, thus establishing their position, their fixation, in space. (The location of these planes should be as apparent in the diagram as in the painting.) Other elements of tension are analyzed in Diagram IV.

At the lower right, the arrow A indicates the rising of the table top away from the horizontal line of the frame and the consequent dynamic rotation to the right of the front plane of the table. This rotation pushes

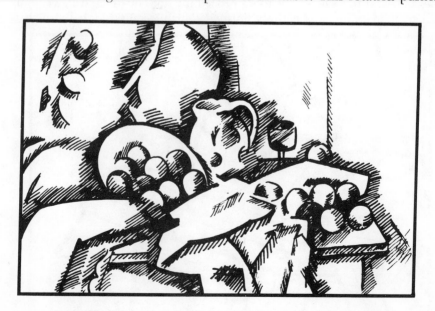

the table into space away from the picture plane. This subtle impetus into the right-hand deep space is probably the origin of the dynamic quality of the painting. Diagram III analyzes the movements in a more general way.

Diagram III shows how space and depth are created as the volumes move in the negative space. In this picture there is movement both to the right and to the left, as indicated by straight arrows. But the movement stays within the borders of the frame. A third movement factor, indicated by arrows revolving in circular activity, keeps the organization well closed. This circular movement is somewhat vague, and difficult to prove graphically. It is both a two-dimensional and a three-dimensional movement. Two-dimensionally, it follows rhythmically along lines in the white cloth (as shown in Diagram VII); its central coil can be felt in the plate and the curved pitcher handle. It is three-dimensional because its path revolves from foreground into background, receding into the deepest part of the so-called "picture box," the *negative* space. The movement activity of the apples is also indicated by arrows.

Light and dark planes have been indicated in order to heighten the volume effect. Diagram II has shown, however, that *the basic spatial relations can be demonstrated with perfectly flat planes.*

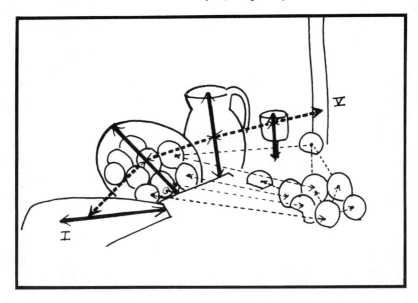

In this painting the dynamic activity of elements moving in space is *controlled* and related to the flat picture plane, partly by eliminating too great a protrusion of the forms at the bottom and partly by expansion and enlargement of the forms in the background: the tipped-up plate of apples, the vertical pitcher, and the heavy vertical drapery against the vertical wall afford the necessary expansion.

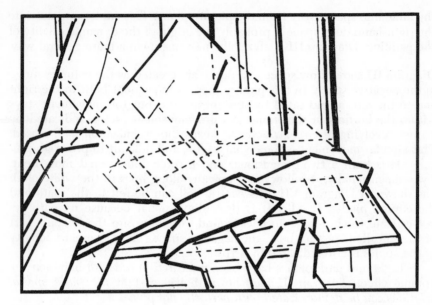

Diagram IV analyzes two elements of tension not emphasized in Diagram II. A tension path, somehow comparable to the act of opening up a fan, can be felt from axis to axis of planes and volumes. Dotted lines running through the center of axis bars, starting at the lower left, marked ı and ending at v, represent this tension path. An important factor in the path referred to is the dynamically tipped pitcher. The pitcher, because of the distortion or tipping, becomes part of the general movement activity; it is no longer a mere object.

A set of tensions between the apples is indicated by dotted lines. This tension would exist both because of the color relations between the apples and because of the similarity in their sizes and shapes. The massing or grouping of the apples is important. On the left, inside the plate, is a large mass (or complex); to the right, there is a medium-sized mass; and behind the white cloth sits a lone apple, related through tension to the other groups of apples.

Diagram V is a two-dimensional, linear construction based on actual as well as subjective or "carry-through" lines. The solid black segments of line are simply traced from the still life. The so-called "subjective" lines, which merely seem to "carry through" from the edge of one object to that of another, are indicated by dotted lines. This important element in the organization of a picture—the network of horizontal, vertical, and diagonal lines—is made more emphatic by leaving the shapes incomplete, in segmented lines. These construction lines, weaving back and forth throughout a picture, give structural power and *two-dimensional balance*. I do not believe that Cézanne conceived of these lines as a factor unrelated to depth and space, and it is only for purposes of analysis that they are shown as a separate element here. (But it is important to notice that

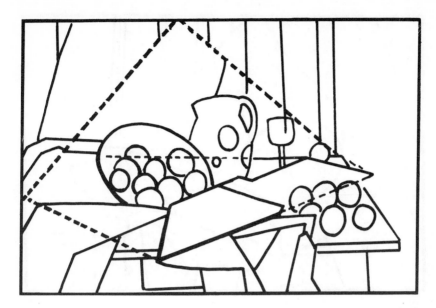

even when an attempt is made to reduce such a painting to its construction lines, a space effect is created. Subjective planes, suggesting space, develop as soon as a line cuts across the picture plane.) The lines may be understood as *dynamic* and *static* elements, the vertical and horizontal being the *static,* and the diagonal the *dynamic,* lines. Of great importance here is the slight tipping of the vertical lines. This habit of tipping lines that are vertical in nature gives to Cézanne's painting a new dynamic quality. In fact, there are no positively static lines in the entire picture. The belief that these dynamic elements resulted from Cézanne's poor eyesight (see Emile Bernard) can by now, perhaps, be discounted! Similar phenomena can be found in the work of many of the great masters of the past. Picasso and Braque, particularly in their first Cubist period, which was a direct development from Cézanne, made extensive use of construction lines.

Diagram VI is concerned with the geometric shapes in the painting. Underlying or subjective shapes are indicated with dotted lines. The largest subjective shape is a diamond, based almost entirely on subjective or carry-through lines. Within the large diamond, the upper half makes a fairly obvious triangle. It was the recognition of these nonobjective shapes in Cézanne and in the old masters that gave the Abstract painters one of their points of departure. The obvious or objective shapes in this picture are seen as circles (apples, and designs on pitcher), ellipses (plate and pitcher), and various triangular and rectangular shapes in the drapery, table, and wall. The aim is to achieve the greatest possible variety and contrast in the size and character of these shapes. (The decorative character of the large objective shapes of draperies is analyzed in Diagram IX.) The two-dimensional balance and the mural character of the picture plane are greatly enhanced by these underlying subjective shapes.

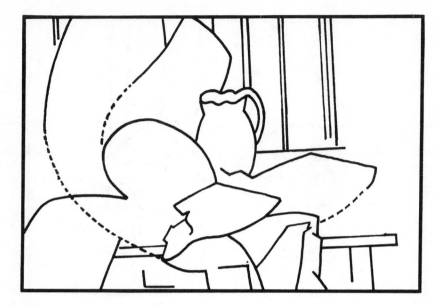

Diagram VII analyzes the organization of rhythmic curved lines. The dotted lines indicate how the curved lines seem to carry through, binding various elements of the picture together, creating rhythm. Go back to Diagram III to see how the circular movement of lines relates to the *movement in space*, which is of fundamental importance. Refer to Diagram V for analysis of straight construction lines.

Consideration should be given to the purely decorative character of line—line for its own sake, or "the beauty of line," as it is often called,

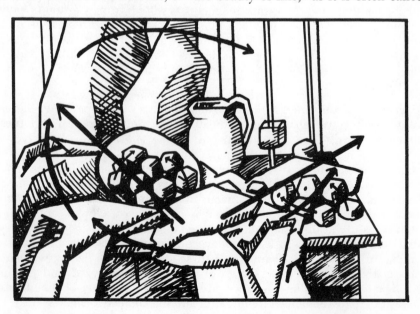

even though it is a comparatively superficial factor. There is a play of round and curved against angular and straight lines. There are the contrasts of long and short lines. The curved and diagonal lines are dynamic; the vertical and horizontal, static. All these diagrams make obvious how important *line* is in the organization of a Cézanne painting. It is difficult to understand the critics' fable of Cézanne's "lack of linear content."

Diagram VIII is based on the most purely individual characteristic in Cézanne's paintings, namely, gradations. The practice of starting with the darkest outer contour of a form and building up from cool darks to the warm lights, as was Cézanne's usual procedure, gave his work the spotty character which has misled so many critics and artists to believe that "Cézanne created his picture with little touches of color" and "avoided the line." Note that all preceding diagrams were line drawings, with no gradations indicated. This method of building up forms with distinctly hewn-out planes of color on the principle of *warm color* for light planes and *cool color* for receding planes is the most widely understood element in Cézanne's effort to "make out of Impressionism something solid, like the art of the museums." It is the element in his form about which he talked so much, but which, according to the approach made here, is decidedly of secondary importance.

The accompanying diagram is an attempt to show how the picture may have looked at an early stage of its development, with the difference that basic outlines are here purposely avoided. The separation of the planes is achieved more through contrasts at the contours than with lines. But, as the painting progressed, the lines were more definitely superimposed at the contours, as we can observe in the photograph of the painting, particularly in the white cloth and in the table. Among followers of Cézanne, Andrew Dasburg and Henry Lee McFee come to mind as painters who depend almost entirely on these contrasts of dark against light, light against dark, and carry a picture to completion with a conscious avoidance of superimposed line.

The merging, the losing of edges at certain points of the contours, is clearly shown in the diagram. When part of a contour thus "passes" into the adjacent form or into the background, a fusion that has a two-dimensionalizing function occurs. With the positive volumes closely related to the background, the entire surface becomes a well-integrated two-dimensional area, and the effect of separate, sculptured units floating in unused, unrealized space is done away with. (Although definite, the importance of fusions or "passages" is comparatively slight in this painting.)

Picasso, Braque, and other artists who developed Analytical Cubism used the elements of Cézanne's form, described in this diagram, as their particular point of departure. Gradations of light to dark, dark to light, with additional lines here, fused edges there, and strong emphasis on oppositions of curved against straight lines are the obvious characteristics of the early manifestations of Cubism.

Diagram IX reduces the light and dark shapes to definitely closed or compartmental areas. The basic light, dark, and gray shapes create an interesting, firmly organized pattern. The vibration of light against dark shapes creates a pictorial light that exudes from the picture itself. It has nothing to do with light and shade, chiaroscuro, or naturalistic light-source concepts. The light in this sense is abstract, a purely plastic, pictorial quality that derives from the formal relations in the picture itself.

Slight variations in texture are also indicated in this diagram. Cézanne was never much concerned with the imitation of textural surfaces, nor was he interested in pigment textures like those invented by Van Gogh, nor in abstract pattern textures, so common in the Abstract painters. Cézanne was always primarily concerned with the structural, voluminous character of forms. But in this painting the flower design in the heavy drapery inevitably created a heavy textural weight that had to be balanced by other textural weights. The lights and darks in the apples create such a balancing weight, and so do the modulations in the white cloth.

Some consideration should here be given to the concept of positive and negative shapes. The positive shapes are the obvious objects and draperies, the gray wall serving as a negative area. The diagram is concerned only with the decorative, two-dimensional qualities of positive and negative. Diagram III explains the three-dimensional concept of the negative deep space or "picture box," within which the positive volumes are moving. It is also interesting to notice how the white cloth, the pitcher, and the plate are all merged into one mass or "complex" of white. A more perfect organization and binding together of the different objects is thus achieved, and the two-dimensional, mural character of the picture plane is heightened.

FROM ART IN CRISIS, THE LOST CENTER (1948)

Hans Sedlmayr

The essential aim of Cézanne then is to represent what "pure" vision can discover in the visible world, vision, that is to say, that has been cleansed of all intellectual and emotional adulteration. The setting of this aim of "pure vision" is a matter of great significance. There is a condition which occurs in our ordinary experience that to some extent corresponds to the thing that Cézanne strives to attain, and the attaining of which he has elevated into a principle. It is that peculiar state between waking and being completely awake in which, so to speak, only the eye is awake, while the mind is still asleep. Then the world that we ordinarily know appears as a pattern of patches and shapes of various kinds, colours, sizes and "textures"; the things with which habit has acquainted us are still behind this coloured web or tissue, waiting to come forth. This tissue is not purely two-dimensional, yet although it contains space, this is not the continuous homogeneous space of our ordinary everyday experience, but chaotic space created by the colours with which the two-dimensional colour elements are inextricably mingled. In this condition we cannot necessarily say what any one line that may emerge out of this texture "really" signifies, nor can we say anything about light, for we can only distinguish between the effect of light upon an object and the colour inherent in a particular object where there is knowledge of objects and their colours.

The magic that pertains to this way of looking at things is that even the most ordinary scene acquires a strange and original freshness, and above all that colour released from its task of indicating and identifying objects, gains an intensity that it never previously possessed. In the moment when our daytime consciousness begins to function, this whole quality disappears and the peculiar enchantment is at an end.

Hans Sedlmayr, *Verlust der Mitte—Die bildende Kunst des 19. und 20. Jahrhunderts als Symptom und Symbol der Zeit* (Otto Müller Verlag, Salzburg, 1948). English translation, *Art in Crisis, The Lost Center* by Brian Batteshaw (Hollis and Carter, London, and Henry Regnery Company, Chicago, 1957); these excerpts, pp. 131–134. By permission of Hollis and Carter, London, and Henry Regnery Company, Chicago.

Cézanne's paintings specialize in this manner of seeing things or in something very like it. They show the world of everyday things in a manner in which they seem more significant, more "real" (endowed more intensely with "being," if one may put it thus) than they ordinarily appear—at least they do this for anyone who has the faculty of not projecting into the picture his intellectual knowledge of the things portrayed. But precisely because he confines us wholly to the experience of the eye, he also to some extent shuts off from us the very world that the eye beholds, and makes it impossible for us really to feel our way into it. . . .

A great many of the peculiarities of Cézanne's paintings can be explained once we have obtained this essential insight into his art. We can understand, for instance, why every trace of human feeling seems to be deliberately excluded from his portrayals of the human face; it also explains why all things that can be seen in his pictures have that essential equality of character and value, though this equality is essentially belied by our natural experience. In Cézanne an apple has the same physiognomic value as a face.

Then there is that strange vegetative stillness, which is not, as has sometimes been maintained, the stillness of still life, but a stillness without life, there is further—and here Cézanne presents a striking contrast to the Impressionists—the lack of any uniform lighting, and finally there is the absence of composition in the classic sense of that term. . .

What is so unique and magnificent in the attitude from which this art is derived and what differentiates it from all the trends of art that profess to portray the visible world, is that in it the artist attains his essential sphere, not by transcending the world of common things, not by passing over it or beyond it, or even by transfiguring it, but by retiring from it, into what are, so to speak, its ultimate origins, and it is precisely here that he discovers the realm of colour *per se*. The art of Cézanne, in a word, does not discover its original element in the sphere of objects, but in a mode of conduct, an attitude.

This principle is at one and the same time something very natural and something artificial. It demands a mode of behaviour which in life can only occur under certain very exceptional conditions, *it demands a state of complete dissociation and disinterestedness on the part of the spirit and the soul from the experiences of the eye*. This makes it easy to understand Novotny's calling the art of Cézanne extra-human and divorced from life (*lebensfern*), for it is indeed contrary to human nature to exclude from the act of perception all the other functions of the human mind in favour of pure seeing.

The art of Cézanne, then, is a borderline affair. It is a kind of narrow ridge between impressionism and expressionism and in its unnatural stillness prepares for the *eruption of the extra-human*.[1]

[1] Fritz Novotny, *Cézanne und das Ende der wissenschaftlichen Perspektive* (Vienna, 1938), also introduction to the volume on Cézanne in the Phaedon Verlag, Vienna, 1947.

What this leads to is that man—again contrary to all natural experience—is put on one level with all other things. Soon after Cézanne, Seurat was to represent man as though he were a wooden doll, a lay figure, or automaton, and still later, with Matisse, the human form was to have no more significance than a pattern on wallpaper, while with the Cubists man was to be degraded to the level of an engineering model.

It is at this point that the behaviour of these allegedly "pure" painters borders on the pathological. They begin to suffer from that diseased condition whose essence is the mind's inability to project itself into the minds of others or into the world outside. When that condition obtains, everything seems dead and alien, men can then only see the outside of things, they are no longer conscious of human life in others.

It is also at this point that the whole world begins to become unstable, for when things are mere phenomena that have no meaning inherent in them, then they begin to be experienced as things without stability, things fleeting, wavering, bodiless and indetermined. They are solid things no longer (*Usnadze*). This may explain why those who wish to see a world in flux are automatically driven towards absolute painting, the painting that is innocent of any meaning whatsoever.

FROM "CÉZANNE'S DOUBT" (1948)

Maurice Merleau-Ponty

Cézanne wished to return to the object without abandoning the Impressionist aesthetic which takes nature as its model. . . . His painting was paradoxical: he was pursuing reality without giving up the sensuous surface, with no other guide than the immediate impression of nature, without following the contours, with no outline to enclose the color, with no perspectival or pictorial arrangement. This is what Bernard called Cézanne's suicide: aiming for reality while denying himself the means to attain it. This is the reason for his difficulties and for the distortions one finds in his pictures between 1870 and 1890. Cups and saucers on a table seen from the side should be elliptical, but Cézanne paints the two ends of the ellipse swollen and expanded. The work table in his portrait of Gustave Geoffrey stretches, contrary to the laws of perspective, into the lower part of the picture. In giving up the outline Cézanne was abandoning himself to the chaos of sensations, which would upset the objects and constantly suggest illusions, as, for example, the illusion we have when we move our head that objects themselves are moving—if our judgment did not constantly set these appearances straight. According to Bernard, Cézanne "submerged his painting in ignorance and his mind in shadows." But one cannot really judge his painting in this way except by closing one's mind to half of what he said and one's eyes to what he painted.

It is clear from his conversations with Emile Bernard that Cézanne was always seeking to avoid the ready-made alternatives suggested to him: sensation versus judgment; the painter who sees against the painter who thinks; nature versus composition; primitivism as opposed to tradition. . . . Cézanne did not think he had to choose between feeling and thought, between order and chaos. He did not want to separate the stable things which we see and the shifting way in which they appear;

Maurice Merleau-Ponty, *Sens et non-sens*, Paris, 1948. "Cézanne's Doubt," *Sense and Non-Sense*, translated by Hubert L. Dreyfus and Patricia Allen Dreyfus (Northwestern University Press, Evanston, Ill., 1961), pp. 9–25; these excerpts, pp. 12–19. By permission of the Northwestern University Press.

he wanted to depict matter as it takes on form, the birth of order through spontaneous organization. He makes a basic distinction not between "the senses" and "the understanding" but rather between the spontaneous organization of the things we perceive and the human organization of ideas and sciences. We see things; we agree about them; we are anchored in them; and it is with "nature" as our base that we construct our sciences. Cézanne wanted to paint this primordial world, and his pictures therefore seem to show nature pure, while photographs of the same landscapes suggest man's works, conveniences, and imminent presence. Cézanne never wished to "paint like a savage." He wanted to put intelligence, ideas, sciences, perspective, and tradition back in touch with the world of nature which they must comprehend. He wished, as he said, to confront the sciences with the nature "from which they came."

By remaining faithful to the phenomena in his investigations of perspective, Cézanne discovered what recent psychologists have come to formulate: the lived perspective, that which we actually perceive, is not a geometric or photographic one. The objects we see close at hand appear smaller, those far away seem larger than they do in a photograph. (This can be seen in a movie, where a train approaches and gets bigger much faster than a real train would under the same circumstances.) To say that a circle seen obliquely is seen as an ellipse is to substitute for our actual perception what we would see if we were cameras: in reality we see a form which oscillates around the ellipse without being an ellipse. In a portrait of Mme Cézanne, the border of the wallpaper on one side of her body does not form a straight line with that on the other: and indeed it is known that if a line passes beneath a wide strip of paper, the two visible segments appear dislocated. Gustave Geoffrey's table stretches into the bottom of the picture, and indeed, when our eye runs over a large surface, the images it successively receives are taken from different points of view, and the whole surface is warped. It is true that I freeze these distortions in repainting them on the canvas; I stop the spontaneous movement in which they pile up in perception and in which they tend toward the geometric perspective. . . . It is Cézanne's genius that when the over-all composition of the picture is seen globally, perspectival distortions are no longer visible in their own right but rather contribute, as they do in natural vision, to the impression of an emerging order, of an object in the act of appearing, organizing itself before our eyes. In the same way, the contour of an object conceived as a line encircling the object belongs not to the visible world but to geometry. If one outlines the shape of an apple with a continuous line, one makes an object of the shape, whereas the contour is rather the ideal limit toward which the sides of the apple recede in depth. Not to indicate any shape would be to deprive the objects of their identity. To trace just a single outline sacrifices depth—that is, the dimension in which the thing is presented not as spread out before us but as an inexhaustible reality full of reserve. That is why Cézanne follows the swelling of the object in modulated colors and indicates *several* outlines in blue. Rebounding among these, one's glance captures a shape that emerges from among them all,

just as it does in perception. Nothing could be less arbitrary than these famous distortions which, moreover, Cézanne abandoned in his last period, after 1890, when he no longer filled his canvases with colors and when he gave up the closely-woven texture of his still lifes.

The outline should therefore be a result of the colors if the world is to be given in its true density. For the world is a mass without gaps, a system of colors across which the receding perspective, the outlines, angles, and curves are inscribed like lines of force; the spatial structure vibrates as it is formed. "The outline and the colors are no longer distinct from each other. To the extent that one paints, one outlines; the more the colors harmonize, the more the outline becomes precise. . . . When the color is at its richest, the form has reached plenitude." Cézanne does not try to use color to *suggest* the tactile sensations which would give shape and depth. These distinctions between touch and sight are unknown in primordial perception. It is only as a result of a science of the human body that we finally learn to distinguish between our senses. The lived object is not rediscovered or constructed on the basis of the contributions of the senses; rather, it presents itself to us from the start as the center from which these contributions radiate. We *see* the depth, the smoothness, the softness, the hardness of objects; Cézanne even claimed that we see their odor. If the painter is to express the world, the arrangement of his colors must carry with it this indivisible whole, or else his picture will only hint at things and will not give them in the imperious unity, the presence, the insurpassable plenitude which is for us the definition of the real. That is why each brushstroke must satisfy an infinite number of conditions. Cézanne sometimes pondered hours at a time before putting down a certain stroke, for, as Bernard said, each stroke must "contain the air, the light, the object, the composition, the character, the outline, and the style." Expressing what *exists* is an endless task.

Nor did Cézanne neglect the physiognomy of objects and faces: he simply wanted to capture it emerging from the color. Painting a face "as an object" is not to strip it of its "thought." "I realize that the painter interprets it," said Cézanne. "The painter is not an imbecile." But this interpretation should not be a reflection distinct from the act of seeing. "If I paint all the little blues and all the little maroons, I capture and convey his glance. Who gives a damn if they want to dispute how one can sadden a mouth or make a cheek smile by wedding a shaded green to a red." One's personality is seen and grasped in one's glance, which is, however, no more than a combination of colors. Other minds are given to us only as incarnate, as belonging to faces and gestures. Countering with the distinctions of soul and body, thought and vision is of no use here, for Cézanne returns to just that primordial experience from which these notions are derived and in which they are inseparable. The painter who conceptualizes and seeks the expression first misses the mystery—renewed every time we look at someone—of a person's appearing in nature. In *La Peau de chagrin* Balzac describes a "tablecloth white as a layer of newly fallen snow, upon which the place-settings rise sym-

metrically, crowned with blond rolls." "All through youth," said Cézanne, "I wanted to paint that, that tablecloth of new snow. . . . Now I know that one must will only to paint the place-settings rising symmetrically and the blond rolls. If I paint 'crowned' I've had it, you understand? But if I really balance and shade my place-settings and rolls as they are in nature, then you can be sure that the crowns, the snow, and all the excitement will be there too."

We live in the midst of man-made objects, among tools, in houses, streets, cities, and most of the time we see them only through the human actions which put them to use. We become used to thinking that all of this exists necessarily and unshakeably. Cézanne's painting suspends these habits of thought and reveals the base of inhuman nature upon which man has installed himself. This is why Cézanne's people are strange, as if viewed by a creature of another species. Nature itself is stripped of the attributes which make it ready for animistic communions: there is no wind in the landscape, no movement on the Lac d'Annecy; the frozen objects hesitate as at the beginning of the world. It is an unfamiliar world in which one is uncomfortable and which forbids all human effusiveness. If one looks at the work of other painters after seeing Cézanne's paintings, one feels somehow relaxed, just as conversations resumed after a period of mourning mask the absolute change and give back to the survivors their solidity. But indeed only a human being is capable of such a vision which penetrates right to the root of things beneath the imposed order of humanity. Everything indicates that animals cannot *look at* things, cannot penetrate them in expectation of nothing but the truth. Emile Bernard's statement that a realistic painter is only an ape is therefore precisely the opposite of the truth, and one sees how Cézanne was able to revive the classical definition of art: man added to nature.

Cézanne's painting denies neither science nor tradition. . . . "The landscape thinks itself in me," he said, "and I am its consciousness." Nothing could be farther from naturalism than this intuitive science. Art is not imitation, nor is it something manufactured according to the wishes of instinct or good taste. It is a process of expressing. Just as the function of words is to name—that is, to grasp the nature of what appears to us in a confused way and to place it before us as a recognizable object—so it is up to the painter, said Gasquet, to "objectify," "project," and "arrest." Words do not *look like* the things they designate; and a picture is not a *trompe-l'oeil*. Cézanne, in his own words, "wrote in painting what had never yet been painted, and turned it into painting once and for all." Forgetting the viscous, equivocal appearances, we go through them straight to the things they present. The painter recaptures and converts into visible objects what would, without him, remain walled up in the separate life of each consciousness: the vibration of appearances which is the cradle of things. Only one emotion is possible for this painter—the feeling of strangeness—and only one lyricism—that of the continual rebirth of existence.

. . . The artist is the one who arrests the spectacle in which most men take part without really seeing it and who makes it visible to the most "human" among them.

There is thus no art for pleasure's sake alone. One can invent pleasurable objects by linking old ideas in a new way and by presenting forms that have been seen before. This way of painting or speaking at second hand is what is generally meant by culture. Cézanne's or Balzac's artist is not satisfied to be a cultured animal but assimilates the culture down to its very foundations and gives it a new structure: he speaks as the first man spoke and paints as if no one had ever painted before. What he expresses cannot, therefore, be the translation of a clearly defined thought, since such clear thoughts are those which have already been uttered by ourselves or by others. "Conception" cannot precede "execution." . . .

Cézanne's difficulties are those of the first word.

"HOW CÉZANNE SAW AND USED COLOUR" (1951)

Gerhard J. R. Frankl

Since Emile Bernard published his reminiscences in 1920, and Roger Fry his critical analysis in 1927, the literature on Cézanne has become very vast. Yet it is, I think, strange that so far no attempt seems to have been made to answer the simple question: "What has Cézanne done and how did he do it?" All those articles and books on Cézanne describe isolated aspects of his work, facets, if you like, of his achievement, but the isolated "symptoms" do not seem to hang together. The interpreters of Cézanne have failed to achieve what he himself thought was of supreme importance when he said: "One must unite in one belief that which is dispersed."

My aim here is to define Cézanne's central belief, his "formula," the optical experience which he had and which, I think, everyone can have—up to a point—who takes the trouble to look with attention at colour relations. We have frequently heard it said— . . . —that Cézanne applied colour to form. I do not think that any painter ever did anything else. We must try to answer the specific question "How did Cézanne apply colour to form?" Only then shall we be able to assess the role of Cézanne.

I must confine myself here to the barest skeleton. We know that Impressionism was Cézanne's raw material. He has said: "I wanted to make Impressionism into an art as solid and as lasting as the art of museums." If we think of a typical Impressionist painter, say, Monet, and if we imagine him at work, then we realise (and of course we also know it from eye-witness accounts) that he tried to catch nature on the wing. Monet had separate canvases for almost each hour of his working day. He would have been unable to go on working on a picture while the light changed and the sun cast new shadows. In Cézanne's case it was different. He, too, worked from nature but he went on for many hours, and it has often been noticed that he rarely depicted such changing features

Gerhard J. R. Frankl, "How Cézanne Saw and Used Colour," *The Listener,* October 25, 1951, pp. 685–686. By permission of *The Listener.*

as cast shadows. He wanted, as a child once said in, I think, a moving way, "to paint what is always there."

So, you see, both the Impressionists and Cézanne painted from nature; but their optical approach must have been different. The optics of Impressionism are well known. We know that seen side by side, in juxtaposition, colours look different from what they look singly, in isolation. For instance, the moment we put some red apples in front of a plain grey wall, the grey wall will look distinctly greenish. This effect is called "colour induction," and these subjective, physiological colours—like the green which appears on the grey wall—are called "inducted colours." They are produced and projected by the eye as it were in protest against irritation. The inducted colours which the eye produces are the opposite colours—the complementaries—of the "real" ones: and so the red apples produce, or "induce," green. This subjective green will influence the "real" red and make it appear stronger, and this process of mutual influence, of mutual colour induction, will go on and produce ever subtler hues. The real Impressionists put these perceptions one after the other on their canvases, and they also superimposed them. Therefore the Impressionists first made visible the important change which makes a grey wall look greenish, and then they added the "finer shades" —those lovely mother-of-pearl tones. But—and it is a serious "but"—the first great change which makes a grey wall into a greenish wall also makes it "lose its identity." The grey wall loses what is called its "local colour"; and that is precisely what Cézanne wanted to avoid. He said: "One must preserve local colour, like the Venetians."

What happened in Cézanne's case? We know that he stared at nature for a long time before he put down even one brush stroke. Was he just a slow worker, and clumsy, as people thought on the occasion of the Post-Impressionist Exhibition of 1911? Let us try to see what happens if we stare for a fairly long time at a colour contrast, for example at those red apples in front of the grey wall. If we do that, if we persist in watching the colour contrast, we can experience something extremely curious. First, of course, the wall—a large part of it—looks greenish, and we still feel that it is at a distance from the apples. But if we go on looking, the subjective green of the wall will seem to shrink, to condense, to coagulate if you like, into a fairly sharply defined rim round the apples—a rim of rather strong green. And this rim "belongs" decisively to the edge of the red. When this happens, when we see this pair of colours formed, then, at the same moment, the distance between the apples and the wall seems to vanish—quite magically.

I first noticed this phenomenon in 1924. Since then many experiments have been made, and recently a little apparatus has been devised which shows this effect clearly. What happens is that the eye gradually sums up or integrates the subjective colours which it produces, and makes them into simple, final colours. Then the eye perceives any colour contrast by oscillating between the neighbouring colours; and so, in due course, it seems to "stitch them together" so that they appear in one plane. The shrinking of the area affected by the physiological, "inducted" colour

means, of course, that the objects "keep their identity," that they do not lose their local colour. Remember that Cézanne was very anxious to preserve local colour.

MISSING LINK BETWEEN
COLOUR AND FORM?

I believe, and some scholars agree, that this physiological experience has a great deal to do with Cézanne's painting, and not only with Cézanne's painting; I think that we have here the missing link between his colour and his form; between his coloured form and his perspective. This contention is far from self-evident. But let us have another look at our apples—perhaps they will look even more like a Cézanne if we try again. Our first experiment has already produced two characteristics which are typical of Cézanne: the final pairs of strong colour, and the lack of naturalistic depth. But when you watch more carefully you can see something else which is equally important. When the final colours are formed by the eye, when they appear, then the outline where they meet will look much simplified, more monumental. The final, or "integrated" colours create their own drawing, and a much monumentalised drawing it is. This again is a gradual process, as Cézanne said himself: "Step by step as the colours become more harmonious, the drawing becomes more precise."

I would like now to consider another major riddle: the relation between Cézanne's colour and his perspective. On this the Cézanne literature is particularly sketchy. Nearly every writer noted that Cézanne —in contrast to the Impressionists—did not use the linear or, if you like, Renaissance perspective, and some noticed that he used several horizons, and occasionally also several viewpoints. But as so often in the case of Cézanne, confusion is caused because traditional devices are ascribed to him as if he had invented them. And then most writers on Cézanne tended to confuse Cézanne's mind with that of his followers who think in terms of "planes parallel to the picture plane"; and who concern themselves with all sorts of other sophisticated devices; such things are indeed important features of Cézanne's pictures, but they are by-products of his vision rather than something he intellectually aimed at.

Why are those "planes parallel to the picture plane" automatically produced by Cézanne's way of contemplating colour? You need only look at a tree in front of one of those mean suburban red-brick houses to get the answer. The two colours inside and just outside the left edge of our tree will appear in one plane—one colour belongs to the red house, and one to the tree; but the pair on the right will also appear in one plane, even if the house goes away from us towards the right, even if it is foreshortened. And since the two pairs are in one plane anyway, because they belong to the same tree, we see the far side of the house as near as the near side; that is to say the house cannot possibly be represented as foreshortened. Again, Cézanne's corrections fully bear out that

he had no *a priori* scheme; he gradually achieved transformations which will always appear magical to us.

I would hate to fall into an obvious trap: we must not say that Cézanne was merely reproducing what physiology dictated to him. True enough, he himself has often insisted that the slightest letting-up, the slightest lack of visual concentration, ruined everything. But he was not simply a trance-painter. He had seen very clearly that the Venetians had painted with a similar vision and technique before him. This is an important point: if you look at a Byzantine mosaic you will at once notice the—in this case—very obvious strips of integrated colour, and you will see that the mosaics do not suggest natural depth. In short, a mosaic looks very much like a Cézanne who, by the way, never saw a mosaic in his life. But again, if you look at a typical Venetian painting—and I mean a typical Venetian painting in Cézanne's sense: Titian, Veronese, Tintoretto—then the mosaic technique is there, too, only less obviously so. The Venetians adopted this technique from the Byzantines, and the Byzantines quite possibly preserved in their mosaics something of the essential Greek heritage. It is quite possible that the use of integrated colour belongs to the great Greek heritage, and that it was originally the counterpart in colour of the Greek bas-relief. In these bas-reliefs we find again plastic forms strongly linked to each other without undercutting, and there also everything takes places within the limits of a shallow stage. Indeed, you need only think of the development of Titian's work to realise that his compositions became more and more frieze-like, that his stage became shallower, and that the total depth of his paintings became more and more limited just in the sense of the Greek bas-reliefs. Now think of Cézanne. It is exactly the same development. From the moment he consciously adopted the use of what we tentatively call integrated colour in 1872, he made his pictures and particularly his landscapes more and more into clearly defined and limited reliefs. He finally even had to treat the sky as a solid. He had to.

Thus colour, form, and perspective cannot be separated. They are linked together by colour contemplation. The far-reaching effect of colour contemplation can be tested and demonstrated. At the beginning I said that we should be able to find out how Cézanne applied colour to form. The optical experience which I have just described does still not quite answer this question because our experience only explains how and why Cézanne's objects are linked together—or how and why the objects on mosaics or on Venetian paintings are linked together; but we have not yet discovered how the modelling takes place, how any of these artists in the Greek tradition found the colour elements which express form. Cézanne has described this process with perfect lucidity; but since people never bothered to try his method of colour contemplation, they could not make head or tail of Cézanne's description, which was even called nonsensical by a prominent Cézanne scholar. Now what Cézanne said was, in effect, that the formation of final colours on the edges sets off a chain reaction. That is to say the artist is forced to find similar simple colours as he progresses towards the centre of his objects. This

process was definitely known to Goethe, who described it in his *Treatise on Colour,* of 1808. You may remember that often there is a white spot at the centre of, say, a hand or an apple painted by Cézanne. Well, he bitterly complained about these troublesome white spots. His difficulty was that if he used too high a key on the edge, he would have no room left for the covering touch in the middle—that is to say, in such a case he could not cover the white spot.

There are still one or two things which should be mentioned. First, about Cézanne's development. There is little doubt that Cézanne discovered the Venetian—or Greek, if you like—colour vision in the Louvre. As early as 1869 he painted the "Railway Cutting," now in Munich, where the use of integrated colour is pushed to an extent never surpassed in his work. But during 1870 and 1871, when he was in hiding at the Estaque, he fell back into the temperamental, earlier manner, and it was only when he met Pissarro again in 1872 that he was—I may say—thunderstruck: Pissarro had already used these "final" colours in his early paintings. Cézanne at once copied one of them, and from then onwards he never looked back. It is rather difficult to imagine an artist working at one fundamental conception for about thirty-five years. It is remarkable that during these thirty-five years he was driven to repeat the development of mosaic from the fifth to the eighth centuries. He first modelled his objects round and round, with long curved brush strokes of varying direction. This phase corresponds to the mosaics of the fifth century. Then he found this method a little awkward and brutal, and so, about 1879, he discovered the overall pattern of brush strokes where all the brushwork goes in one direction, nearly vertical. This corresponds to the mosaic technique which led to the finest works from the sixth to the eighth century.

MAN OF DESTINY

Shortly before 1890, Cézanne again found himself in an *impasse:* he had used the final—integrated—colours for descriptive purposes, and that was not satisfactory. It would not be fair to attempt a description of the last phase in the few moments which remain to me. But it should be said that by applying the essentially Greek tradition of colour vision to the direct representation of nature Cézanne became an intensely traditional and an immensely revolutionary painter. More, perhaps, than any other European painter he was a man of destiny. By completing the circle of classical tradition he at the same time demolished it. When Cézanne died, the young painters turned to barbaric art. But, and that is very important, they borrowed their formal means from Cézanne. Cézanne's work which had been held together by humility and obedience, was now dissected; it quickly disintegrated into its components: into the strong colour which in Cézanne's case was not merely decorative but heightened colour; it disintegrated into the simplified drawing which in Cézanne was not arbitrary; and into the new, or seemingly new, ap-

proach to perspective—which led to poster, children's art, and Dada. Cézanne became so influential and in so many ways becau.;e he applied the traditional Greek method to the direct representation of nature. By doing this Cézanne both fulfilled the Greek heritage, and became an innovator of extraordinary and bewildering influence.

FROM "CÉZANNE AND THE UNITY OF MODERN ART" (1951)

Clement Greenberg

Cézanne, as is generally enough recognized, is the most copious source of what we know as modern art, the most abundant generator of ideas and the most enduring in newness. The modernity of his art, its very stylishness—more than a retroactive effect—continues. There remains something indescribably racy and sudden—racier than Dufy, as sudden as Picasso or Matisse—in the way his crisp blue line separates the contour of an apple from its mass. Yet how distrustful he was of bravura, speed—all the attributes that go with stylishness. And how unsure down at bottom about where he was going.

On the verge of middle age Cézanne had the crucial revelation of his artist's mission; yet what he thought was revealed was in good part inconsistent with the means he was already developing under the impact of the revelation. The problematic quality of his art—the source, perhaps, of its unfading modernity—and of which he himself was aware, came from the ultimate necessity of revising his intentions under the pressure of a style that evolved as if in opposition to his conscious aims. He was making the first—and last—pondered effort to save the intrinsic principle of the Western tradition of painting: its concern with an ample and literal rendition of the illusion of the third dimension. He had noted the Impressionists' inadvertent silting up of pictorial depth. And it is because he tried so hard to re-excavate that depth without abandoning Impressionist color, and because his attempt, while vain, was so profoundly conceived, that his work became the discovery and turning point it did. Completing Manet's involuntary break with Renaissance tradition, he fell upon a new principle of painting that carried further into the future. Like Manet and with almost as little appetite as he for the role of revolutionary, he changed the course of art out of the very effort to return it by new paths to its old ways. . . .

Recording with a separate dab of paint almost every perceptible—

Clement Greenberg, "Cézanne and the Unity of Modern Art," *Partisan Review*, May–June 1951, pp. 323–330, these excerpts, pp. 324, 326, 327. By permission of the author.

or inferred—shift of direction by which the presented surface of an object defines the shape of the volume it encloses, he began in his late thirties to cover his canvases with a mosaic of brush-strokes whose net effect was to call attention to the physical picture plane just as much as the tighter-woven touches of the orthodox Impressionists did. The distortions of Cézanne's drawing, provoked by the extremely literal exactness of his vision as well as by a growing compulsion, more or less unconscious, to adjust the representation in depth to the two-dimensional surface pattern, contributed further to his inadvertent emphasis on the flat plane. Whether he wanted it or not—and one can't be sure he did —the resulting ambiguity was a triumph of art, if not of naturalism. A new and powerful kind of pictorial tension was set up such as had not been seen in the West since the mosaic murals of fourth and fifth century Rome. The little overlapping rectangles of paint, laid on with no attempt to fuse their dividing edges, drew the depicted forms toward the surface while, at the same time, the modeling and contouring of these forms, as achieved by the paint dabs, pulled them back again into illusionist depth. The result was a never-ending vibration from front to back and back to front. The old masters had generally sought to avoid effects like this by blending their brush-strokes and covering the surface with glazes to create a neutral, translucent texture through which the illusion could glow with the least acknowledgment of the medium—*ars est artem celare*. This is not to say, however, that they paid no heed at all to surface pattern; they did. But given their different aim, they put a different, less obvious yet less ambiguous emphasis upon it. Cézanne, in spite of himself, was trying to give the picture surface its due as a physical entity. The old masters had conceived of it more abstractly. . . .

. . . Cézanne's desire to give Impressionism a solid aspect was thus shifted in its fulfillment from the structure of the pictorial illusion to the configuration of the picture as an object—as a flat surface. He got the solidity he was after, but it became in large part a two-dimensional solidity. It could hardly have been otherwise in any case once he abandoned modeling in darks and lights—even though his perception of cool tones such as green and blue in receding planes preserved something of the essence of that kind of modeling. This too was a factor in the play of tensions.

The real problem would seem to have been, not how to re-do Poussin according to nature, but how to relate more carefully than he had every part of the illusion in depth to a surface pattern endowed with equally valid aesthetic rights. The firmer binding of the three-dimensional illusion to a decorative surface effect, the integration of plasticity and decoration—that was the true object of Cézanne's quest.

FROM *PAUL CÉZANNE* (1952)

Meyer Schapiro

The mature paintings of Cézanne offer at first sight little of human interest in their subjects. We are led at once to his art as a colorist and composer. He has treated the forms and tones of his mute apples, faces, and trees with the same seriousness that the old masters brought to a grandiose subject in order to dramatize it for the eye. His little touches build up a picture-world in which we feel great forces at play; here stability and movement, opposition and accord are strongly weighted aspects of things. At the same time the best qualities of his own nature speak in Cézanne's works: the conviction and integrity of a sensitive, meditating, robust mind.

It is the art of a man who dwells with his perceptions, steeping himself serenely in this world of the eye, though he is often stirred. Because this art demands of us a long concentrated vision, it is like music as a mode of experience—not as an art of time, however, but as an art of grave attention, an attitude called out only by certain works of the great composers.

Cézanne's art, now so familiar, was a strange novelty in his time. It lies between the old kind of picture, faithful to a striking or beautiful object and the modern "abstract" kind of painting, a moving harmony of colored touches representing nothing. Photographs of the sites he painted show how firmly he was attached to his subject; whatever liberties he took with details, the broad aspect of any of his landscapes is clearly an image of the place he painted and preserves its undefinable spirit. But the visible world is not simply represented on Cézanne's canvas. It is re-created through strokes of color among which are many that we cannot identify with an object and yet are necessary for the harmony of the whole. If his touch of pigment is a bit of nature (a tree, a fruit) and a bit of sensation (green, red), it is also an element of construction which binds sensations or objects. The whole presents itself to

Meyer Schapiro, *Paul Cézanne* (Harry N. Abrams, Inc., New York, 1st edition 1952, 2nd edition 1962, 3rd edition 1965); these excerpts, pp. 9–10, 14–17, 19–20, 27. By permission of the author and publisher.

133

us on the one hand as an object-world that is colorful, varied, and harmonious, and on the other hand as the minutely ordered creation of an observant, inventive mind intensely concerned with its own process. The apple looks solid, weighty, and round as it would feel to a blind man; but these properties are realized through tangible touches of color each of which, while rendering a visual sensation, makes us aware of a decision of the mind and an operation of the hand. In this complex process, which in our poor description appears too intellectual, like the effort of a philosopher to grasp both the external and the subjective in our experience of things, the self is always present, poised between sensing and knowing, or between its perceptions and a practical ordering activity, mastering its inner world by mastering something beyond itself.

To accomplish this fusion of nature and self, Cézanne had to create a new method of painting. The strokes of high-keyed color which in the Impressionist paintings dissolved objects into atmosphere and sunlight, forming a crust of twinkling points, Cézanne applied to the building of solid forms. He loosened the perspective system of traditional art and gave to the space of the image the aspect of a world created free-hand and put together piecemeal from successive perceptions, rather than offered complete to the eye in one coordinating glance as in the ready-made geometrical perspective of Renaissance art. The tilting of vertical objects, the discontinuities in the shifting levels of the segments of an interrupted horizontal edge contribute to the effect of a perpetual searching and balancing of forms. Freely and subtly Cézanne introduced besides these nice variations many parallel lines, connectives, contacts, and breaks which help to unite in a common pattern elements that represent things lying on the different planes in depth. A line of a wall is prolonged in the line of a tree which stands further back in space; the curve of a tree in the foreground parallels closely the outline of a distant mountain just below it on the surface of the canvas (Fig. 10). By such means the web of colored forms becomes more cohesive and palpable, without sacrifice of the depth and weight of objects. These devices are the starting point of later abstract art which proceeds from the constructive function of Cézanne's stroke more than from his color. But however severely abstracted his forms may seem, the strokes are never schematic, never an ornament or a formula. The painting is finally an image and one that gives a new splendor to the represented objects.

Cézanne's method was not a foreseen goal which, once reached, permitted him to create masterpieces easily. His art is a model of steadfast searching and growth. He struggled with himself as well as his medium, and if in the most classical works we suspect that Cézanne's detachment is a heroically achieved ideal, an order arising from mastery over chaotic impulses, in other works the conflicts are admitted in the turbulence of lines and colors. . . .

Some will object that the themes of a painter have little to do with the value or character of his art. But I believe it is revealing to consider Cézanne's paintings as images of the real world—in doing so

we have the support of his letters in which he often speaks of his joy in the sites he paints and the importance of his sensations and emotions before the bit of nature he selects for painting. The kind of objects that attract him, his point of view in representing them, count for something in the final aspect of the pictures and bring us nearer to his feelings.

His landscapes rarely contain human figures. They are not the countryside of the promenader, the vacationist, and the picnicking groups, as in Impressionist painting; the occasional roads are empty, and most often the vistas or smaller segments of nature have no paths at all. In many pictures the landscape, seen from an elevation, is cut off from the spectator by a foreground of parallel bands or by some obstacle of rocks or trees. We are invited to look, but not to enter or traverse the space. Cézanne has given us an ideal model in the painting of a path to a house which is blocked by a barrier in the foreground. Elsewhere a deep pit or quarry lies between us and the main motive; or steep rocks obstruct the way inward. The ground itself, extending into the far distance, is often broken and difficult, without the neat roads, marked by trees and buildings, that carry us through the breadth and depth of the land in the earliest Western landscapes. The nature admired and isolated by Cézanne exists mainly for the eye; it has little provision for our desires or curiosity. Unlike the nature in traditional landscape, it is often inaccessible and intraversable. This does not mean that we have no impulse to explore the entire space; but we explore it in vision alone. The choice of landscape sites by Cézanne is a living and personal choice; it is a space in which he can satisfy his need for a detached, contemplative relation to the world. Hence the extraordinary calm in so many of his views—a true suspension of desire.

The same—or a similar—attitude governs also his choice of still life. This may seem paradoxical, for the idea of still life—an intimate theme—implies another point of view than landscape. Indeed, Cézanne is unique among painters in that he gives almost equal attention to both types of subject. We can hardly imagine Poussin as a painter of still life or Chardin as a landscapist. Yet common to both themes is their relative inertness, their non-human essence. That Cézanne was able to represent still life and landscape alike shows how deeply he was possessed by this need for painting what is external to man. But in the still life, as in the landscape, it is the choice of objects and his relation to them that are important. Here again we discover a unique attitude which is significant for his art as a whole.

Still life in older painting consists mainly of isolated objects on the table conceived as food or decoration or as symbols of the convivial and domestic, or as the instruments of a profession or avocation; less common are the emblems of moral ideas, like vanity. Things that we manipulate and that owe their positions to our handling, small artificial things that are subordinate to ourselves, that serve us and delight us—still life is an extension of our being as masters of nature, as artisans and tool users. Its development coincides with the growth of landscape; both

belong to the common process of the humanizing of culture through the discovery of nature's all-inclusiveness and man's power of transforming his environment.

Cézanne's still life is distinctive through its distance from every appetite but the aesthetic-contemplative. The fruit on the table, the dishes and bottles, are never chosen or set for a meal; they have nothing of the formality of a human purpose; they are scattered in a random fashion, and the tablecloth that often accompanies them lies rumpled in accidental folds. Rarely, if ever, do we find in his paintings, as in Chardin's, the fruit peeled or cut; rarely are there choice *objets d'art* or instruments of a profession or hobby. The fruit in his canvases are no longer parts of nature, but though often beautiful in themselves are not yet humanized as elements of a meal or decoration of the home. (Only in his early works, under Manet's influence, does he set up still lifes with eggs, bread, a knife, and a jug of wine.) The world of proximate things, like the distant landscape, exists for Cézanne as something to be contemplated rather than used, and it exists in a kind of pre-human, natural disorder which has first to be mastered by the artist's method of construction.

The qualities of Cézanne's landscapes and still lifes are also present in his human themes, at least after 1880.

Many writers have remarked on the mask-like character of Cézanne's portraits. The subject seems to have been reduced to a still life. He does not communicate with us; the features show little expression and the posture tends to be rigid. It is as if the painter has no access to the interior world of the sitter, but can only see him from outside. Even in representing himself, Cézanne often assumes an attitude of extreme detachment, immobilized and distant in contemplating his own mirror image. The suspended palette in his hand is a significant barrier between the observer and the artist-subject.

This impersonal aspect of the portraits is less constant than appears from our description. If their abstractness determines the mood of some portraits, there are others of a more pathetic, responsive humanity.

The idea of painting portraits, foreign to Poussin, is already an avowal of interest in a living individual. We must admit that Cézanne's contemplative position varies with his objects (and with his mood at the moment); some draw him nearer than others, involving him in a current of emotion.

But as we turn from the isolated human figure to the group, entering the domain of the social, his detachment becomes even more marked than in the landscapes. His bathers, and especially the women, are among the least "natural" of all his subjects. Except for secondary distant figures in a few versions, there is little sportiveness among these idyllic nudes in the open air. Most often they neither bathe nor play, but are set in constrained, self-isolating, thoughtful postures. They belong together as bathing figures, but like his still life objects their relations are indeterminate and we can imagine other groupings of their bodies which will not change their meaning. Transpositions of older images of mythical nudes,

which expressed a dream of happiness in nature (still vivid in Renoir's pictures), Cézanne's bathers are without grace or erotic charm and retain in their unidealized nakedness the awkward forms of everyday, burdened humanity. The great statuesque nude [Fig. 8] in the Museum of Modern Art stands for all the bathers in the strange combination of walking and pensiveness, with contrasted qualities of the upper and lower body.

The *Card Players* (Fig. 15) is perhaps the clearest example of Cézanne's attitude in interpreting a theme. It is a subject that has been rendered in the past as an occasion of sociability, distraction, and pure pastime; of greed, deception, and anxiety in gambling; and the drama of rival expectations. In Cézanne's five paintings of the theme we find none of these familiar aspects of the card game. He has chosen instead to represent a moment of pure meditation—the players all concentrate on their cards without show of feeling. They are grouped in a symmetry natural to the game; and the shifting relation between rules, possibility, and chance, which is the objective root of card playing, is intimated only in the silent thought of the men. Cézanne might have observed in an actual game just such a moment of uniform concentration; but it is hardly characteristic of the peasants of his Provence—their play is convivial and loud. In selecting this intellectual phase of the game—a kind of collective solitaire—he created a model of his own activity as an artist. For Cézanne, painting was a process outside the historical stream of social life, a closed personal action in which the artist, viewing nature as a world of variable colors and forms, selected from it in slow succession, after deliberating the consequence of each choice for the whole, the elements of his picture. (In a letter to Pissarro he has likened the landscape of L'Estaque to playing cards, but what he had in mind were the stark contrasts of the colors of the bright Provençal scene, as in the flat primitive designs on the cards.) The painting is an ordered whole in which, as Cézanne said, sensations are bound together logically, but it is an order that preserves also the aspect of chance in the appearance of directly encountered things.

Observation of his subjects shows then a fairly uniform or dominant attitude. Within the broad range of themes—and no other artist of his time produced this variety, at least in these proportions—Cézanne preserves a characteristic meditativeness and detachment from desire. His tendency coincides with what philosophers have defined as the aesthetic attitude in general: the experience of the qualities of things without regard to their use or cause or consequence. But since other painters and writers have responded to the religious, the moral, the erotic, the dramatic, and practical, creating for aesthetic contemplation works in which the entire scope of everyday life is imaged, it is clear that the aesthetic attitude to the work of art does not exclude a subject matter of action or desire, and that Cézanne's singular choice represents an individual viewpoint rather than the necessary approach of artists. The aesthetic as a way of seeing has become a property of the objects he looks at; in most of his pictures, aesthetic contemplation meets nothing that will awaken

curiosity or desire. But in this far-reaching restriction, which has become a principle in modern art, Cézanne differs from his successors in the twentieth century in that he is attached to the directly seen world as his sole object for meditation. He believes—as most inventive artists after him cannot do without some difficulty or doubt—that the vision of nature is a necessary ground for art. . . .

Cézanne once expressed the wish to paint nature in complete naiveté of sensation, as if no one had painted it before. Given this radically empirical standpoint, we can understand better his deformations of perspective and all those strange distortions, swellings, elongations, and tiltings of objects that remind us sometimes of the works of artists of a more primitive style who have not yet acquired a systematic knowledge of natural forms, but draw from memory and feeling. We cannot say how much in Cézanne's distortions arises from odd perceptions, influenced by feeling, and how much depends on calculations for harmony or balance of forms. In either case there is an expressive sense in the deformation, which will become apparent if we try to substitute the correct form. Some accent or quality of expression will be lost, as well as the coherence of the composition which has been built around this element. In general, one may say that for Cézanne a strict perspective would be too impersonal and abstract a form. The lines converging precisely to a vanishing point, the objects in the distance becoming smaller at a fixed rate, would constitute too rigid a skeleton of vision, a complete projective system which precedes the act of painting and limits the artist. But with his desire for freshness of sensation, he could retain those space-building devices which are not bound to a fixed armature of converging lines: the overlapping of objects and the variation of contrast of tones from the foreground to the distance. The loosening of perspective had already been prepared by the Impressionists and older artists who were more attentive to color, light, and atmosphere than to the outlines of things and painted directly from nature, without a preliminary guiding framework. But Cézanne's deviations, which are accompanied by a restoration of objects, have other roots.

How are these peculiarities of form related to Cézanne's conception of the objects? We have observed that just as he often selects themes which have little attraction for desire, he represents objects in space so as to reduce the pull of perspective to the horizon; the distant world is brought closer to the eye, but the things nearest to us in the landscape are rendered with few details—there is little difference between the textures of the near and far objects, as if all were beheld from the same distance. To his detached attitude correspond also those distortions and breaks that reduce the thrust of dominant axes and effect a cooler expression. Cézanne's vision is of a world more stable and object-filled and more accessible to prolonged meditation than the Impressionist one; but the stability of the whole is the resultant of opposed stable and unstable elements, including the arbitrary tiltings of vertical objects which involve us more deeply in his striving for equilibrium. In the composition, too, our passions are stilled or excluded; only rarely is there a dramatic

focus or climax in the grouping of objects and their rich colors. The composition lacks in most cases—the *Women Bathers* and the *Card Players* are exceptions—an evident framework of design, an ideal schema to which the elements have been adapted and that can be disengaged like the embracing triangle in older art. The bond between the elements, the principle of grouping, is a more complex relationship emerging slowly in the course of work. The form is in constant making and contributes an aspect of the encountered and random to the final appearance of the scene, inviting us to an endless exploration. The qualities of the represented things, simple as they appear, are effected by means that make us conscious of the artist's sensations and meditative process of work; the well-defined, closed objects are built up by a play of open, continuous and discontinuous, touches of color. The coming into being of these objects through Cézanne's perceptions and constructive operations is more compelling to us than their meanings or relation to our desires, and evokes in us a deeper attention to the substance of the painting.

The marvel of Cézanne's classicism is that he is able to make his sensing, probing, doubting, finding activity a visible part of the painting and to endow this intimate, personal aspect with the same qualities of noble order as the world that he has imaged. He externalizes his sensations without strong bias or self-assertion. The sensory element is equally vivid throughout and each stroke carries something of the freshness of a new sensation of nature. The subjective in his art is therefore no isolated, capricious thing, but a manifestation of the same purity as the beautiful earth, mountains, fruit, and human forms he represents. . . .

Much has been written about Cézanne's new rigor of composition and plastic use of color; but I would emphasize the importance of the object for this new style. There is here a kind of empiricism, naïve and deeply sincere, which is a necessary condition of the new art. In reconstituting the object out of his sensations, Cézanne submits humbly to the object, as if in atonement for the violence of his early paintings. The object has for him the same indispensable role that the devotion to the human body had for the Greeks in creating their classic sculpture. The cohesiveness, stability, and individual character that Cézanne strove for in the painting as a whole he also sought in realizing on the canvas the object before him. It is true that he had always been a studious painter of objects, and even in his Impressionist phase he rarely carried the dissolution of things in atmosphere and sunlight as far as did the other Impressionists. But compared to his older painting, the new weight and clearness of the object are a true reform of his art. Just before 1875 we observe in his landscapes and still lifes much unstable spotting, a rich, picturesque blur of color; the composition, though unified, is not as legible through the contours of things, and lacks the noble simplicity of the later works. The closer scrutiny of the object goes hand in hand with a firmer consolidation of the canvas as a whole. I should add, however, that the new feeling for the object is anticipated on the margin of the Impressionist style, in the early 1870's, in his careful studies of still life which are like exercises—little paintings of a few apples, precious for

the purity of vision of the roundness and color of the fruit. In the 1880's, Cézanne presents objects very simply and frankly, often in centered arrangements like the primitives, but with an aspect of chance in the varied positions and overlappings, which are balanced with a powerful ingenuity. Cézanne had been thinking seriously about the grouping as well as the appearance of objects, and had no doubt learned much from the masters in the Louvre. . . .

What strikes us most of all in the 1890's is the resurgence of intense feeling—it may be related to the new tendencies of the forms with their greater movement and intricacy. The work of his last years offers effects of ecstasy and pathos which cannot be comprised within the account of Cézanne's art as constructive and serene. The emotionality of his early pictures returns in a new form.

The truth is that it had never died out. When Cézanne in the 1870's was converted to the Impressionist method, he repudiated romantic art in ironical sketches of a *Homage to Woman* in which the painter, the poet, the musician, and the priest all celebrate the Eternal Feminine who poses in shameless nudity before them. He continued to paint the nude, at first in versions of Saint Anthony's temptation, then in groups of bathers who recall in their postures the nude women of the hermit's imagination. But later there are bacchanals, scenes of violent passion, and copies' of Delacroix's *Medea Slaying Her Children* and *The Abandoned Hagar and Ishmael in the Wilderness*. These fanciful themes are only a small part of Cézanne's later work and had little effect on the main course of his art after 1880. Yet it is worth noting these exceptional pictures—they permit us to see more clearly how the new art rests on a deliberate repression of a part of himself which breaks through from time to time. The will to order and objectivity has the upper hand in the 1880's, although he does not exclude his feelings altogether. He understands the emotional root of his need for order and can speak of "an exciting serenity." Besides that strangely impersonal self-portrait in which the artist is assimilated to his canvas, easel, and palette, there is another, now in Bern, in which Cézanne, without signs of his profession, gazes at us in sadness and self-concern, a figure of delicate frame, painted with a feeling half-Gothic, half-Rembrandtesque. The inner world of solitude, despair and exaltation penetrates also some landscapes of this time. One of them, *The Great Tree*, a work of tumultuous feeling, with swaying form and tall crown of foliage silhouetted against the deep blue sky, revives the sentiment of verses about a tree that he had composed as a boy thirty years before, under the spell of the Romantic poets.

In the last years of his life he often seeks out themes of grandiose solitude. He loves the secluded, shadowy interiors of the woods, rocky ledges, unused quarries, ruined buildings—sites where man is no longer at home and which are marked by the violence of nature. He recreates on his canvases a space, still detached, but even farther from humanity, in which his old aggressive impulses have been transposed to nature itself. For the early scenes of murder and rape and gloomy introspection, he substitutes an abandoned catastrophic landscape. It is the world of a

hermit who is still occupied with his own impurity and guilt but can feel, too, in the stony or overgrown solitude some ecstasies of sense. He alternates between the dimness of the forest and the dry, burning heat of the sun in the silence of the quarry. Ideas of death are never far away. Returning to his studio, he delights in painting skulls upon the table where he had recently piled the red fruit and adjusted the folds of cloth. Among the great works of this time is the portrait of a young man meditating before a skull, like another hermit Jerome. (Is there here some identification with himself—the son remembering the father whom he had once pictured ironically with a skull at table?)

These ideas of solitude and death and nature's violence are not in themselves the ground of the baroque tendency in his forms, although it would be hard to imagine certain of these late scenes in the calm style of the 1880's. The angular view and greater depth of the still lifes, their new elaborateness, can hardly come from the same sentiment as the pictures of pathos. Yet, considered together beside the earlier phase, they are alike in their aspect of movement and intensity. The emotions of the contemplating mind have begun to have their say and stamp the painting with their mood, whether of melancholy or exaltation. . . .

Cézanne's accomplishment has a unique importance for our thinking about art. His work is a living proof that a painter can achieve a profound expression by giving form to his perceptions of the world around him without recourse to a guiding religion or myth or any explicit social aims. If there is an ideology in his work, it is hidden within unconscious attitudes and is never directly asserted, as in much of traditional art. In Cézanne's painting, the purely human and personal, fragmentary and limited as they seem beside the grandeur of the old content, are a sufficient matter for the noblest qualities of art. We see through his work that the secular culture of the nineteenth century, without cathedrals and without the grace of the old anonymous craftsmanship, was no less capable of providing a ground for great art than the authoritative cultures of the past. And this was possible, in spite of the artist's solitude, because the conception of a personal art rested upon a more general ideal of individual liberty in the social body and drew from the latter its ultimate confidence that an art of personal expression has a universal sense.

FROM *THE ART OF CÉZANNE* (1956)

Kurt Badt

FROM "CEZANNE'S SYMBOLISM
AND THE HUMAN ELEMENT
IN HIS ART"

Cézanne himself has given sufficient indication that a number of his pictures can be understood as symbolical representations of some of the events of his own life to induce me to interpret them thus and to feel justified in doing so. In developing this interpretation I became convinced beyond a shadow of a doubt that a great deal of his art had a meaning for him, even if he were at times himself unconscious of it. Moreover, the study of those works of his which can be so interpreted revealed the means he adopted of coming to terms with certain problems in his life.

In Cézanne's works there is not only a "symbolism of events" but also, parallel to that, a "symbolism of artistic design." This was based on an insight into the significance of visible phenomena, an insight which in turn had its origin in his experience and his understanding of the way in which his own life fitted into the world in which he lived.

The mere fact that he took his own person and destiny as subject-matter for his art marked Cézanne out as a modern painter; his modernity was further demonstrated by the fact (not unconnected) that loneliness played a great and significant rôle in his art. . . .

By dedicating himself wholly to his art, he now accepted [around 1870] the fate of loneliness as an essential prerequisite of his work, surrendered to it, and thereby gained that new view of the world which was expressed in all his work from now on. In place of the "angry

Originally published as *Die Kunst Cézannes* (Prestal-Verlag, Munich, 1956). English translation, *The Art of Cézanne*, by Sheila Ann Ogilvie (University of California Press, Berkeley and Los Angeles, 1965; copyright, Faber and Faber, Ltd., London, 1965). These excerpts, pp. 131, 142, 143, 147, 148, 150, 151, 157, 159, 160, 161, 162, 163, 164, 170, 181. By permission of Faber and Faber, Ltd., and University of California Press.

interpretation" there came a quiet, relaxed and solemn contemplation and understanding of people and things. This was the moment when Cézanne's art underwent that fundamental and final change of style which determined all his later work. Up till then his painting had in its "anger" oscillated among a variety of different ideals, because it possessed no sure stronghold, no anchor, no foundation; from now on, on the other hand, it developed along a straight line, ceased to change and search, because it had found a firm anchorage in the new attitude of the artist.

. . . The new attitude towards objects, which his pictures tell us he now achieved, could never have been acquired save through submission to that very loneliness which he had hitherto so greatly hated, and under which he had suffered so deeply. Here, indeed, we are not dealing simply with a change of technique or a new style. On the contrary—the warping, rigidity and distortion formerly seen in his works [before 1870] are no longer present, the objects depicted no longer show opposition towards one another; they are no longer subjected to an uneasy, melancholy pressure, heavy with gloom and despair, which seeks violently to force them together. They are now shown "standing together and existing together" in a way that is unforced and dignified, at first, it is true, somewhat uncertain and muddled, but becoming later ever more clear and unambiguous. Cézanne's world attained quiet, peace, harmony and unity; loneliness, which had hitherto created a feeling of intolerable suffering, now formed a foundation for a new and peaceful existence.

We are dealing here with a genuine "conversion," indeed one of a religious nature; not merely a rational conclusion that loneliness was inevitable and resistance senseless, but an inspired insight which was later to appear in his works. . . .

The transformation in Cézanne's attitude towards loneliness must be understood as an event brought about by faith. . . .

Cézanne, in contrast to [the Impressionists] of his time, did not take refuge in a vision of nature as something friendly, enlivened by the changing seasons, something which charmed and pleased the senses. Confronted with nature he did not forget his loneliness. Whereas other artists worked in an atmosphere of self-enjoyment, in a subjective and intimate relationship with the subjects which they were painting, which was intensified as they worked, Cézanne on the other hand painted in a state of self-oblivion, dedicating himself wholly to the objects into whose essential nature he sought to penetrate and preserving a permanently impregnable detachment. So his manner of recording nature in his works, in contrast to that of Pissarro, Monet, Renoir and Sisley, was still further demonstration of his innate religious attitude. . . .

. . . his attitude can only be properly described in the language of mysticism. . . . In general, however, the religious aspect of Cézanne's art was quite independent of the subject matter and was not specifically Christian. It was revealed rather in the way he tracked down the absolute, the ultimate and the timeless. In order to understand this,

one must bear in mind that it is possible to have a religious work of art of which the theme is absolutely and completely non-religious. Cézanne's religious "primary force," the "inner divine melody" which he discovered in all things, consisted of that which is permanent, and is preserved in permanency, the irremovable, the unmoving. . . . Cézanne reveals the deep, religious significance of the fact that life exists by his manner of representing and transfiguring secular and ephemeral things.

. . . When he spoke of his artistic aims he talked of reproducing his *sensations*, portraying objects in relief, showing clearly the depth of space, and finding the precise equivalent for every shade of colour and every deviation of shape which he observed. These indications of his own views are indeed important: yet they are only indications, for they mention the means, but still not the goal and the ultimate aim of the artist. . . . Cézanne frequently stressed that an artist's success was determined by the extent of his revelation of such universal truths. Truth is, however, first and foremost transcendent; so Cézanne's aim was to represent the real world in his pictures as an expression, a symbol, a bearer of such transcendence.

. . . He devoted all his efforts to bringing the movement of curves (and of straight lines too) to a standstill in his pictures; and because he succeeded, he derived great profit from this difficulty, for he actually illustrated this process (of bringing movement to a standstill) and so created a doubly strong impression that things bounded by curves were standing still, permanent, persisting.

The methods employed by Cézanne for this purpose were: interruption, shading off and the interaction of two or more curves on one another (particularly obvious in the still-lifes with fruits) in such a way that a junction was formed between them which had almost the effect of a right-angle on their tendency towards movement and so cancelled it out. All this can be seen to particular advantage in the still-lifes, the distorted nature of which can indeed be explained by this procedure. The openings in circular pots, soup plates and cups, abnormal from the point of view of perspective, are not oval but are drawn with the long sides parallel and the corners turned almost in the shape of a right angle; the edges of tables do not continue in the expected position in the picture plane (e.g. V. 196, 210, 341). These "faults" are not, as others have said, to be attributed to the adoption of different horizons; rather does all serve to bring to a standstill those outlines which suggest movement, to discourage the eye from sliding along them and thus to prevent it from apprehending the things themselves as having been moved, that is to say, being found in a state of change.

The desire to paint what was immobile, what was permanent and had achieved "mutual self-preservation" through indissoluble interrelationships, guided Cézanne also in his choice of motifs and models. He favoured definite forms, clear-cut images, established things: apples and pears, pots and cups, bare mountains, rocks, tree trunks and houses. The unemotional clarity of southern landscapes, endowed by nature with a

structure inviting plastic portrayal, set a standard for his entire conception of nature. . . .

Cézanne's peculiar and personal conception of space can also be explained by the fact that he wanted to show objects as unalterably linked to one another but unconnected with human beings. This was the origin of the most impressive quality of space in his pictures, its perfect stillness and immobility. The tendency of spatial perspective to develop into movement is halted. What he portrayed was not the impression of measured distances, but a permanent and harmonious disposition of objects in space governed by their being together. Cézanne did not plan space as an empty shell into which he later imported objects and placed them in a certain relationship to each other, expressed through diminishing size, diminishing clarity and changing colour; on the contrary, his essential method of reproducing space was to show solids as convex, as detached and separate from each other or as partially covering each other, in other words by making the plasticity of things manifest everywhere and by making them overlap. Solids are more important than space, fullness than emptiness; what possesses weight and the quality of forming a centre is more important than the wavering outline which has no weight; and the fact of filling counts for more than the fact of being a recipient: what can be seen of space seems to be filled. This last characteristic is especially plain in the atmosphere, which does not appear as a medium floating high above the earth, drifting away into infinite heavenly space, but is represented as something solid reaching right down to the ground. Since the quality of emptiness in space or space as such is not stressed, the possibility of movement (which of course includes the possibility of things changing) is eliminated. In Cézanne's pictures there is no emptiness, no space in which anything could move; every object is linked to another and here even the air is only one such object among others. By developing this characteristic, Cézanne in fact made a radical break with "scientific perspective," the whole point of which is to construct a continuous *empty* space, and which painters employ for the very reason that it lets them create a picture containing freely moving figures.[1] It is understandable that Cézanne, who aimed at doing the very opposite of this, was compelled to use "wrong" perspectives, though of course "wrong" only in the traditional meaning of the expression. Yet it is not correct to say, as Novotny does, that "what he painted was no longer, practically speaking, perspective at all." In Cézanne's pictures space is seen just as much in perspective as in those of any other artist and he used both the device of tapering and the convergence of lines of perspective; yet he employed neither of these devices as the foundation of a composition, only as something subordinate to and serving the relationships continuously produced between objects themselves.

All the same, space as seen by Cézanne is certainly "not a space in which objects can *live*," not an "illusory space," offering a false picture of the everyday world to man; it is the space in which things have their

[1] Fritz Novotny, *Cézanne und das Ende der wissenschaftlichen Perspektive*, p. 81.

being, in which they exist together, which they themselves actually create in the first instance merely by their being together: it is both the possibility and the result of their existing together. Thus it is no longer something special in itself but is inextricably a part of the objects depicted in the picture. It acquires its special qualities from this characteristic. . . .

Similarly the homogeneity of what appears in the section of the world portrayed is furthered by presenting all objects with the same degree of distinctiveness (which is by no means realistic or to be assessed in realistic terms), enabling space to be apprehended as the space in which things have their being, regardless of what the human eye sees. This unreal clarity is produced in two ways in Cézanne's work. First, one solid is divided from another by bands and patches of colour which form shadows and hold the composition together; the arrangement of these, which is due in each case to the particular character of that part of the world being shown, separates them from one another. Secondly, this clarity is assured by reducing objects to simple, definite stereometric forms, easily grasped as units, and by the unbroken modulation of the modelling colours. The uniform distinctness thus achieved depends not on a faithful and clear rendering of detail but on the general application of the method of reducing shapes to simplified units.

A symbolical *one*-ness can be traced running through the "facture" of Cézanne's paintings, representing something permanent, which is preserved eternally unchanged in "being," the fundamental characteristic shared, despite their great diversity, by all things seen. An example of this is the way in which all things seen are indicated by colours and every colour is seen as shadow, is made use of for shading so that the representation of "being" seems to be subjected to a uniformly solemn darkness which has a subduing effect on even the most intense tones of colour and actually dims the fire of Cézanne's most colourful late works. . . .

Then there is a second unifying feature of the "facture," namely, the detached patches of colour frequently but not invariably applied in one direction. They evoke the carpet-like character of the mature works, that special quality which differentiates Cézanne's painting from the other types of "free" ("broken colour") painting with which we are familiar. In a woven carpet an impression of a positive remoteness from nature predominates; a distortion of the natural forms is caused by the technique and by the rigidity of the web itself. The tension thus created between the real thing and its artificial representation and the exploitation of this tension can be an asset endowing the carpet with a certain indefinable charm; a further advantage is the exceptional evenness of a picture woven into a carpet, accentuated by the fact that the qualities of the material of which the carpet is made prevail over the very different visual qualities of the substances of which the things portrayed are made, whether they are clothes, flesh, flowers, fruits or utensils.

. . . it surely cannot be said that Cézanne's art is remote from life. What is true is that it offers a completely new conception of life.
. . .

I disagree with Sedlmayr's analysis and consider that Cézanne's art ought, on the contrary, to be regarded as a last great attempt to oppose the general tendency towards "unbridled chaos" with a sane and purposefully ordered conception of the world of human beings supporting and maintaining each other in a common fate. In him, in fact, painting "emerges as the last metaphysical activity within European nihilism" —Nietzsche's view of the great art of his time in general.

"CÉZANNE'S DREAM OF HANNIBAL" (1963)

Theodore Reff

Before he turned seriously to painting around 1860, Cézanne's primary means of expression was poetry. Like many aspiring young men in the provinces, where the Romantic poets were still cherished and imitated, he composed "fulsome verses on the joys of nature and imaginary loves," but also, in a more original style, "fancies of a macabre violence in prose and verse, centering on women and the family. They have been ignored as immature effusions, but they are worth considering for the light they throw on Cézanne's personality and his relations to his parents." [1]

The *Songe d'Annibal*, reprinted here in an appendix, is one of the longest and most powerful of these youthful poems. It occurs in a letter to Zola written the day after Cézanne's graduation from the Collège Bourbon in November 1858.[2] Having dreaded the baccalaureate examinations, especially in classical literature, he is immensely relieved:

> Oui, mon cher, oui mon cher, une très vaste joie,
> A ce titre nouveau, dans mon cœur se déploie,
> Du latin et du grec je ne suis plus la proie!

Nevertheless, the Latin authors he has been studying remain in his mind, linked with thoughts of industry and irresponsibility and a vague sense of guilt. "Travaille, mon cher," the letter abruptly begins, "nom [*sic*] labor improbus omnia vincit"—a paraphrase of the well-known line in

Theodore Reff, "Cézanne's *Dream of Hannibal*," *The Art Bulletin*, XLV, 1963, pp. 148–152. Revised for this edition. By permission of Theodore Reff and *The Art Bulletin*.

[1] Meyer Schapiro, *Paul Cézanne*, New York, 1952, p. 22; see also pp. 23, 29, and 108. This is the first serious attempt to interpret Cézanne's poetry in relation to his personality and later art. The earlier essay by Carlo Carrà, "Le Poesie di Cézanne," in *Documenti per Cézanne*, Milan [1946], is entirely discursive.

[2] Letter of November 13, 1858; Paul Cézanne, *Correspondance*, ed. John Rewald, Paris, 1937, pp. 40–44.

Virgil's *Georgics*, "labor omnia vicit improbus." [3] Suddenly changing tone, he apologizes profusely for not having written sooner: "Excuse, ami, excuse-moi! Oui, je suis coupable. Cependant, à tout péché miséricorde. Nos lettres doivent s'être croisées. . . ." With themes of guilt and moral obligation, then, and a manner alternately learned and light, Cézanne begins the letter containing the *Songe d'Annibal,* a poetic fantasy in which all these elements recur with a heightened intensity.[4] Although written in an exuberant spirit that conceals his earnestness, it is a sincere attempt to project in an imaginative form his conflicting feelings about himself and his family, and thus represent perhaps his first authentic work of art.

Introduced to Zola as "matière de vers latins donnés en rhétorique et traduits en français par nous, poète," the poem undoubtedly depends on a classroom reading of Livy's History of the Second Punic War or Cornelius Nepos' life of Hannibal, both of which were as popular textbooks in the 1850's as they are today.[5] There are also suggestive similarities between some of Cézanne's verses and certain passages in the *Punica* of Silius Italicus, particularly those describing Hannibal's feast at Capua, his sleep and dream, and Hamilcar's fierce demeanor;[6] but since it was neither available in the school editions that were Cézanne's only contacts with the classics, nor by any means a popular work at the time,[7] it was probably unfamiliar to him. His most likely source of inspiration was Livy's account of the dissipation of Hannibal's army at Capua, perhaps combined with that of Dido's banquet in the first book of the *Aeneid;*[8] and this seems all the more likely when we discover that Zola, too, treated the Capuan sojourn in a play written around 1858.[9]

It was not these classical texts, however, that formed Cézanne's conception of Hannibal's character, for they describe it as being stoically severe: "His consumption of meat and drink was determined by natural desire, not by pleasure . . . what time remained when work was done he gave to sleep . . . " etc.[10] In creating his own profligate hero, who

[3] I. 145. The "nom" is presumably a misprint for the conjunction "nam." On Cézanne's classical studies, see Marcel Provence, "Cézanne collégien. Les prix de Cézanne," *Mercure de France,* CLXXXI, 1925, pp. 820–822.

[4] For a similar mock classical expression of guilt, see the letter to Zola, May 3, 1858; *Correspondance,* p. 28: "moi-même, j'ai fait . . . des *meà culpà, meà culpà,* ter, quater, quinter, *meà culpà!* . . . [pour] toutes nos impiétés passées."

[5] For editions that Cézanne may have used, see *Narrationes ex Tito Livio excerptae ad usum scholarum,* ed. F. D. Aynès, Lyons, 1852, and Cornélius Népos, *Vies des grands capitaines de l'antiquité,* ed. W. Rinn, Paris, 1855.

[6] *Punica,* 11. 270–302, 10. 351–371, and 13. 732–751, respectively. For an edition Cézanne could have used, see Silius Italicus, *Les Puniques,* trans. E.-F. Corpet and N.-A. Dubois, Paris, 1836.

[7] See the sampling of current opinions in *Lucain, Silius Italicus, Claudien,* ed. J. M. Nisard, Paris, 1850, pp. 206–211.

[8] Livy XXII. xviii. 10–16; *Aeneid* I. 695ff. On the latter, see also note 21, below.

[9] Bibliothèque Nationale, *Emile Zola,* Paris, 1952, No. 42.

[10] Livy XXI. iv. 5–7. See also Pauly-Wissowa, *Real-Encyclopädie der klassischen Altertumwissenschaft,* VII, Stuttgart, 1912, s.v. "Hannibal."

falls asleep under the table after a drunken orgy and dreams of his father's stern reprimand, Cézanne changes the historical situation to conform more closely with what he imagines to be his own. His fear of his powerful bourgeois father, with whom he was already struggling for independence, and his permanent sense of failure in his father's eyes, are well known; still under their spell many years later, even as a man of forty, he would labor desperately to conceal from the latter the existence of his mistress and child.[11] The urgency of these feelings may explain, too, the dominant role he assigns in the poem to Hamilcar, though the older general had in fact died before Hannibal's career began. But these departures from history merely confirm what is obvious in the very texture of the verse, whose abrupt changes and inappropriate emphases betray the extent of Cézanne's personal investment. Although evidently intended as a burlesque of ancient rhetoric, trivial incidents such as the punch that Hannibal spills (lines 6–24) are exaggerated beyond the requirements of satire and charged with a more obscure significance.

That Cézanne was acquainted with classical rhetoric in its most celebrated form, we know in another poem on a subject from Roman history written a few months earlier.[12] Entitled "Cicéron foudroyant Catilina, après avoir découvert la conspiration de ce citoyen perdu d'honneur," it is based on Cicero's *First Catiline Oration*, an equally popular text in Latin classes.[13] Not only does its imagery include objects specifically described in that text, such as the dagger and eagle-topped standard, but the drawing which accompanies it in the same letter is inscribed with a paraphrase of Cicero's opening words: "Quo usque tandem abutere, Catilina, patientia nostra?"[14] Here, too, however, Cézanne departs from his source, transforming the classical author's urbane irony into a vehement denunciation, and his opponent's silence into a swoon of terror; and here, too, we sense in the exaggeration something of his own situation, in which Cicero stands for the righteous father whose anger he fears, and Catiline for himself, the culprit whose crime is disclosed. (Elsewhere he writes: "Tu pourrais, dans ton dépit, t'écrier avec Cicéron: Quosque [*sic*] tandem, Cézasine, abuteris patientia nostra?", assimilating the sound of his own name to Catiline's.)[15] Thus it is not entirely in a spirit of mockery that he admits to Zola:

[11] On Cézanne's relation to his father, see Gerstle Mack, *Paul Cézanne*, New York, 1935, Chs. vii, xi, and xxvi, and John Rewald, "Cézanne and His Father," *Studies in the History of Art, 1971–1972*, Washington, 1972, pp. 39–62. The portrait of Hamilcar in lines 35–39 of the *Songe d'Annibal*, however, is not a description of the father, but a caricature designed to make him more frightening; compare the photograph and portraits in Rewald, *op. cit.*

[12] Contained in a letter to Zola, . . . 29, 1858; *Correspondance*, pp. 30–31.

[13] For an edition that Cézanne may have used, see Cicéron, *Première Catilinaire*, ed. P. Longueville, Paris, 1850 (Nouvelle Bibliothèque latine des aspirants au baccalauréat ès lettres).

[14] The pen and watercolor drawing is reproduced in *Correspondance*, fig. 4.

[15] Letter to Zola, January 17, 1859; *Correspondance*, p. 52.

> A chaque mot qui sort (j'ai horreur, je frissonne)
> De Cicéron parlant tout mon sang en bouillonne,

and that he depicts Catiline prostrate with fear in his drawing.

Familiar with the orations of Cicero, Cézanne may well have studied, too, the concluding episode of *On the Republic,* a widely read and influential narrative entitled "The Dream of Scipio." [16] Like his own composition, whose title echoes that of the "Somnium Scipionis," it tells of a young military hero who, after being entertained royally, falls asleep and dreams that his father appears before him to issue moral injunctions on filial and civic duty: "Scipio, imitate your grandfather here [Scipio Africanus the Elder, also present]; imitate me, your father; love justice and duty, which are indeed strictly due to parents and kinsmen. . . ." [17] Although there is a vestige of this milder attitude in Hamilcar's concluding advice—"Va, suis plutôt, mon fils, l'exemple des aïeux" (line 60)—his reaction is primarily a violent indignation centering on his son's wantonness and irresponsibility:

> Au lieu de protéger les murs de ta patrie . . .
> O fils dégénéré, tu fais ici la noce! (45–57)

And Hannibal, whose "irrévocable honte" is deeply ingrained, cowers in fear before the terrible old man, his momentary anger quickly repressed, whereas Scipio weeps upon seeing his father and longs to join him in heaven.[18] If, then, the classical dream narrative provided Cézanne with a formal model, the content of his poem clearly derives from a more intimate source.

What is the meaning of this enigmatic dream? That it proceeds from a profound sense of guilt is evident even in the dreamer's posture: "Il baille, étend les bras, s'endort du côté gauche" (line 29), the "left" being a familiar equivalent of "wrong" in the symbolism of dreams.[19] But does this guilt arise simply from idleness or irresponsibiilty, as Hamilcar's concluding speech and the paraphrase of Virgil at the beginning of the letter imply? These sentiments hardly seem appropriate for the morning of Cézanne's successful graduation, nor do they explain the many odd images and turns of phrase in which the poem abounds. Especially

[16] For an edition that Cézanne may have used, see Cicéron, *Le Songe de Scipion,* ed. N. A. Dubois, Paris, 1853 (Nouvelle Bibliothèque latine des aspirants au baccalauréat ès lettres).

[17] *On the Republic* VI. xvi.

[18] *Le Songe d'Annibal,* lines 42–45; *On the Republic* VI. xiv.

[19] See especially Freud's analysis of a dream of Bismarck's in *The Interpretation of Dreams,* Ch. VI; *The Complete Psychological Works of Sigmund Freud,* ed. James Strachey, London, 1953ff., V, pp. 378–381. Rewald, *op. cit.,* p. 45, n. 3, has objected that "the crucial word in this verse is *débauche* and that Hannibal would have fallen asleep *sur la droite* or *sur les dos* provided they offered a rhyme with . . . *auche!*" But at the present stage in the development of literary criticism this purely pragmatic conception of rhyme seems outmoded and shallow. Compare the meaning of left and right in Cézanne's version of Hercules at the Crossroads, in my article, "Cézanne and Hercules," *Art Bulletin,* XLVIII, 1966, p. 35.

through these elements of imagery and language, which have the highly charged, ambivalent character of a disguised sexual fantasy,[20] we are brought instead to recognize as the central theme the adolescent author's remorse about masturbation and consequent fear of discovery. Almost the entire first stanza can in fact be read as a metaphor in this sense, culminating in the lament:

> O punch tu méritais un tout autre tombeau! . . .
> Il te laissa gisant sur le sol, ô Cognac! (20–24)

Hence the detailed account of the wine and rum that Hannibal spills, a sustained symbolism of ejaculation, from the "grand coup de poing" that upsets the table to the dishes floating

> tristement dans des ruisseaux limpides
> De punch encore tout chaud, regrettable dégât! (7–11)

Hence, too, the exaggerated regret that follows directly, further identifying the liquors as inherited substances which, like semen, are too precious to be wasted:

> Se pouvait-il, messieurs, qu'Annibal gaspillât,
> Infandum, Infandum, le rhum de sa patrie?
> Du vieux troupier français, ô liqueur si chérie? (12–14)

In alluding to Aeneas's melancholy reply to Queen Dido, "Infandum, regina, iubes renovare dolorem . . . ,"[21] Cézanne repeats a motif he had already employed in an earlier letter, where its erotic significance is more obvious: "Avec toi," he tells Zola, "que de sujets n'ai-je pas à traiter, et la chasse, et la pêche, . . . et l'amour (Infandum n'abordons pas ce sujet corrupture)."[22] Even more interesting in relation to the *Songe d'Annibal*

[20] This is already evident in Hamilcar's phrase, "tu fais ici la noce," which suggests both an orgy and a wedding banquet. According to Rewald, *op. cit.,* p. 45, n. 3, "it definitely suggests no such things to Frenchmen, and any reliable dictionary would have told [me] that *faire la noce* has nothing to do with nuptials and still less with an orgy. . . ." Which dictionaries does he have in mind? The most comprehensive recent one, Robert (1959), defines "faire la noce" as "mener de manière habituelle une vie de débauche," and for the related verb "nocer" cites a passage in Jules Vallès' novel *Le Bachelier* (1881) where it is explicitly linked with "orgie." Similar definitions are given by Larousse (ca. 1870), by Hatzfeld and Darmesteter (ca. 1895), and by the Académie Française (1935). And in the *Dictionnaire érotique moderne,* "par un professeur de langue verte" [Alfred Delvau], Freetown, 1864, "Noce (faire la)" is defined: "Passer son temps à baiser quand on est homme, à se faire baiser quand on est femme."

[21] *Aeneid* II. 3–6. Around 1875 Cézanne illustrated the scene of Aeneas's encounter with Dido in two small drawings, now in the Henry Pearlman Collection, New York; see the catalogue of the exhibition of that collection at M. Knoedler and Co., New York, January 1959, Nos. 22 and 23, and *Aeneid* I. 579ff., though here the details are somewhat different.

[22] Letter to Zola, July 9, 1858; *Correspondance,* p. 35. The suggestion in Jack Lindsay, *Cézanne, His Life and Art,* London, 1969, p. 35, that Cézanne unconsciously identified himself with Ascanius, who, disguised as Cupid, is fondled by Dido in the ban-

is the little poem on love that follows in the same letter, for here the symbolic equivalence of drinking and sexuality, itself an ancient theme, is made explicit:

> Je n'ai pas encore porté
> A mes lèvres innocentes,
> Le bol de la volupté
> Où les âmes aimantes
> Boivent à satiété.

This equivalence is also implied in Hamilcar's concluding advice to his son: "Loin de toi, ce cognac et ces femmes lascives," etc. (lines 60–64). Is there not, moreover, in Hamilcar's last words, "c'est très pernicieux," a reflection of the conventional warning about masturbation that Cézanne undoubtedly heard from his own father? And in the stress placed on Hannibal's vest, "tout taché de sauce," etc. (lines 58–59), is there not an obvious reflection of his fear of discovery? [23]

Apart from such internal evidence, this interpretation of the dream is justified by its consistency with "what we learn of the young Cézanne from his letters and the accounts left by his friends. He appears in these documents an unsociable, moody, passionate youth who is given to compulsive acts which are followed by fits of despair. . . . The one mention of a real woman concerns a working-girl in Aix whom he dares not approach and who, he discovers, is already loved." [24] This inhibition was to become increasingly pronounced as Cézanne grew older and more withdrawn, jealous of his solitude, estranged from his wife, fearful even of employing nude models; we recall, as an incident typical of many, his terrified flight from his gardener's daughters, whom he imagined to be tempting him.[25] It is not difficult to recognize in all this the pattern of behavior already visible in the youthful poem.

However personal in content, the *Songe d'Annibal* depends on an older literary type, without which it is hardly conceivable: the melodramatic poem of love and adventure, alternately passionate and ironic in tone, created some thirty years earlier by Alfred de Musset.[26] Im-

quet scene mentioned above, and that "the 'unspeakable love' that stirs Paul's mind and senses belongs to the fondled boy who finds himself willynilly in his father's place," is intriguing psychologically but unfounded philologically. For the passage on Ascanius (I. 717–722) does not contain the "infandum" motif; there is no evidence that Cézanne was "strongly affected" by the later passage where it does occur (IV. 83–85); and that in turn should not be translated as "being able to cheat *infandus amor.*"

[23] Compare Freud's similar interpretation of stained trousers in *The Psychopathology of Everyday Life,* Ch. ix; Freud, *op. cit.,* VI, pp. 199–200. See also the definition of "Sauce d'amour" in the *Dictionnaire érotique moderne* as "le sperme."

[24] Schapiro, *op. cit.,* p. 22.

[25] On Cézanne's marriage and fear of women, see Mack, *op. cit.,* Ch. XX and pp. 316–317, where, however, the psychological problem is oversimplified.

[26] See Pierre Gastinel, *Le Romantisme d'Alfred de Musset,* Rouen, 1933, Ch. iii.

mensely popular among the young men of Cézanne's generation, espe-
cially in provincial towns like Aix, Musset's confessional manner liberated
them from the constraints of bourgeois convention and encouraged them
to express their conflicting feelings in a spontaneous artistic form. Re-
calling the importance of Musset's verse for himself and Cézanne around
1856, Zola later wrote: "Il nous parlait des femmes avec une amertume
et une passion qui nous enflammaient. . . . Il était sceptique et ardent
comme nous, plein de faiblesse et de fierté, confessant ses fautes avec le
même élan qu'il avait mis à les commettre." [27] It is not surprising, then,
that their own literary efforts were influenced by *Rolla, Les Nuits,* and the
Contes d'Espagne et d'Italie, entire sections of which, Zola further re-
calls, they would memorize and recite during their long excursions. Thus
Zola's *Comédie Amoureuse: Rodolpho* is an obvious pastiche of *Don Paez,*
just as Cézanne's fragmentary verses on Hercules recall those in *Rolla.*[28]

If the *Songe d'Annibal* also contains echoes of *Rolla,* it was more
profoundly inspired by one of the earlier *Contes d'Espagne,* a one-act
play in verse entitled *Les Marrons du feu.* In this farcical melodrama set
in eighteenth-century Italy, the wealthy count Rafael Garuci, bored with
his mistress, invites the Abbé Annibal Desiderio to replace him in a
rendezvous with her; to revenge herself, she persuades the abbé with a
promise of love to murder Rafael, but when this is done, blandly dis-
misses him.[29] The play closes with the abbé lamenting:

> J'ai tué mon ami, j'ai mérité le feu,
> J'ai taché mon pourpoint, et l'on me congédie.

—a possible source for the phrase "ton pourpoint neuf est tout taché" in
Cézanne's poem, though there the stains are wine and sauce instead of
blood. What makes the connection plausible, besides the presence in
both works of a guilty character named Annibal, is an earlier scene in
which the abbé, after feasting and drinking with Rafael, falls asleep
under the table.

> L'abbé s'est endormi.—Le voilà sous la table . . .
> O doux, ô doux sommeil! ô baume des esprits!

the count declares, before brusquely awakening him.[30] Here not only the
episode but the ironic tone in which it is told remind us of Cézanne's

[27] Emile Zola, "Alfred de Musset," *Documents littéraires*; his *Œuvres complètes,* ed.
Maurice Le Blond, Paris, 1928f., XLV, pp. 73–80; the quotation is from p. 78.

[28] See my "Cézanne and Hercules," p. 36. Zola's early poetry, selected by him and
published in 1882, is reprinted in *Mélanges, prefaces et discours*; his *Œuvres com-
plètes,* L, pp. 335ff.

[29] Alfred de Musset, *Poésies complètes,* ed. Maurice Allem, Paris, 1957, pp. 19–58.
Written in 1829, it is, like Cézanne's poem, the invention of a young man of nine-
teen.

[30] Scene V; *ibid.,* pp. 36–38.

déjà le fameux vainqueur de Cannes allait
S'endormir sous la table: ô étonnant miracle! (4–6)

Through these parallels in language, in themselves trivial, we are
led to discover in the two poems a more pervasive thematic parallelism,
which in turn hints at the existence of a deeper, otherwise inaccessible
level in Cézanne's. Like Musset's Annibal (appropriately surnamed
Desiderio), like himself in fantasy at least, his protagonist is self-indul-
gent, irresponsible, preoccupied with wine and women; because of the
one he sleeps under the table, and because of the other, stains his vest.
That the abbé in acting thus must break his vow of chastity, just as Cé-
zanne must disregard his father's wish or command, is another secret link
between them; it reminds us of his later preoccupation with the theme
of the Temptation of St. Anthony.[31] Cézanne thus identifies himself in
imagination with Annibal—a scoundrel who murders his friend in order
to possess his mistress. But this friend, the count Garuci, is like his own
father—a commanding figure whose wealth and amorous success are
conspicuous.[32] We may ask, then, whether the young artist does not re-
veal in his choice of a literary model an unconscious desire to eliminate
his own father as a rival and threat, an impulse which is hardly surprising
when we consider his temperament and relations to his parents.

Transposing spontaneously into verse what was undoubtedly a
real dream, perhaps inspired by a family celebration of his graduation
on the previous day, Cézanne achieves in the *Songe d'Annibal* a remark-
able note of conviction; however naïve or awkward at times, it is an
authentic document of his adolescence.[33] This would not have been pos-
sible without the liberating example of Romantic verse, especially Mus-
set's, with its concentration on erotic themes, its ironic confessional tone,
and its freedom of language and rhyme. Neither would it have been pos-
sible, however, if the young Cézanne were not already determined to
admit into his work the whole span of his troubled feelings—an attitude
of decisive importance for his later development as an artist. It is the
ground of that absolute sincerity which, even in this phase, distinguishes
his poetry from the equally Romantic but more shallow and obviously
contrived poetry of Zola. Thus the latter's account of a *Vision,* also based
on Musset, is a sentimental lyric lacking the urgency of Cézanne's
dream.[34] Zola himself was aware of the difference: "Mon vers est peut-
être plus pur que le tien," he admitted to Cézanne in 1860, "mais certes

[31] See my article, "Cézanne, Flaubert, St. Anthony, and the Queen of Sheba," *Art Bulletin,* XLIV, 1962, pp. 113–125.

[32] However, the relative ages of Rafael and Annibal correspond more closely to those of Cézanne and his father, respectively.

[33] This does not mean, however, that Cézanne's poetry was written impulsively, with-out a programme or preliminary draft, as John Rewald assumes (*Cézanne, sa vie—son œuvre, son amitié pour Zola,* Paris, 1939, p. 29), since there is evidence to the contrary in certain letters; see *Correspondance,* pp. 41 and 51.

[34] Zola, *Mélanges, prefaces et discours,* pp. 367–370.

le tien est plus poétique, plus vrai; tu écris avec le coeur, moi, avec l'esprit; tu penses fermement ce que tu avances, moi, souvent, ce n'est qu'un jeu, un mensonge brillant." [35]

Of the mature artist's practices and values, however, there is little evidence here. The one sign of visual sensibility, the interesting combination of color words in Hamilcar's

> Rougis, corbleu, rougis,
> Jusqu'au blanc de l'œil. (47–48)

is fortuitous and in any event unique. It is rather in his pictures of intoxication and sensuality, painted in the 1860's and early 1870's, that we discover the poem's true descendants. The earliest of these, reportedly submitted to the Salon of 1867, has not survived, but its composition is probably preserved in a group of slightly later works with the same title: *L'Après-midi à Naples, ou le Punch au rhum.*[36] The title may not be Cézanne's own, yet the second phrase recalls the "punch encore tout chaud," a dominant motif in the *Songe d'Annibal,* and the first phrase suggests the Italian setting of *Les Marrons du feu,* itself the product of a Romantic notion of Italy as a place of gaiety and uninhibited sensuality: "Italie . . . c'est la rime à la folie," Rafael declares.[37] Echoes of the earlier poem appear also in the imagery of *L'Après-midi à Naples,* an exotic tableau in which two lovers sprawling on a couch are served food and drink by a Negro servant, the latter evidently inspired by Delacroix's *Femmes d'Alger.* Drinking and love are again combined, this time in a genre idiom influenced by contemporary Impressionist taste, in *Les Ivrognes* of about 1872–1875, an outdoor tavern scene containing men wrestling or overcome with wine, a couple embracing in a doorway, and a drunkard lying asleep, like a modern Hannibal, under the table.[38]

More important than these in relation to the poem is a large canvas of around 1868 representing an orgy in an antique or Renaissance setting.[39] The long banquet table laden with dishes, the profusion of

[35] Letter of August 1, 1860; *Correspondance* (*1858–1871*); his *Œuvres complètes,* XLVIII, pp. 147–149.

[36] Lionello Venturi, *Cézanne, son art—son œuvre,* Paris, 1936, Nos. 112, 223, and 224, the earliest of which is dated 1870–1872. On the lost work, see Ambroise Vollard, *Paul Cézanne,* Paris, 1914, pp. 21–22 and 25. However, Vollard's account of the naming of the picture is extremely doubtful, and his reference to the Salon of 1866 is incorrect; see John Rewald, *The History of Impressionism,* rev. ed., New York, 1961, pp. 168–170, quoting newspaper articles of April 1867 that mention *Le Grog au vin.* But Rewald's suggestion that the earliest surviving version (ill. *ibid.,* p. 170) be redated 1866–1867 seems incompatible with the style of the works definitely done at that time, such as the *Portrait de Valabrègue* and *L'Enlèvement* (ill. *ibid.,* pp. 138 and 158).

[37] Scene v; Musset, *op. cit.,* p. 36; see also p. 614 n. 42.

[38] Venturi, *op. cit.,* No. 235.

[39] *Ibid.,* No. 92; oil on canvas, 130 x 81 cm. There dated 1864–1868, but now generally considered somewhat later; see Douglas Cooper, "Two Cézanne Exhibitions—I," *The Burlington Magazine,* XCVI, 1954, p. 346 (as 1867–1868), and Lawrence Gowing, "Notes on the Development of Cézanne," *ibid.,* XCVIII, 1956, p. 187 (as

gold and silver vessels, servants carrying wine, lascivious women—many elements described or alluded to in the text are present here, including even a figure like the sleeping Hannibal whose limbs are just visible at the lower border.[40] But it is not exclusively the illustration of a dream: some twenty years earlier an orgy—in fact a Roman orgy—had been the subject of an immensely popular picture by Couture, of which Cézanne later owned a reproduction; and the banquet had often been represented in older art, especially by the Venetians, whom Cézanne particularly admired.[41] If Veronese's sumptuous feasts, one of which Cézanne copied in the Louvre at this time, come to mind first, however, the closest parallel to *L'Orgie* is not in these calm symmetrical designs, but in the dynamic theatrical compositions of a late Baroque artist like Pannini, whose *Banquet*, also in the Louvre, may indeed be considered a distant source.[42] Like Musset's poetry, it provided a model for the treatment of an exotic subject in a highly dramatic style abounding in exaggerated actions and tonal contrasts. But Cézanne brings the image into closer accord with the mood of the *Songe d'Annibal*, transforming Pannini's aristocratic society, its elegant décor and restrained erotic play, into a wild orgy in which most of the embracing and struggling figures are nude and the draperies stream out like colored clouds.[43] Even the musician and spectators appear magically suspended in the sky above, though they are in fact supported by the drapery-covered entablature—a motif probably inspired by the distant figures in Pannini's colossal architecture.

When, many years later, Cézanne takes up the subject again, this Baroque conception is replaced by a sober classical one, frontal and sym-

1871–1872). Venturi's title, although now current, is also inaccurate, since the picture was first exhibited in 1895 as *Le Festin*; see Vollard, *op. cit.*, pp. 31 and 58.

[40] The description of Belshazzar's feast in Daniel 5:1–4, a popular subject in Baroque art, would also account for this image, but it is unlikely that Cézanne was acquainted with it or would have attempted to illustrate it. Indeed, the numerous preliminary studies for *L'Orgie* show him searching for expressive forms and groupings without a clearly established scene in mind; see Adrien Chappuis, *Les Dessins de Paul Cézanne au Cabinet des Estampes du Musée des Beaux-Arts de Bâle*, Olten, 1962, Nos. 12 and 14–17.

[41] See Jean Seznec, "*The Romans of the Decadence* and Their Historical Significance," *Gazette des Beaux-Arts*, 6, XXIV, 1943, pp. 221–232, and the Veroneses cited there. For Cézanne's copy after one of the figures in the *Romans*, see Wayne Andersen, "A Cézanne Drawing after Couture," *Master Drawings*, I, No. 4, Winter 1963, pp. 44–46.

[42] Leandro Ozzolà, *Gian Paolo Pannini, pittore*, Turin, 1921, pl. 8, a very large circular canvas. A small oil sketch, rectangular in format, is also in the Louvre; Seymour de Ricci, *Description raisonnée des peintures du Louvre*, I, Paris, 1913, Nos. 1402 and 1403. Cézanne's copies after Veronese's *Marriage at Cana* are Chappuis, *op. cit.*, Nos. 28 and 29. In some of the preliminary drawings for *L'Orgie*, Chappuis also observes the influence of Delacroix; *ibid.*, No. 15. And a specific connection with Delacroix's *Heliodorus* mural has been suggested, not quite convincingly, by Sara Lichtenstein, "Cézanne and Delacroix," *Art Bulletin*, XLVI, 1964, p. 58.

[43] These figures reappear around 1875–1877 in *La Lutte d'amour*, a related subject; Venturi, *op. cit.*, Nos. 379 and 380. But more surprisingly, some of them also occur in the contemporaneous *Baigneuses; ibid.*, No. 265.

metrical in arrangement, and the scene is no longer an orgy but a *Préparation du banquet* dominated by draperies and vessels, the objects of an extended still life.[44] It is the last impersonal vestige of an exuberant poem written more than thirty years earlier.[45]

APPENDIX

SONGE D'ANNIBAL. ANNIBALIS SOMNIUM

Au sortir d'un festin, le héros de Carthage,
Dans lequel on avait fait trop fréquent usage
Du rhum et du cognac, trébuchait, chancelait.
Oui, déjà le fameux vainqueur de Cannes allait
5 S'endormir sous la table: ô étonnant miracle!
Des débris du repas effrayante débâcle!
Car d'un grand coup de poing qu'appliqua le héros
Sur la nappe, le vin s'épandit à grands flots.
Les assiettes, les plats et les saladiers vides
10 Roulèrent tristement dans des ruisseaux limpides
De punch encore tout chaud, regrettable dégât!
Se pouvait-il, messieurs, qu'Annibal gaspillât,
Infandum, Infandum, le rhum de sa patrie?
Du vieux troupier français, ô liqueur si chérie?
15 Se pouvait-il, Zola, commettre telle horreur,
Sans que Jupin vengeât cette affreuse noirceur?
Se pût-il qu'Annibal perdit si bien la tête
Pour qu'il pût t'oublier d'une façon complète,
O rhum?—Eloignons-nous d'un si triste tableau!
20 O punch tu méritais un tout autre tombeau!
Que n'a-t-il donné, ce vainqueur si farouche,
Un passe-port réglé pour entrer dans sa bouche,
Et descendre tout droit au fond de l'estomac?
Il te laissa gisant sur le sol, ô cognac!
25 —Mais par quatre laquais, irrévocable honte,
Est bientôt enlevé le vainqueur de Sagonthe
Et posé sur un lit; Morphée et ses pavots
Sur ses yeux alourdis font tomber le repos,
Il baille, étend les bras, s'endort du côté gauche;
30 Notre héros pionçait après cette débauche,
Quand des songes légers le formidable essaim
S'abbatit tout à coup auprès du traversin.

[44] *Ibid.*, No. 586; there dated ca. 1890. The same elements do in fact appear in a still life: *ibid.*, No. 200; there dated 1875–1876, but more likely contemporary with No. 586.

[45] Elsewhere, however, I have suggested that the extraordinary and otherwise inexplicable posture of Cézanne's *Baigneur aux bras écartés*, a frequent subject in his work between 1875 and 1885, ultimately derives from the same personal source as this early poem; see "Cézanne's Bather with Outstretched Arms," *Gazette des Beaux-Arts*, 6, LIX, 1962, pp. 173–190.

I am grateful to my colleague Meyer Schapiro for many useful suggestions, and to the Council on Research in the Humanities, Columbia University, for a travel grant during the summer of 1961.

Annibal dormait donc.—Le plus vieux de la troupe
S'habille en Amilcar, il en avait la coupe.—
35 Les cheveux hérissés, le nez proéminent,
Une moustache épaisse extraordinairement;
Ajoutez à sa joue une balafre énorme
Donnant à son visage une binette informe,
Et vous aurez, messieurs, le portrait d'Amilcar.
40 Quatre grands chevaux blancs attelés à son char
Le traînaient: il arrive et saisit Annibal par l'oreille
Et bien fort le secoue: Annibal se réveille,
Et déjà le courroux . . . Mais il se radoucit
En voyant Amilcar qu'affreusement blêmit
45 La colère contrainte: "Indigne fils, indigne!
Vois-tu dans quel état le jus pur de la vigne
T'a jeté, toi, mon fils—Rougis, corbleu, rougis,
Jusqu'au blanc de l'œil. Tu traînes sans souci,
Au lieu de guerroyer, une honteuse vie.
50 Au lieu de protéger les murs de ta patrie,
Au lieu de repousser l'implacable romain,
Au lieu de préparer, toi vainqueur au Tésin,
A Trasimène, à Cannes, un combat où la ville
Qui fut des Amilcars toujours le plus hostile
55 Et le plus acharné de tous les ennemis,
Vit tous ses citoyens par Carthage soumis,
O fils dégénéré, tu fais ici la noce!
Hélas! ton pourpoint neuf est tout taché de sauce,
Du bon vin de Madère et du rhum! C'est affreux!
60 Va, suis plutôt, mon fils, l'exemple des aïeux.
Loin de toi, ce cognac et ces femmes lascives
Qui tiennent sous le joug nos âmes trop captives!
Abjure les liqueurs. C'est très pernicieux
Et ne bois que de l'eau, tu t'en trouveras mieux."
65 A ces mots Annibal appuyant sur son lit
Sa tête, de nouveau profondément dormit.

Biographical Data [1]

1839 Born at Aix-en-Provence on January 19.

1852 Student at the Collège Bourbon at Aix; friendship with Emile Zola and Baptistin Baille.

1858 Zola leaves for Paris; Cézanne passes the baccalauréat at the second attempt; works at the Academy of Drawing in Aix.

1859 Studies law at the University of Aix; his father, Louis-Auguste Cézanne, acquires the house known as "Jas de Bouffan."

1861 Abandons law studies. First trip to Paris, visits the Salon and meets Pissarro at the Atelier Suisse. Returns discouraged to Aix and enters his father's bank.

1862 Leaves the bank to devote himself to painting. Rejoins Zola in Paris, where he remains, with intermittent visits to Aix, until 1870. Fails in examinations for the École des Beaux-Arts.

1863 In Paris, probably for the entire year. Exhibits at the Salons des Refusés; goes with Zola to the exhibition. Works at the Atelier Suisse. Requests permission to make copies at the Louvre.

1864–1869 Rejected at the Salon.

1869 Zola begins work on *Rougon-Macquart* series. About this time Cézanne meets Hortense Fiquet.

1870 Works in Aix and, in order to evade conscription, at L'Estaque, where he lives in secret with Hortense Fiquet. Returns to Paris late in the following year. A caricature of Cézanne by Stock is published in Paris press.

1872 Birth of his son. Moves to Pontoise and works alongside Pissarro.

1873 Leaves Pontoise at end of 1872, settles in nearby Auvers-sur-Oise. Friendship with Dr. Gachet, in whose attic he makes a few etchings. Zola publishes *Le Ventre de Paris* in which Claude Lantier, a painter resembling Cézanne, appears.

1874 At Auvers. Participates in first Impressionist exhibition with three pictures.

[1] For a more complete bibliographical outline see John Rewald, *Paul Cézanne* (New York, 1968), pp. 215–222, from which the above data is drawn.

1877 In Paris most of the year; shows sixteen works in the third Impressionist exhibition, praised only by Rivière.

1878 In Aix. His father discovers Cézanne's secret liaison and tries to force him to abandon Hortense Fiquet and her son, without success. Rejected at the Salon.

1879–1881 Works at Médan where he stayed with Zola. Also worked in Paris and at Pontoise. Rejected at Salon, 1879, 1881.

1882 At L'Estaque with Renoir, and in Paris. A portrait is admitted to the Salon, sponsored by Guillemet.

1883–1885 At Aix and L'Estaque, also visiting Paris. Rejected at the Salon.

1885 Has mysterious love affair. In the following year he marries Hortense Fiquet with his father and mother as witnesses.

1886 Louis-Auguste dies, leaving Cézanne a substantial income. Zola publishes *L'Oeuvre,* Cézanne breaks off the friendship.

1887–1889 In Aix and in Paris. From 1888 on, Cézanne's name appears occasionally in Symbolist journals.

1889 Cézanne's *Maison du pendu* exhibited at Paris World's Fair, thanks to Chocquet.

1890 Exhibits by invitation with Les XX in Brussels.

1891–1894 In Aix and in Paris; visit to Monet at Giverny.

1895 Vollard organizes first one-man show of Cézanne's work, exhibiting one hundred and fifty pictures. Two paintings by Cézanne enter the Luxembourg museum with the Caillebotte bequest.

1896 In Aix. Meets Joachim Gasquet, the first of the young admirers who came to visit him in his last years. Visit to the Lac d'Annecy.

1897–1899 In Aix, working at the quarry called Bibémus, in Paris and at Fontainebleau and Pontoise. Two paintings hung in Berlin National Gallery but banned by the Kaiser.

1899 Exhibits three paintings at the Salon des Indépendants.

1900 In Aix, where he spends most of the rest of his life. Three works shown at the Centennial Exhibition in Paris.

1901 Builds a studio on the Chemin des Lauves at Aix. Maurice Denis shows his *Hommage à Cézanne* at the Salon. Cézanne exhibits two paintings at the Salon des Indépendents.

1902 Death of Zola in Paris. Exhibits three paintings at the Salon des Indépendants.

1903 Seven paintings by Cézanne exhibited at the Secession in Vienna and three in Berlin. Death of Pissarro.

1904 Visited by Emile Bernard, with whom he subsequently corresponds. Exhibits nine paintings in La Libre Esthétique in Brussels and others at the Salon d'Automne in Paris, where one room was consecrated to his works. One-man show organized in Berlin.

1905 Shows ten paintings at Salon d'Automme. Monet publically expresses his admiration for Cézanne.

1906 Exhibits a *View of Chateau Noir* with the Société des Amis des Arts in Aix; lists himself in the catalogue as "pupil of Pissarro"; shows ten paintings at Salon d'Automne. Bronchitis attack in August; caught in a storm, collapses and dies October 22.

Notes on the Editor and Contributors

Judith Glatzer Wechsler. 1940– . She has published articles and reviews of contemporary art and a study of the Song of Songs in twelfth and thirteenth century Latin Bibles. Currently she is at work on Daumier's use of gesture and the physiognomy of the spectator, and on aesthetic perspectives in science and technology associated with her work at the Massachusetts Institute of Technology where she is associate professor of art history.

Alexandre, Arsène. 1859–1937. Art critic and novelist. Alexandre was a critic for *Le Figaro.* In the 1880's and 1890's he published novels and studies on decorative art, caricature, Daumier and the theater.

Allard, Roger. 1885–1961. Poet, critic, essayist. Allard was an early supporter of Cubism and author of monographs on de la Fresnaye, Dufy, Moreau, and Laurencin.

Badt, Kurt. 1890– . Art historian. Badt was at the Warburg Institute in London from 1939 to 1952 and subsequently was professor of art history at the University of Berlin. He has published books on Delacroix's drawings, Constable, Vermeer and Poussin, as well as his 1956 book on Cézanne.

Bell, Clive. 1881–1964. Art theorist and essayist. Bell advocated "significant form" as the criterion for quality in art. Along with Roger Fry he organized the first post-Impressionist exhibition in London.

Bernard, Emile. 1868–1941. Painter and art theorist. Bernard was a leading figure in the Symbolist circle of Gauguin at Pont-Aven in Brittany in the late 1880's and early 1890's. He published his first article on Cézanne in 1891 and various other essays on the painter until 1926. He met Cézanne in 1904 and carried on discussions and a lengthy correspondence regarding Cézanne's theories of art.

Denis, Maurice. 1870–1943. Painter and art theorist. Denis was a Symbolist and neotraditionalist, a Catholic who sought Christian, mystical and Neoclassical elements in art. He was an ardent admirer of Cézanne and published various articles on the painter from 1905 to 1924. Denis' famous dictum of 1900 forecasted abstract art.

Dufy, Raoul. 1877–1953. Painter. Dufy evolved a highly decorative style under the impact of the Fauve movement.

Frankl, Gerhart J. R. 1901–1965. Painter. Frankl was born in Vienna but spent his last twenty-seven years in England. He was a lecturer at the University of Vienna and art master at The King's School, Chester. The influence of Cézanne is apparent in his paintings.

Fry, Roger. 1866–1934. Art historian and critic. Fry was one of Cézanne's most significant interpreters. He introduced Post-Impressionist painting to England. Fry's lucid formal analyses had a major effect on twentieth-century criticism. He is the author of numerous books and essays many of which are collected in *Vision and Design, Transformations,* and *Last Lectures.*

Gauguin, Paul. 1848–1903. Painter. Foremost member of the Symbolist circle in Pont-Aven. Gauguin, a leading nineteenth-century painter, has had a major influence on twentieth-century painting. He was deeply impressed by Cézanne beginning in the 1880's. Cézanne, on the other hand, disliked and distrusted Gauguin.

Geffroy, Gustave. 1855–1926. Biographer of Monet. Geffroy published his first article on Cézanne in 1894 and another piece in 1895, revealing an early sympathetic understanding of Cézanne's work.

Gleizes, Albert. 1881–1953. *Metzinger, Jean.* 1883–1956. Both painters and co-authors of the most influential writing on Cubism, *Du Cubisme,* 1912, the first book devoted wholly to Cubism. They acknowledged the Cubists' debt to Cézanne.

Greenberg, Clement. 1909– . Art critic and essayist. Greenberg is a leading twentieth-century critic and principal exponent of the modernist aesthetic in painting and sculpture. He is the author of books on Miro, Matisse and Hoffman, and numerous essays, some of which appear in *Art and Culture.*

Gris, Juan. 1887–1927. Cubist painter. Gris developed the purist version of synthetic Cubism based on mathematical ratios. He referred to Cézanne in various of his theoretical writings.

Huysmans, J. K. 1848–1907. Novelist and art essayist. His novel, *A Rebours,* 1884, marked his break with Zola and naturalism and his new association with Symbolism. Huysmans praised Cézanne in his *L'Art moderne* of 1889.

Kandinsky, Wassily. 1866–1944. Painter. Born in Moscow, trained in Munich. He was a founder of the Blaue Reiter movement and "pure" abstract painting.

Lawrence, D. H. 1885–1930. Novelist, poet, essayist and playwright. Lawrence advocated the acknowledgment of sensuality in art. His reflections on Cézanne appeared in an introduction to his own paintings, published in 1929.

Léger, Fernand. 1881–1955. Painter. Léger developed a curvilinear Cubism based on dynamic shapes of machinery. He distinguished between the "new realism" of structure which Cézanne prefigured and the imitative realism of past art.

Loran, Erle. 1905– Painter. Professor of art at the University of California, Berkeley. Loran lived in Cézanne's studio in Aix-en-Provence for two years. His article and book on Cézanne focused on the painter's concrete means and methods.

Matisse, Henri. 1896–1954. Painter. Matisse was the principal figure of the Fauve movement. His style was influenced by Cézanne in 1901–1903. Matisse stated in 1936 that Cézanne's work sustained him in his critical movements as an artist.

Mauclair, Camille. 1872–1945. Poet, novelist and art essayist. Mauclair was an art critic for *Mercure de France* and author of numerous books on French painting. His was the first study of the French Impressionists to be translated into English.

Meier-Graefe, Julius. 1867–1935. Art historian. His numerous enthusiastic writings introduced Impressionism to Germany. Meier-Graefe published studies on Cézanne, Van Gogh and the development of modern art.

Merleau-Ponty, Maurice. 1907–1961. Philosopher. Merleau-Ponty was the foremost phenomenologist of the postwar period. He saw in Cézanne's painting a paradigm for the perceptual process.

Montifaud, Marc de. 1850– ? . Art critic and woman of letters. Pseudonym for Mme. Leon Quivogne de Montifaud. She reviewed the Salons for *L'Artiste*, and was the author of *Les Courtisannes de l'antiquité* and other books.

Morice, Charles. 1861–1919. Art theorist and critic. Morice helped define the Symbolist movement in his *La Litterature de tout à l'heure*, 1889.

Natanson, Thadée. 1868– ? . Playwright, editor and critic. He was one of the editors of *La Revue Blanche*. In 1895 he recognized Cézanne as a master of still-life painting.

Novotny, Fritz. 1902– . Austrian art historian. Novotny has been Director of the Österreichische Galerie in Vienna and Professor at the University of Vienna since 1939. He published the first serious studies of Cézanne's spatial structure.

Picasso, Pablo. 1881–1973. Painter. In 1907 Picasso was strongly influenced by Cézanne when Cubism was still being formulated. Picasso referred to Cézanne as "the father of us all."

Pissarro, Camille. 1831–1903. Painter. Pissarro was a central figure in the Impressionist movement. He was responsible for guiding Cézanne to paint from nature rather than from imagination. Cézanne referred to Pissarro with great admiration and affection as "the humble and colossal Pissarro." Pissarro spoke on Cézanne's behalf to Huysmans, Duranty, Vollard and others.

Prouvaire, Jean. 18??– ? . Poet and writer. Pseudonym for Auguste Foures. He published poems, articles and art criticism in the 1870's–1890's.

Reff, Theodore. 1930– . Art historian. Professor at Columbia University. Reff has published numerous articles on Cézanne's drawings, sources and imagery. He has also published articles on Degas, Manet and Picasso, among others.

Rilke, Rainer Maria. 1875–1926. Austrian poet. Lived with Rodin as his secretary from 1905 to 1906. Rilke's letters of 1907 on Cézanne were written after visiting the retrospective exhibition at the Salon d'Automne. He is the

author of the *Duino Elegies, The Notebooks of Malte Laurids Brigge, Auguste Rodin* and many other works.

Rivière, Georges. 1855–1943. Writer and art critic. Rivière issued a small paper during the third Impressionist exhibition of 1877, *L'Impressionniste*. He was the first critic to praise Cézanne's paintings. Rivière is the author of *Renoir et ses amis* (1921) and biographical studies of Cézanne (1923) and Degas (1935).

Rochefort, Henri. 1830–1913. Drama critic for the satirical paper *Charivari* and later for *Figaro*. He was editor of *La Lanterne, L'Intransigeant,* and contributed regularly to *Gil Blas*.

Rouault, Georges. 1871–1958. Expressionist painter. Rouault participated in the *Mercure de France* inquiry regarding Cézanne in 1905.

Royère, Jean. 1871– ? . Editor and contributor to *La Phalange*, a Fourierist paper. Fourierism advocated a harmonious relationship between man and nature. This view is reflected in Royère's article on Cézanne.

Schapiro, Meyer. 1904– . Art historian and University Professor at Columbia University. Author of numerous studies on Early Christian, Medieval and modern art. The first to seriously consider the role of subject matter in Cézanne's art.

Schnerb, J. F. 1879–1915. . . and *Rivière, R. P.* 18??– ? . Schnerb was a painter, engraver and art critic. He exhibited in 1908 at the Salon des Indépendents and Salon d'Automne. Together with R. P. Rivière, a printmaker, he visited Cézanne in 1905.

Schuffenecker, Claude Emile. 1851–1934. Painter, designer and architect. He was a friend of Pissarro, confidant to Seurat and Gauguin and one of the founders of the Salon des Indépendents.

Sedlmayr, Hans. 1896– German art historian. Sedlmayr studied with Max Dvôrák and published studies on Borromini and Baroque architecture. He took a reactionary view of Cézanne, seeing his art as leading to the degeneration of the human spirit.

Sérusier, Paul. 1865–1927. Painter. Sérusier was in the circle of Gauguin and the Symbolists. He was a central participant from 1888–1890 in "The Nabi," which was strongly anti-Naturalistic and mystical in its ideology.

Thiébault-Sisson, François. 1856– ? . Painter and sometime critic for *Le Temps*.

Venturi, Lionello. 1885–1961. Art historian. Venturi is renowned for his catalogue raisonné of Cézanne. He has also published *Les Archives de l'Impressionnisme* and studies of other nineteenth- and twentieth-century painters.

Vollard, Ambroise. 1867–1939. Art dealer. Vollard gave Cézanne his first exhibition in 1895. A strong supporter of progressive painting. In 1896 he exhibited Bonnard, Vuillard, Denis, Maillot. Vollard held a Van Gogh exhibition in 1899, the first one-man show of Picasso in 1901, and a Matisse exhibition in 1904.

Zola, Emile. 1840–1902. Novelist. Leader of the Naturalist movement. Zola was a friend of Cézanne's from adolescence until the publication of Zola's novel *L'Oeuvre* in 1886. An early defender of Manet, Zola became increasingly conservative in matters of painting. By 1880, he wrote that the Impressionists were meager artists. Zola came to the defense of Dreyfus in his pamphlet, *J'Accuse*.

Selected Bibliography[1]

ANDERSEN, WAYNE V. *Cézanne's Portrait Drawings*, Cambridge and London, 1970.

BADT, KURT. *Die Kunst Cézannes*, Munich, 1956. (Trans. by Sheila Ann Ogilvie, *The Art of Cézanne*, Berkeley and Los Angeles, 1965.)

BERGER, JOHN. "The Sight of Man," *New Society*, April 16, 1970.

BERNARD, EMILE. "Souvenirs sur Paul Cézanne et lettres inédites," *Mercure de France*, October 1 and 15, 1907. (Reprinted in *Souvenirs sur Paul Cézanne et Lettres*, Paris, 1921.)

BERTHOLD, GERTRUDE. *Cézanne und die alten Meister*, Stuttgart, 1958.

BRION-GUERRY, LILIANE. *Cézanne et l'expression de l'espace*, Paris, 1950, 1966.

CÉZANNE, PAUL. *Correspondance*, ed. John Rewald, Paris, 1937. (English trans. by M. Kay, Oxford, 1941.)

CHAPPUIS, ADRIEN. *The Drawings of Paul Cézanne*. A Catalogue Raisonné, 2 vols., Greenwich, Connecticut, and London, 1973.

DENIS, MAURICE. "Cézanne," *L'Occident*, September, 1907. (Reprinted in *Théories*, Paris, 1912 and in *Du symbolisme au classicisme*, Collections Memoirs de l'art, Hermann, Paris, 1964.)

FRY, ROGER. *Cézanne, a Study of His Development*, London, 1927, New York, 1958.

GASQUET, JOACHIM. *Cézanne*, Paris, 1921, 1926.

LORAN, ERLE. *Cézanne's Composition*, Berkeley and Los Angeles, 1943, 1970.

MEIER-GRAEFE, JULIUS. *Cézanne und sein Kreis*, Munich, 1920.

MERLEAU-PONTY, MAURICE. "Cézanne's Doubt," *Sense and Non-Sense*, translated by Hubert L. Dreyfus and Patricia Allen Dreyfus, Northwestern University Press, 1961. (First published in *Sens et non-sens*, Paris, 1948.)

NOVOTNY, FRITZ. "Das Problem des Menschen Cézanne im Verhältnis zu

[1] For a more complete bibliography see: John Rewald: *The History of Impressionism*, New York, 1961, pp. 621–626, and *Paul Cézanne*, New York, 1968 edition, pp. 223–230. Many of the articles excerpted in the text are not cited here for reasons of space.

seiner Kunst," *Zeitschrift für Ästhetik und allgemeine Kunstwissenschaft,* XXVI, 1932.

———. *Cézanne und das Ende der wissenschaftlichen Perspektive,* Vienna, 1938, 1972.

REFF, THEODORE. "Cézanne and Poussin," *Journal of the Warburg and Courtauld Institute,* XXIII, January 1960, pp. 150–174.

———. "Cézanne's Drawings, 1875–1885," *The Burlington Magazine,* CI, May 1959, pp. 171–176.

REWALD, JOHN. *Paul Cézanne,* translation by Margaret H. Leibman, New York, 1948, 1968.

SCHAPIRO, MEYER. *Paul Cézanne,* New York, 1952, 1962, 1965.

———. "The Apples of Cézanne: An Essay on the Meaning of Still-life," *Art News Annual,* XXXIV, 1967, pp. 33–53.

VENTURI, LIONELLO. *Cézanne, son art - son oeuvre,* 2 vols., Paris, 1936.

ZOLA, EMILE. *Oeuvres complètes,* Paris, 1928, 1969. (*Correspondance, Mon Salon, L'Oeuvre*).